What I hear I forget
What I see I remember
What I do I understand

LETTER PRESS

LETTERPRESS: New applications for traditional skills

A RotoVision Book

Published and distributed by RotoVision SA
Route Suisse 9
CH-1295 Mies
Switzerland

RotoVision SA
Sales & Editorial Office
Sheridan House, 114 Western Road
Hove BN3 1DD, UK

Tel: +44 (0)1273 72 72 68
Fax: +44 (0)1273 72 72 69
Email: sales@rotovision.com
Web: www.rotovision.com

Copyright © RotoVision SA 2006

While every effort has been made to contact owners of copyright
material produced in this book, we have not always been successful.
In the event of a copyright query, please contact the Publisher.

10 9 8 7 6 5 4 3 2 1

ISBN: 2-940361-20-7

Designed by David Jury
Art Director Luke Herriott
Photography by Xavier Young and David Jury

Reprographics and printing in Singapore by ProVision Pte.
Tel: +65 6334 7720
Fax: +65 6334 7721

Introduction

"The principles of typography are not a set of dead conventions but the tribal customs of the magic forest …" **Robert Bringhurst**, *typographer and poet*

This book offers the opportunity to compare the work of artists, craftsmen, and designers. Although the subject is letterpress, the emphasis is not exclusively so. Instead, I have taken the opportunity to display and celebrate an eclectic range of typographic material, exploring the notions of craft and the underlying motivation of those using letterpress today.[1]

Letterpress, because of its remarkable commercial longevity – over 550 years – tends to be associated with tradition. The history of printing was driven by proven, sensible formulae within the print trade. Eventually, however, forces from outside the trade began to question established norms and to influence the appearance and the function of type.

Right: A spread from *The Next Call*, edited and designed by H. N. Werkman in Gröningen, circa 1925.

Left: *Alphabete Sierschriften und Monogramme,* published by Fr. Bartholomäus in Erfurt, circa 1870s.

Following page: Grot (sans serif) wood type.

Since the latter years of the nineteenth century, there has been an antiestablishment movement that has sought, for commercial, political, social, or aesthetic reasons, to debunk conventions. There can be few activities more reliant upon, and more bound by convention than typography, and printed typography, until the middle of the twentieth century, largely meant letterpress. Antiestablishment attitudes naturally test the boundaries of taste and also the technical ingenuity of those utilizing letterpress – traditionally considered the least flexible of printing processes.

Letterpress printers vigorously protected their craft (and their commercial viability) and perhaps inadvertently, shrouded their activities in an aura of mystery, even romance. The reality was that it was physically demanding, medically dangerous, and often tedious.[2] Precious few managed to escape the confines of the commercial printworks and challenge themselves and the printing standards or conventions of their time. The truth is that few probably ever had any inclination to.

The concept of the designer as a free agent, capable of initiating change, was incomprehensible until a degree of autonomy was achieved in the 1950s and 1960s. Intervention from within an industry such as printing, in which the division and organization of labor was so deeply embedded, was, at best, short-lived and did not affect the conventional rules in the long run. Even the early independent typographers – Charles Ricketts in England and Daniel Berkeley Updike in North America – did not wish to stray far from the norm: most had received a significant part of their training in the printing office.

It required the single-minded, more selfish attitude of individuals from outside the print fraternity to really make an impact upon the appearance and function of letterpress. Undoubtedly, William Morris (poet, designer, craftsman, socialist writer, and leader of the Arts and Crafts movement) was the first of these, but, and in the sharpest possible contrast, he was followed by the consciously unstructured working methodologies of the avant-garde artists. Both Morris and the avant-garde artists, in their own very different ways, broke down barriers. Their contrasting ideological tensions seem to be reflected in the letterpress process itself; the requirement for order and planning, and the inherent rigidity of the physical components, contrasting with an outcome which aims to be fluid, natural, and unstrained.

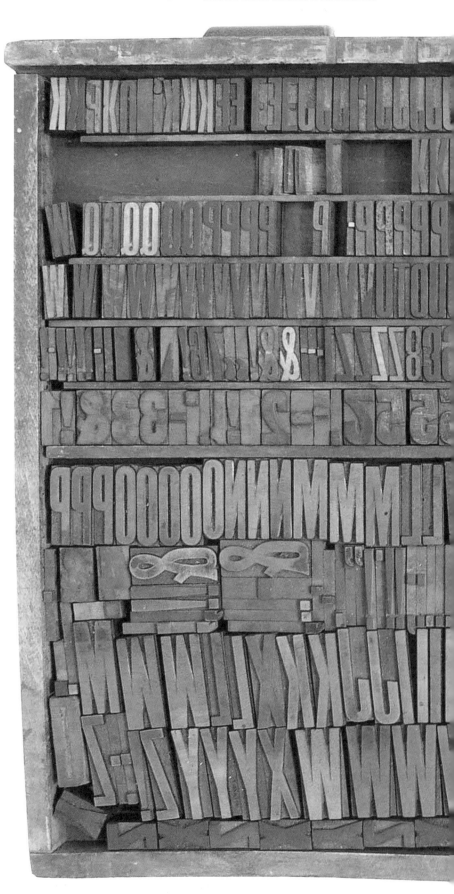

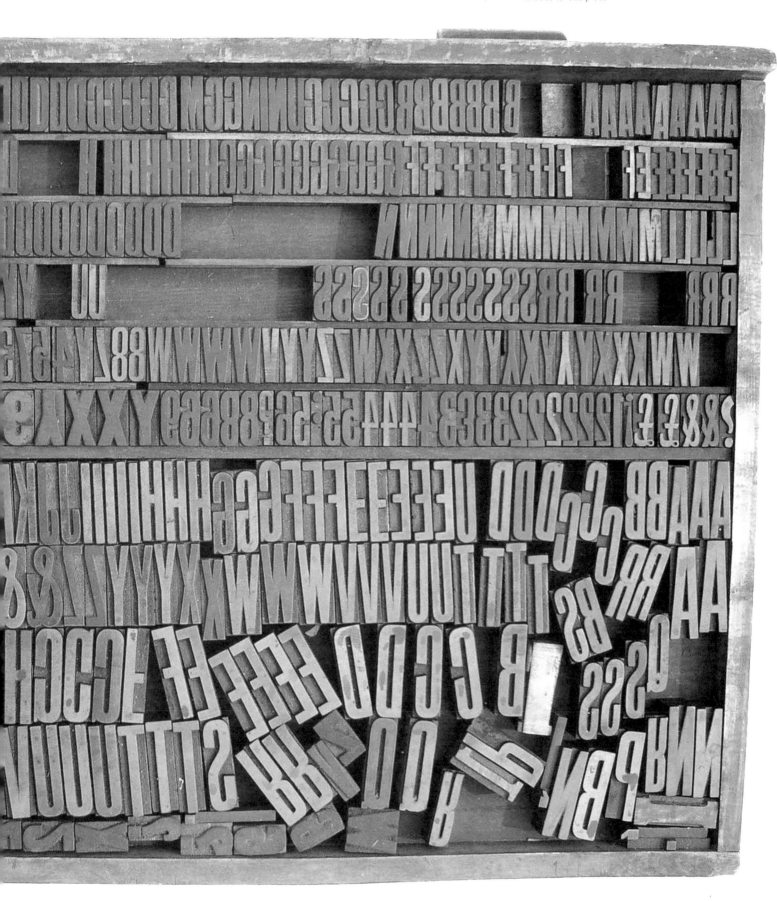

The nature of letterpress

"For the worker, machine production has meant a heavy, almost deadly loss in the value of experience, and it is entirely wrong to put it on a pedestal. That it is 'modern' is by no means the same as saying that it has value or that it is good; much more is it evil." *Jan Tschichold*, *typographer*

The need for control

There was a time when the output from mass-production was generally of a worse quality than anything made by hand. Today, the workmanship of a cup or a car appears to be as good as it could be. By the same criteria, printed matter, designed on a computer, using digitized fonts and images, and printed from lithographic plates, can be exemplary. (The quality of paper and binding is another matter.) If "handmade" no longer equates exclusively with quality, what advantages does "handmade" bring to printed matter?

The almost universal automation of commercial printing is designed to minimize the need for human intervention and, in this way, to reduce the possibility of errors and serious flaws in quality. Once a job has been correctly set up on the press, mechanization can take over, performing a sequence of operations that will result in the precise and consistent replication of texts and images at many hundreds of copies per minute. Inevitability of outcome – predictability – is an objective for which printers have striven since Gutenberg devised his system of cast metal type in the mid-1450s.

Right: Original composition (and photograph) by Susanna Edwards for a book cover. Metal type can be manipulated and applied in much the same way as wood type. Nevertheless, its cold and apparently more resistant material means that, initially, it reminds one of its industrial roots and mass-production. However, once composed and locked up in a chase, its function and beauty transcends its engineering origins, and it takes on the allure of a handmade object.

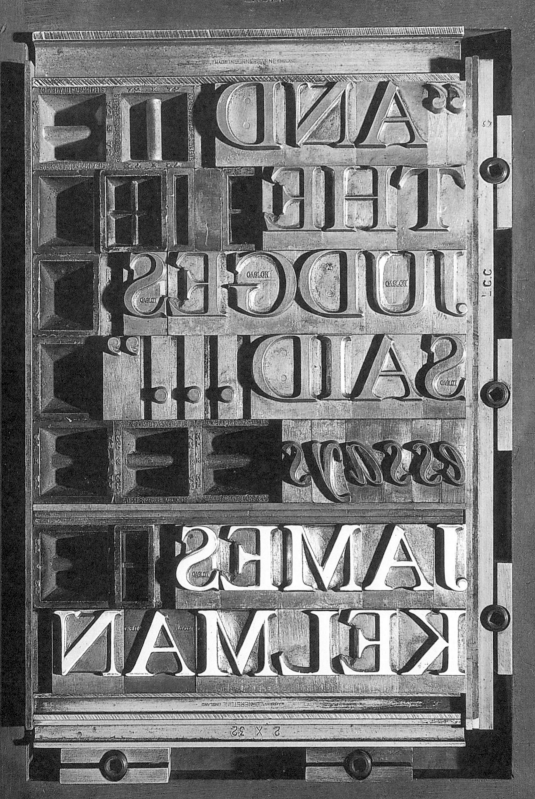

Printing required a sequence of quite distinct activities, the aim of which was to obtain an outcome that had been predetermined by the master printer. There is clearly a sense of automation about such work – attempting to repeat an act, as precisely as possible, in order to replicate a given outcome. This has always been the nature of print, even at William Morris' Kelmscott Press.

Of course, there has always been an element of mechanized automation about the letterpress print process, although proportionally, the amount of handwork was certainly higher in the fifteenth century than subsequently. The majority of operations in the process of production relied upon the combined knowledge and skills of the compositor, the ink man, and the pressman in order to maintain control of quality and provide the required consistency of outcome from copy to copy.

In the main, from 1500 onward, a printer using letterpress was more likely to act as an interpreter, working on Ruskin's principle that, "the thoughts of one man can be carried out by the labor of others." Digital technology, in which the processes of design and print have become virtually one, has largely negated the intepretive role of the commercial printer. As certainty of outcome becomes ever more reliable, the printing house is slowly becoming more akin to a sophisticated copyshop. Predictability, of course, is a huge advantage when attempting to maximize efficiency because it enables costs to be calculated with a high degree of accuracy. But as the outcome becomes inevitable, as long as the printer does not interfere, so any sense of craftsmanship disappears.

There is more to the handmade article than the human factor that produced it; something about the handmade object, or its results, has always been valued. By describing what this is, I hope to explain the allure that is responsible for the continued use of letterpress.

All images: Front and back cover and spreads from *TypoGraphic* no. 60, designed by A2–GRAPHICS/SW/HK. The wood letters were printed by Stan Lane at Gloucester Typesetting Services. Wood type can easily be damaged. Minor scratches or indentations can be overcome by judicious inking and the use of underlays and pressure, but many contemporary users of wood type like the "personalized" nature of type that displays its age and something of its past.

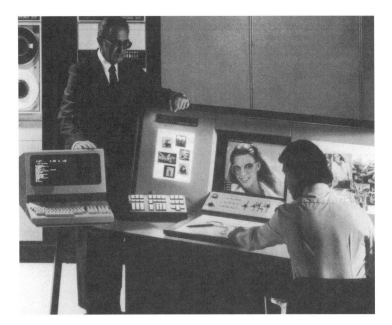

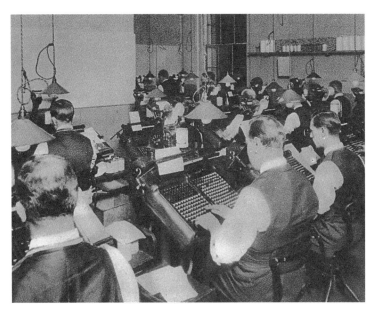

William Morris

Our current concept of "handmade" or "handicraft" has been deeply influenced by the Arts and Crafts movement; a protest against the loss of workmanship resulting from the introduction of mechanization. To William Morris, the leader of the Arts and Crafts movement, "handicraft" meant, primarily, work without "division of labor," something that he argued made the workman himself, "a mere part of the machine." [1]

One of the reasons Morris so admired the medieval period was because, at that time, there was little or no division of labor, and what "machinery" there was tended to be used simply as an extension of a hand tool – an aid to the workman's labor rather than a replacement for it. However, for Morris, the term "handicraft" did not exclude the use of machines or mechanical aids; for him, its strong social and historical connotations put it beyond being merely a description of a guild-based activity.

He recognized, perhaps better than any of those who followed, that the "handmade" factor is not, of itself, valuable. "Handmade" may often be more expensive than "machine-made," but it is certainly not a guarantee of quality – far from it.

Top: A promotional image for the Crossfield and Scitex electronic display system, 1983, reproduced in *TypoGraphic* no. 21, 1983.

Above: The Monotype keyboard room at *The Times*, circa 1920s.

Right: A small booklet published in the 1930s using "craftsmanship" as a means of enticing school-leavers into the print industry.

Far right: A page from Morris' *The Works of Geoffrey Chaucer*, 1896, shows one of the many "plain" pages next to a "rich" page, with its black borders of acanthus and vine, initial words wrapped in woody foliage, and Dantesque scenes by Burne-Jones. William Morris himself stated that the key to good book design was not decoration. "I lay it down, first, that a book quite unornamented can look actually and positively beautiful, and not merely unugly..." He felt that text should be tight. "...the aim should be to knit the page together, like solidly bonded brickwork."

Til that the pale Saturnus the colde,
That knew so manye of aventures olde,
Foond in his olde experience an art,
That he ful soone hath plesed every part.
As sooth is seyd, elde hath greet avantage;
In elde is bothe wysdom and usage;
Men may the olde atrenne, and noght atrede.
Saturne anon, to stynten strif and drede,
Al be it that it is agayn his kynde,
Of al this strif he gan remedie fynde.
My deere doghter Venus, quod Saturne,
My cours, that hath so wyde for to turne,
Hath moore power than woot any man.
Myn is the drenchyng in the see so wan;
Myn is the prison in the derke cote;
Myn is the stranglyng and hangyng by the throte;
The murmure, and the cherles rebellynge,
The groynynge, and the pryvee empoysonynge;
I do vengeance and pleyn correccioun
While I dwelle in the signe of the leoun.
Myn is the ruyne of the hye halles,
The fallynge of the toures and of the walles
Upon the mynour or the carpenter.
I slow Sampsoun in shakynge the piler;
And myne be the maladyes colde,
The derke tresons, and the castes olde;
My lookyng is the fader of pestilence.
Now weepe namoore, I shal doon diligence
That Palamon, that is thyn owene knyght,
Shal have his lady, as thou hast him hight.
Though Mars shal helpe his knyght, yet nathelees
Bitwixe yow ther moot be som tyme pees,
Al be ye noght of o compleccioun,
That causeth al day swich divisioun.
I am thyn aiel, redy at thy wille;
Weep now namoore, I wol thy lust fulfille.
Now wol I stynten of the goddes above,
Of Mars, and of Venus, goddesse of love,
And telle yow, as pleynly as I kan,
The grete effect, for which that I bygan.
Explicit tercia pars. Sequitur pars quarta.
Greet was the feeste in Athenes that day,
And eek the lusty seson of that May
Made every wight to been in such plesaunce,
That al that Monday justen they and daunce,
And spenden it in Venus heigh servyse;
But, by the cause that they sholde ryse
Eerly, for to seen the grete fight,
Unto hir reste wenten they at nyght.
And on the morwe, whan that day gan sprynge,
Of hors and harneys, noyse and claterynge
Ther was in hostelryes al aboute,
And to the paleys rood ther many a route
Of lordes, upon steedes and palfreys.
Ther maystow seen devisynge of harneys
So unkouth and so riche, and wroght so weel
Of goldsmythrye, of browdynge, and of steel;
The sheeldes bright, testeres, and trappures;
Gold-hewen helmes, hauberkes, cote-armures;
Lordes in paraments on hir courseres,
Knyghtes of retenue, and eek squieres
Nailynge the speres, and helmes bokelynge,
Giggynge of sheeldes, with layneres lacynge;
Ther as nede is, they weren nothyng ydel;
The fomy steedes on the golden brydel
Gnawynge, and faste the armurers also
With fyle and hamer, prikynge to and fro;
Yemen on foote, and communes many oon,
With shorte staves, thikke as they may goon;
Pypes, trompes, nakers, and clariounes,
That in the bataille blowen blody sounes.
The paleys ful of peples up and doun,
Heere thre, ther ten, holdynge hir questioun,
Dyvynynge of thise Thebane knyghtes two.
Somme seyden thus, somme seyde it shal be so;
Somme helden with hym with the blake berd,
Somme with the balled, somme with the thikke herd;
Somme seyde he looked grymme and he wolde fighte,
He hath a sparth of twenty pound of wighte.
Thus was the halle ful of divynynge
Longe after that the sonne gan to sprynge.
The grete Theseus, that of his sleepe awaked
With mynstralcie & noyse that was maked,
Heeld yet the chambre of his paleys riche,
Til that the Thebane knyghtes, bothe yliche
Honoured, were into the paleys fet.
Duc Theseus was at a wyndow set,
Arrayed right as he were a god in trone.
The peple preesseth thiderward ful soone
Hym for to seen, and doon heigh reverence,
And eek to herkne his heste and his sentence.
An heraud on a scaffold made an Hoo!
Til al the noyse of peple was ydo;
And whan he saugh the noyse of peple al stille,
Tho shewed he the myghty dukes wille.
The lord hath of his heigh discrecioun
Considered, that it were destruccioun
To gentil blood, to fighten in the gyse
Of mortal bataille now in this emprise;
Wherfore, to shapen that they shal nat dye,
He wolde his firste purpos modifye.
No man therfore, up peyne of los of lyf,
No maner shot, ne polax, ne short knyf
Into the lystes sende, ne thider brynge;
Ne short swerd, for to stoke with poynt bitynge,
No man ne drawe, ne bere by his syde.
Ne no man shal unto his felawe ryde
But o cours, with a sharpe ygrounde spere;
Foyne, if hym list, on foote, hymself to were.
And he that is at meschief, shal be take,
And noght slayn, but be broght unto the stake
That shal ben ordeyned on either syde,
But thider he shal by force, and there abyde.
And if so falle, the chieftayn be take
On outher syde, or elles sleen his make,
No lenger shal the turneyinge laste.
God spede yow! gooth forth, and ley on faste!
With long swerd & with mace fighteth youre fille.
Gooth now youre wey; this is the lordes wille.

I AM REAL LY SORRY PAUL! I WILL NEVER MAKE THAT MIST AKE AGAIN

This is an apology to Paul Rand, I spelled his name wrong on a poster announcing a lecture with Adbusters March 2nd 99 at the Royal College of Art. Henrik Kubel Graphic Department. The Typography Workshop, March 99

Right: Poster by Henrik Kubel, now half of A2–GRAPHICS/SW/HK (see also page 12). Designed and printed while Kubel was still a college student.

Design

I suspect that graphic designers often imagined they had more control over the workmanship of typesetters and printers than was actually possible. Standards of composition and printing were established by printers. The designer might have got used to such standards, and quite rightly expected them, perhaps eventually coming to believe that they got them because they demanded them. However, the truth of the matter would have become apparent if they had to change printers and found that their replacement did not work to the same standards. In such a case, all the designer could say was "do it again." If the work was poor a second time, their resources would probably have been at an end. They could not demand good printing. (Of course, printers would experience similar frustrations when having to print the work of typographers who, at least in their opinion, knew little of how type worked.)

This situation was made worse by the fact that the designer was not privy to the workings of the technology involved. (The barriers that separated the designer from the production process were clearly considered to be beneficial to the printer and the type-setter.) It was digital technology that gave the designer overall control, with the result that the skills of the compositor/typesetter, previously taken entirely for granted, had to be undertaken by the designer. Design courses have not yet responded to these rapid, technology-driven changes, while print courses now barely touch on the subject of typography at all. The rule-governed craft of typographic grammar is far too low a priority in design education.

Typography and printing tend to be judged by two criteria; utility (or "fitness for purpose") and aesthetics. Both criteria relate to the appropriateness of the means and methods employed. The quality of workmanship tends to be judged by reference to the designer's intention. In many cases, perhaps the majority, utility and aesthetics will, of necessity, be indistinguishable. In some instances precision of workmanship will be necessary to the intended message while in others it will not; in particular projects, imprecise (not "poor") workmanship might be essential.[2]

When using letterpress some typographers, certainly those working as graphic designers, too often rely almost entirely on the incidental nature of letterpress materials for their effect. Wood type is a prime example. Not only does it change shape and size with age, but its surface is very easily damaged. Consequently, printing from wood type – especially if no trouble is taken to ensure that each letter is packed to the same height – instantly provides plenty of visual character with minimal effort required from the designer.

The effects of age and wear are incorrigible, as every letterpress printer knows; they will leave their mark at every opportunity. These marks might be beneficial, but the decision as to whether such incidental damage should be displayed is fraught with dangers. Normally, when an unobserved mistake is made during the process of printing it is irreparable. But damaged, worn type (like anything else) can be employed if it is capable of endorsing the message. Distressed surfaces of one sort or another have been prized since ancient times, as have accidental (uncontrollable) modifications such as crackle glazes, and the weathering of stone and wood.

The function of wood type has always been to attract, through its size and its flamboyant design. Today, it is the physical characteristics that are unique and, therefore, attractive.

Below: Contemporary letterpress-printed ephemera is often produced for other letterpress users and distributed at fine-press fairs and conferences. It is common for references in such material to be made to the work of those, such as de Does, Morison, Rogers, Updike, Warde, and, as in this case, William A. Dwiggins. This keepsake was included in a collection of printed ephemera from the Eighth Annual Conference of the American Printing Association, 1983.

Above and right: The Wapping Project is a restaurant, performance studio, and gallery all designed by Frost Design. Vince Frost has no letterpress equipment or materials of his own, but he has accumulated a huge collection of letterpress-printed specimens. Frost designed an identity and signage for The Wapping Project and has gone on to design posters and invitations. This foldout poster was designed to publicize an exhibition of Magnum photography celebrating the spirit of New York.

Left: Cover of a portfolio of prints designed by Dennis Ichiyama in 2001, sponsored by Mohawk Paper Mills. Dennis Ichiyama teaches in the Department of Visual and Performing Arts at Purdue University, West Lafayette, Indiana.

Print

Although mass-production has brought down the print cost per unit for the customer and the end user, the investment costs required continue to rise, so there is a strong incentive to design within standardized formats – those that utilize the standard procedures – and thereby avoid the need for machine adjustments requiring human intervention. The resulting impoverishment is the price we pay for cheap mass-production in which only the conventional, highly predictable outcome is practicable.

The handmade object states its speculative nature by the fact that each piece, even with letterpress printing, is an original rather than a copy of the original. During the letterpress printing process, the designer/printer is constantly judging the pressure and amount of ink, to maintain the chosen standard. The process requires constant reappraisal, suggesting improvisations, deviations, even irregularities, and continually offering fresh and unexpected alternatives to form and pattern, color and texture. Such variations are, in fact, slight and subtle. There is the ever-present risk that they will be overplayed, but they will ensure that every sheet, despite all the printer's endeavors, will be different. It is part of the unavoidable contrast and tension – between regulation and freedom, uniformity and divergence – that is at the heart of letterpress. How these characteristics are exploited will reflect the printer's own concerns and preferences.

While the process itself offers intervention, letterpress offers fewer typographical options in the detailed composition of type than the computer, if the designer were to venture beyond the software default settings. The occasional ill-fitting character pairs (typically Wa, Va, and Ta) are so ubiquitously part of the look of letterpress that today, instead of being considered wrong, they are commonly described as quirky, interesting, and friendly! Clearly, this is, in part, nostalgia. However, such a deeply embedded response can undoubtedly be a powerful ally to the typographer, advertiser, graphic designer, and private press.[3]

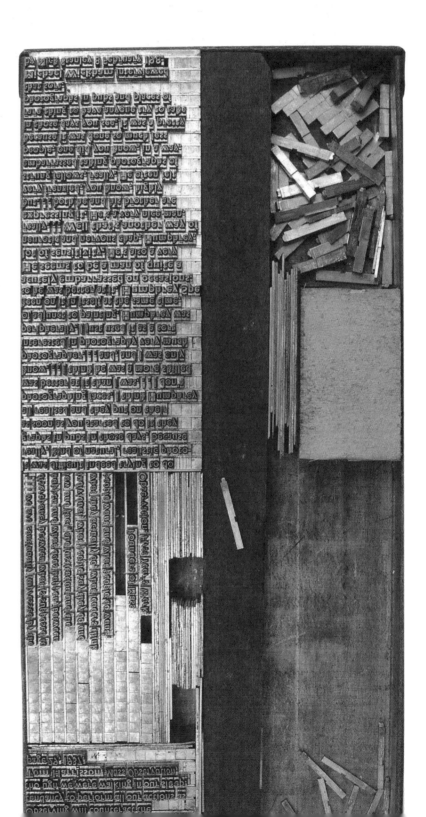

Right: A galley of type (held temporarily in place by a wooden galley stick) waiting to be dissed.

Far right: The nature of letterpress printing is unambiguous. Everything is held together, for the most part, with inflexible materials, and to keep things from moving about, any space needs to be filled with a wedge of the same dimensions. Here, leading can be seen between the lines and also between characters. The ability of wood type to change shape and size can clearly be seen.

The art of Sculpture

is a creative approach to problem solving, combined with a wide range of skills & capabilities

Sculpture

Benson Sedgwick

Established in 1930 Benson Sedgwick has unrivalled experience in many branches of Engineering manufacture.

Sited close to the A12, A13 and M25 our modern 1700 sq. metre factory offers a comprehensive service to the sculptor and industry.

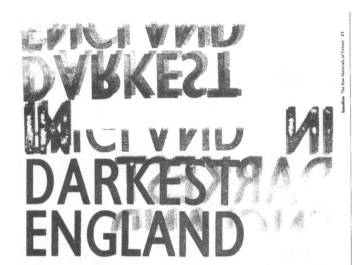

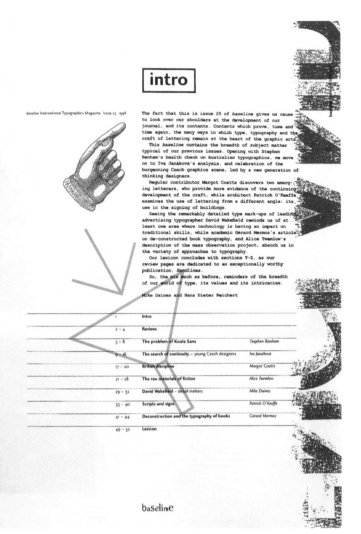

Left: A rough, pasted mock-up, using the various printed elements, of the first page of a brochure for Benson-Sedgwick Engineering Ltd, designed by Darren Hughs, David Jury, and Kelvyn Smith. The process of designing with letterpress remains an essentially physical activity. Of course, prepress planning will normally be carried out, but once things start to really happen – as the various elements are locked up and printed – another level of planning, equally important and equally creative, takes place.

Above: Two pages from *baseline*, 1998, an international typographic magazine. The first is the editorial page signalling the inclusion of an article concerning letterpress, and the second emphatically marks the beginning of the article. Designed by Hans Dieter-Reichert, using raw material provided by David Jury.

Freedom

While design is a matter of imposing order on things, the intended results can often be achieved without denying spontaneity and improvisation. Letterpress appears to me to be a natural way to work: order permeated by individuality. It was once the case that highly regulated workmanship was admired because it was rare and difficult to produce, but that situation has now been reversed, so design and/or print that has individuality – that carries the recognizable characteristics of its maker – is admired, valued, and even anticipated with pleasure.

A case of mature wood or metal type (such as that reproduced on pages 8 and 9) exudes individuality. It displays its age, and signs of its previous applications are clearly visible. This physical manifestation of its past is, perhaps, the single most important, and certainly the most profound difference between letterpress and digital typography.

Let us be clear; letterpress, in itself, regardless of design or content, is not innately superior to digitally designed, mass-produced print. Today, there is no reason to continue with letterpress unless it is used to promote only the best possible workmanship, allied to the best possible design. This must imply that it should not appear as a predictable pastiche of the past, but should display its flexibility in telling new stories and providing current information in current ways. In short, letterpress must remain relevant and continue to perform a function, not merely decorate.

There is no need for letterpress to pose. It does not have to equate with "solemnity of purpose" or preaching. Too often such attitudes have their basis in a kind of snobbery. Those who think they are upholding typographic standards by reproducing contemporary versions of Italian fifteenth-century books do more damage to the craft of letterpress than any social or economic factor ever could.

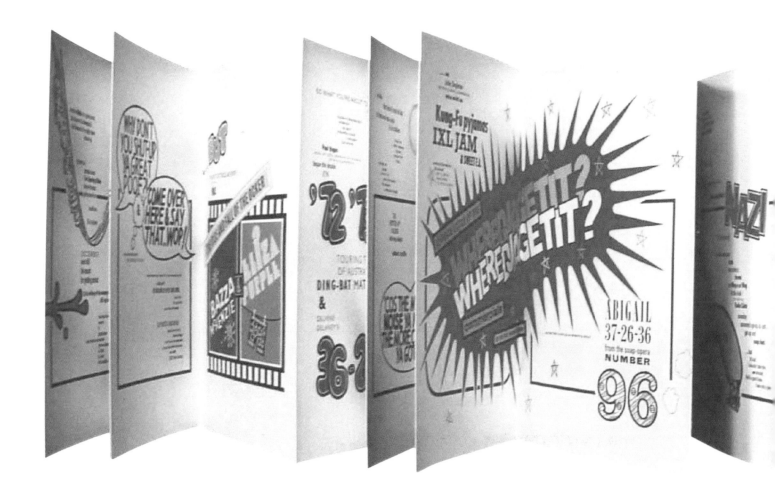

The future of letterpress lies in design and creative thinking. Designers who come to recognize the unique qualities the medium is capable of providing (and other qualities that we have yet to discover) will ensure that it survives. In return, letterpress will restore to its user the opportunity to extend the design process beyond the computer screen. There is a whole new world out there to explore!

Below: *Ockers*, 1999, from the Wayzgoose Press. The Wayzgoose Press is run by Mike Hudson and Jadwiga Jarvis in Katoomba, NSW, Australia. The appearance of their work changes quite radically, depending upon the subject. *Ockers*, is a very Australian take on life in the 1970s.

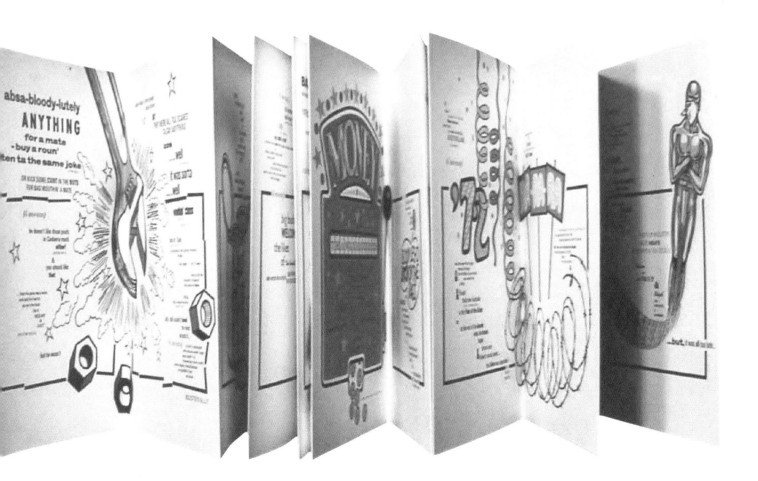

THE

WORKS

OF

Dr. Jonathan Swift,

Dean of St. PATRICK's, Dublin.

VOLUME VII.

LONDON,
Printed for T. OSBORNE, W. BOWYER, C. BATHURST,
W. STRAHAN, J. RIVINGTON, J. HINTON, L. DAVIS
and C. REYMERS, R. BALDWIN, J. DODSLEY,
S. CROWDER and Co. and B. COLLINS.
MDCCLXVI.

Durability

Materials are generally assessed by their durability. People buy the best-quality materials because they will last. However, the use of high-quality materials will not improve poor design or poor printing. Equally, low-quality materials might be the right materials. Decisions concerning materials and finish are always going to be deeply influenced by content. "Fitness for purpose" was the reason the futurists chose cheap, standard, mass-produced papers and bindings for their pamphlets and magazines.

Ruskin famously said, "If we build, let us build for ever," and there are, of course, many very good arguments for durability. Clearly, objects we inherit from the past provide us with a tangible link with those who have lived before us, while on a more practical note, poor-quality materials, even over a relatively short length of time, will alter the appearance and interfere with the function of print quite significantly as it gives way to age and wear. For example, direct sunlight will fade the color of modern papers and inks, and heat will make the glues used for bindings brittle.

Signs of wear that have occurred due to normal use, however, affect printed matter in an entirely different way. Signs of use suggest a useful book. This aging process is entirely natural, takes little away from the book, and should be celebrated. Of course, such wear can only occur if a book has been designed to last. If all books were designed to break apart on first opening, we would be denied that beauty. Such premature failure, nowadays, is not the fault of bad workmanship, but caused by the need for higher profit margins which requires the use of poor-quality materials.

A good artist or designer will take responsibility for the durability of what they make and will, at the very least, try to make the unseen parts of their work as sound as those that are visible. But their concern goes further than that.

Durability is apt to become an end in itself, quite apart from moral considerations. The artist/designer is likely to suggest that a book is not made properly unless it is made to last. There are some who uphold the idea of cheapness, the argument being that it makes information more widely available. And, presumably, if it is cheap enough, one can simply buy another when the first has fallen apart! However, we have no cause to regret that durability was an issue acted upon in the past.

Of course, when durability is a major issue, the design will tend to be traditional. By its very nature, the only sound method of testing durability is to study the methods and materials used in the making of similar objects in the past. Any deviation from these methods, even if using the same materials, cannot guarantee the same level of durability. The traditional association between standard format and construction and durability is a genuine problem for contemporary designers who want to devise a document that responds directly to the subject in hand rather than to the making of a predictable if beautiful book.

In contrast, there are just as many instances where, because of its purpose, the expected life span of printed matter is very short. Information on a flyer might be out of date within hours. Yet the instantaneous quality of printed ephemera has helped produce some of our most dynamic and informative printed matter. There is an element of fashion in most design, but inevitably more so in printed matter designed to function for just a short length of time. Such material is rarely truly appreciated during its lifetime. Letterpress printing remained remarkably competitive for short print runs, so it continued to be the preferred commercial print option for ephemera.

Ephemera, like all kinds of printed matter, are collectable, but unlike most collectors, collectors of ephemera generally celebrate the evidence of use, particularly in the form of handwritten additions. However, for collectors of other printed matter, those items most prized must be as close in appearance as possible to the day they were first issued. It is a fact that some collectors will buy a first-edition book and never open it in the expectation and hope that its value will increase. In an effort to separate creative endeavor from such financial speculation, some book artists have attempted to make their books valueless.

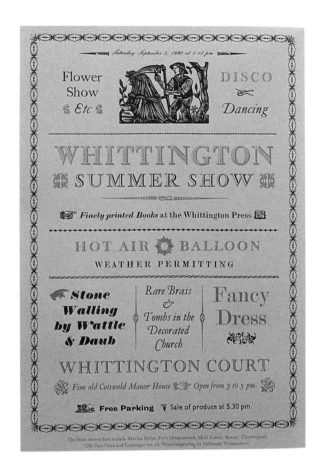

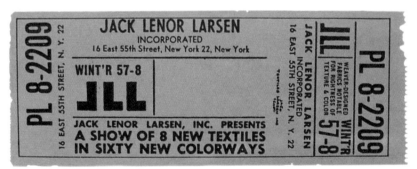

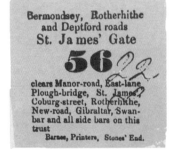

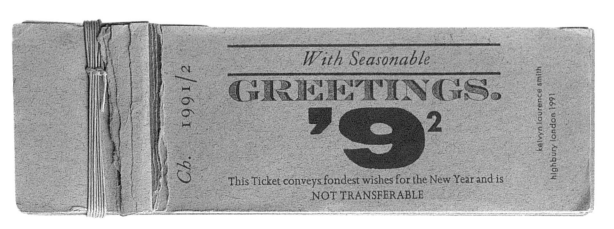

Far left: This modest little book, clearly printed with little thought for quality, is, nevertheless, a very pleasant book to hold and to read. Despite clear signs of damage it remains intact and very readable because the rag paper used has proved to be so durable. Printed in London, 1766.

Top: John Randle at The Whittington Press: a poster for the annual summer village show. Traditional events occasionally call for a traditional treatment.

Above left: An exhibition ticket, New York, date unknown.

Above right: A tollgate ticket, UK, circa 1840.

Left: Greetings "tickets." An ironic seasons wishes from Kelvyn Smith, UK, 1992. Nothing represents the time for which it was designed like printed ephemera. Some letterpress presses take on, indeed seek out small-scale commercial work in order to help fund other, more major projects.

[The nature of letterpress] 1.2 The material of letterpress

Conventions

For most of us, most of the time, the technology of modern printing serves its purpose. In the commercial activity of printing, there are few who would argue that letterpress printing should still be necessary today. However, there are some, myself included, who make much of the significance and consequences of its commercial demise. We are, after all, in the midst of a revolution in information transmission and there is the potential for significant improvements, as long as we can retain previous good practice while accepting the best of what digital technology can deliver.

The conventions by which typographers are still bound were, to an enormous degree, formed by the technology of letterpress. Leading, kerns and serifs, ems and ens – all terms used in digital technology – were physical things whose forms were influenced by the tools that made them and the materials from which they were made. Letterpress was the dominant medium of graphic communication for 500 years and has determined the way typography looks and functions. It is inconceivable that typography will ever stray far from what letterpress has made it. Despite, or perhaps because of the continual growth of digital typefaces and the dominance of computer typesetting and digital prepress planning and printing in trade publishing today, new private letterpress publishers continue to start up. At the same time students, having grown up with the computer playing an all-pervasive role in their lives, have responded to the potential of this alternative technology by utilizing its capacity for visual impact.

Above: This package containing 6pt quads from Stephenson Blake & Co. is thought to date from the late 1950s.

Left: A small packet of braces. The material of letterpress is generally compact, very heavy, and rather humble in appearance. The packaging of letterpress material by typefounders has usually shown the same, unaffected philosophy.

Right: Detail from a larger box of "specials," circa 1950s. On the lid the printer had written "Royalty." All of these are from the Justin Knopp Collection.

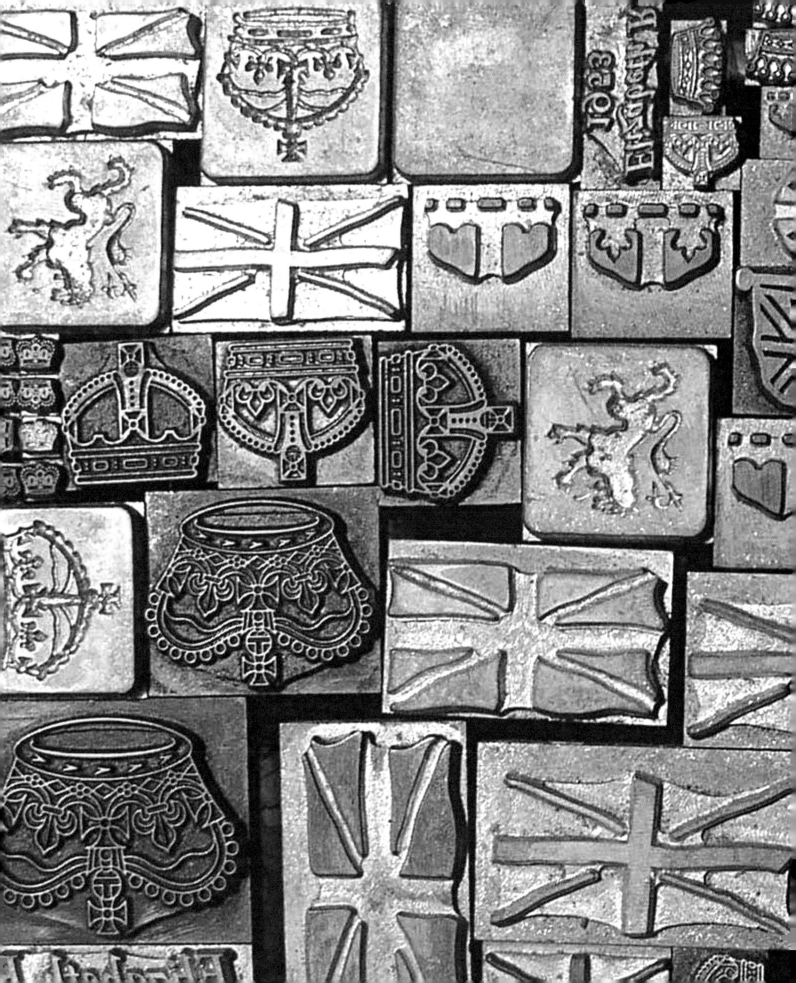

Physical substance

With letterpress, the letters and the spaces within, between, and around them exist. Being made of metal or wood, all the elements that go into producing printed material are heavy, often bulky, and need to be carefully stored. Therefore, everything associated with letterpress is built to support huge weights and rough handling. Often made of wood, the warm colors of the frames, racks, and benches contrast sharply with the dull, lead-gray of the metal they hold. They are prized because they are august, functional, and inevitably display the scars of countless "wounds" caused by previous owners. This constant reminder of their past, and the precarious nature of the printing industry, only adds to their appeal.

As well as the intense mental effort required for all typographic endeavor (be it digital or letterpress), letterpress also requires a physical effort. This physical aspect, which would once have been equated with manual labor, is now considered to be liberating, offering as it does the opportunity to move about a workshop; to handle metal and wooden type, and spacing materials; to mix inks; cut and tear paper; and work directly on the presses.

In other words, letterpress frees the typographer from the ubiquitous swivel chair, keyboard, mouse, and monitor. Just as sitting at a computer screen was once a novelty, now the ability to move about a workshop, getting ink on your hands and interacting with others, appears strangely insurrectionary. Its potential to express ideas, offer alternative ideas, and encourage a more thoughtful, more intelligent use of type are the essential reasons for the continued use of letterpress, together with the fact that it is more fun.

Printing from metal or wood type results in an original object. Contemporary commercial printing, whether from offset lithographic plates or laser printer, can only provide copies of the original object, which today will commonly exist only in digital form. Naturally, something is lost; an immediacy, a physical presence that provides a distinct authority for the words, and a tangible link between the author and the reader.

Right: In 1986, IM Imprimit began printing for the first complete publication of 23 sets of early nineteenth-century, wood-engraved ornamented types now in the collection of the St. Bride Printing Library. The physical condition of the engraved blocks was remarkably good considering their age, although some of the surfaces were a little worn. All are end-grain boxwood, made from single blocks. (Photograph courtesy of Helen Craig and IM Imprimit.)

Far right: Obtaining a perfectly printed image from these old blocks required adjustment of the levels of underlay and, of course, numerous proofs to be pulled. (Photograph courtesy of Andrew Dunkley and IM Imprimit.)

Standards

The preservation of letterpress printing is important for a number of disparate reasons, but what is far more important is the effect an understanding of the craft has upon the demand for excellence in all its associated skills and materials.[1] Ink, paper, and binding are all judged in the light of the demands that the typographer places upon him- or herself. Thus, by using letterpress, the concept that the work in hand represents the very best of the typographer's endeavors is nurtured.

The use of letterpress is growing. Private presses and book artists have been quick to make full use of the Internet and have formed national and international associations through which they organize numerous international book and print fairs.

Such a positive, upbeat situation is all the more extraordinary when you consider the state of support for letterpress technology. Not surprisingly, finding letterpress equipment is becoming more problematic as the last few family-owned letterpress printworks close down, and very little letterpress equipment is manufactured any longer. As for type, there is no more than a handful of the old, commercial foundries casting type worldwide. Instead, typefounding has largely passed into the hands of private foundries, often set up as a natural extension of a private press, or simply operated by people who love metal type and wish to ensure its continued availability. Letterpress equipment was, fortunately, made to be indestructible, so furniture, formes, quoins, grinders, rule-cutters, etc., are still plentiful and therefore relatively cheap secondhand. Similarly, letterpress printing and proofing presses still appear regularly at auctions and often need little more than a wipe with an oily rag to bring them back to life.

The best time for buying letterpress equipment was during the 1970s, and it is no coincidence that there was a resumed interest in letterpress at this time. All over Europe and North America, letterpresses were being scrapped, while thousands of cases of foundry type and irreplaceable matrices were being thrown into dumpsters to make room for the continued advance of lithographic, computer-generated print production.

This flood of unwanted machinery and materials was thrown onto the market so cheaply that it became accessible to anyone whose primary interests were not industrial, nor even commercial, but literary, artistic, or craft oriented. The rebirth of the private press, and the recovery of a print technology by them, was the result.

There also remained, throughout this period, an important reservoir of traditional printing craft in a number of art colleges and universities, where small teams or individuals had quietly continued to use letterpress as a means of teaching typography, and to encourage an interest in fine-quality printing. The large Columbian and Albion presses previously used in proofing were bought and housed in printmaking departments to be used for relief printing. For these presses, and the new, private presses, inspiration has been eclectic. The richness and diversity of styles and approaches adds emphasis not only to the versatility of letterpress and its potential for providing the means for creative interpretation, but also to its demand for planning, analysis, and the development of critical standards.

Letterpress puts the user in touch with the words, the characters, and the spaces. The precarious nature of the type, how it moves and constantly threatens to fall apart because of a momentary lapse of concentration or a clumsy movement, becomes well known to them. The pressures and movements inherent in the mechanisms of the press quickly draws their attention to poor setting by "lifting" characters and spaces that are not secure. The smallest slither of detritus trapped under a character will cause an "emboldened" image. Lines of type might not be square or parallel; characters might have been set upside down; a stray character, mistakenly dissed, might have been inserted.

The users of letterpress will be aware that all their critical faculties must be brought to bear upon the first proof. This needs to be read – slowly, deliberately, and critically. Every character will be studied. Having handled the characters, chosen the spaces, cut and positioned the strips of leading, the user will certainly be aware that nothing can be taken for granted.

Right: Loose type matter in a galley.

Far right, top and bottom: *In Darkest England* is a document comprising a boxed set of 21 loose sheets printed principally letterpress. This publication explored complex relationships and differing memories of the same events typographically. Providing form for the complex interrelationships was as important as giving form to the content itself. The type becomes smaller as the linking key words take the memories further away from the original text. As a consequence, the line length becomes shorter. The sheets are presented loose in a solander box lined with a print representing typical cheap wallpaper of the time. David Jury, Foxash Press, 1998.

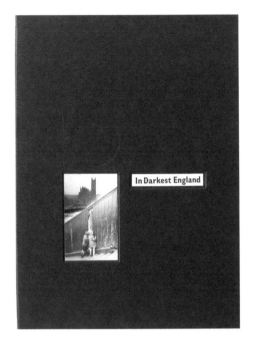

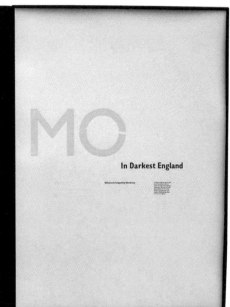

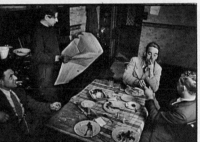

2

Conventions and rebellions 2.1 Establishing conventions

"We don't inhabit the twenty-first century, nor, for that matter, the fifteenth or the second. We live in the bits that interest us ..." *Mike Hudson and Jadwiga Jarvis, Wayzgoose Press*

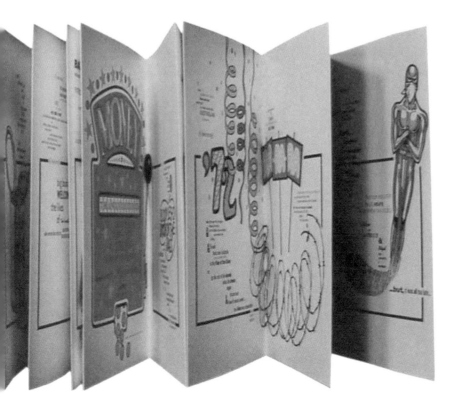

Left: A portion of *Ockers* from the Wayzgoose Press, Australia, 1999. More of this continuous concertina-bound book is reproduced on pages 24 and 25.

The scholar printers

Although letterpress remained essentially unchanged, physically, for 500 years, the way it has been used, by whom, and for what purpose have dramatically changed the nature of the printed outcome. The adaptability of letterpress has been made clear by its rich and varied role in the cultural development of arts and crafts.

It was Johannes Gutenberg[1] who devised and perfected the system of casting separate pieces of metal type for different sizes and versions of each of the 26 letters of the Roman alphabet. The printer was then able to rapidly assemble loose letters by hand to spell out a piece of text, lock them into place, and print from them. When sufficient numbers of copies had been run off, the metal letters could be released, returned to storage, and subsequently reassembled to form a different text, using the same pieces of type.

Right: Gutenberg's *42-line Bible* was printed in Mainz, circa 1450. (The Pierpont Morgan Library.)

non fuisse ausum affirmare se raptu̅
in corpore sed dixisse · siue in corpore si
ue extra corp̄ nescio deus scit. Hijs et
talib̧ argumentis apocriphas in li
bro ecclesie fabulas arguebat. Super
qua re lectoris arbitrio iudiciu̅ derelin
quens illud a̅moneo non haberi da
nielem apud hebreos inter ꝓphetas:
sed inter eos qui agyographa conscri
pserūt. In tres siquidē partes omnis
ab eis scriptura diuiditur: in legē in
prophetas et in agyographa id est
in quinq̧ et octo et undecim libros: de
quo nō est hui̅ temporis disserere. Que
aūt ex hoc ꝓpheta · ꝓmo contra hu̅c
libru̅ porphirius obiciat testes sunt
methodi̅ eusebius apollinaris: qui
multis versuu̅ milib̧ eius vesanie re
spōdentes nescio an curioso lectori satis
fecerint. Unde obsecro vos o paula et
eustochiū fundatis · ꝓ me ad dūm pre
ces: ut quādiu i̅ hoc corpusculo su̅ scri
bā aliqd gratu̅ vobis utile ecclesie: di
gnu̅ posteris. Presentiū quippe iudicijs
oblatrantiu̅ nō satis moueor: q̄ in utra
q̧ parte aut amore labunt aut odio.
Explicit ꝓlog. Incipit daniel ꝓpheta

Anno tercio regni io
achim regis iuda ve
nit nabuchodono
sor rex babilonis ihe
rusalem et obsedit eā:
et tradidit domin̄
in manu eius ioachim regē iude et parte
vasoru̅ domus dei et asportauit ea in
terrā sennaar in domū dei sui: et vasa
intulit in domū thesauri dei sui. Et ait
rex asfanez ꝓposito eunuchoꝝ ut intro
duceret de filijs isrł et de semine regio
et tyranoru̅ pueros i̅ quib̧ nulla esset
macula decoros forma et eruditos o̅
ni sapientia cautos scientia et doctos

disciplina: et qui possent stare in pala
tio regis : ut doceret eos litteras et lin
guam chaldeoꝝ. Et cōstituit eis rex an
nona̅ per singulos dies de cibis suis
et vino unde bibebat ipse: ut enutriti
trib̧ annis postea starent in cōspectu
regis. Fueru̅t ergo inter eos de filijs iuda
daniel ananias misahel et azarias.
Et imposuit eis ꝓpositus eunuchoꝝ
nomina danieli balthazar: ananie
sidrac misaheli misac et azarie abde
nago. Proposuit aūt daniel in corde
suo ne pollueretur de mensa regis neq̧
de vino potus eius: et rogauit eunuchoꝝ
ꝓpositu̅ ne cōtaminarec̄. Dedit aūt de
us danieli gratiam et misericordiam
in cōspectu principis eunuchoꝝ. Et ait
princeps eunuchoꝝ ad danielem. Timeo
ego dūm meu̅ regem qui cōstituit vobis
cibu̅ et potu̅: qui si viderit vultus uos
macilentiores pre ceteris adolescentib̧
coetus vestris : condemnabitis caput
meu̅ regi. Et dixit daniel ad malasar
quem cōstituerat princeps eunuchoꝝ su
pre danielem ananiā misahele et aza
riam. Tempta nos obsecro seruos tuos
diebus decem et detur nobis legumina
ad vescendū et aqua ad bibendum: et
cōtemplare vultus nostros et vultus
puerox qui vescuntur cibo regio: et si
cut videris facias cum seruis tuis. Qui
audito sermone huiuscemodi tempta
uit eos dieb̧ decem. Post dies aūt de
rem apparueru̅t vultus eoꝝ meliores
et corpulentiores: pre omnibus pueris
qui vescebātur cibo regio. Porro ma
lasser tollebat cibaria et vinu̅ potus e
orum: dabatq̧ eis legumina. Pueris
aūt hijs dedit deus scientiam et discipli
nam in omni libro et sapientia: danie
li aūt intelligentiā omnium visionum
et somnioꝝ. Completis itaq̧ diebus

This remained the basic method of printing with type until the development of stereotype printing plates around 1705. The introduction of the Linotype and Monotype machines in the latter decades of the nineteenth century were responsible for the mechanization of the casting and composition of type.

The craft of letterpress printing spread with astonishing speed. Its early development took place at the height of the Renaissance when demand for knowledge was insatiable. The demand for books, particularly from the increasing number of students,[2] was growing at a considerable rate. The sheer number of books obviously increased opportunities to consult and compare. Once old and new texts came together on the same bookshelf, a diverse range of ideas and specialist disciplines could be combined.

Even before a single print had been pulled, essential meetings between typefounders, proofreaders, translators, copy editors, illustrators or print dealers, indexers, and others engaged in editorial work would have taken place. Of course, a number of these roles might have been undertaken by the printer; a master printer could serve not only as publisher and bookseller, but also as indexer, abridger, translator, lexicographer, and chronicler. Printing encouraged such forms of collaboration between men of various intellectual disciplines as well as between intellectual and craft-based disciplines. This independence of spirit was a major inspiration to those seeking to rekindle something of the original craft and intellectual gravitas of letterpress printing during the late nineteenth and early twentieth centuries.

It is difficult for us to realize what precision must have meant to those living in the second half of the sixteenth century when today we see it in every trivial throwaway product we buy. Our current reflections upon "truth to nature" and the natural order that we value must, during the late fifteenth century, have seemed far less amiable, something people wished to put behind them: precision and regularity symbolized mastery, sophistication, and control.

Once the outcome became more predictable, many entrepreneurs were attracted to letterpress printing and/or publishing by the lure of profits. By the end of the fifteenth century, printing was established as a mass-production industry. Certainly, from 1500 onward, the majority of printers simply replicated what was handed to them in a perfunctory manner, and it soon became obvious that printing was not going to be restricted purely to the spread of knowledge. And when no one is particularly concerned about the quality of the finished product, there will be little consideration for the conditions in which it is produced. As early as the 1530s, French compositors resorted to a tactic that would be repeated on numerous occasions – they went on strike.

For the first time the public (or, at least, those who could read) were able to judge political and religious ideas via a "mass" medium that utilized their own, vernacular language. Both State and Church considered this freedom of information an intolerable threat, and oppressive "supervision" (effectively censorship) followed. The Papacy prescribed which books might be printed in Roman Catholic countries, as did Henry VIII in Protestant England. Civil wars and religious strife across Europe added to the economic chaos. The few printers licensed, under close control, had a virtual monopoly, and their work suffered from lack of competition. In the meantime, the first press was established in the US between 1638 and 1639.

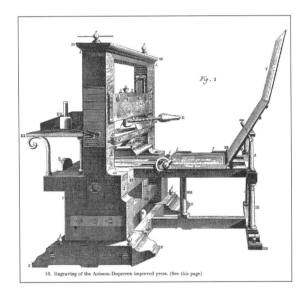

Right: An engraving of the Anisson-Duperron improved wood printing press.

Below: A printing house in the seventeenth century. The man kneeling on the left is dampening paper for the press. On top of the press is a gryphon with a pair of ink-daubers in its talons.

16. Engraving of the Anisson-Duperron improved press. (See this page)

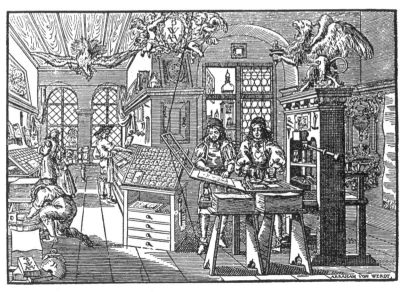

53

12 DE AMPHITHEATRIS QVÆ EXTRA ROMAM LIBEL. 13

Above: Aldus Manutius, *Gli Asolani*, 1505. Manutius foresaw, with the increase in literacy, the decline of the large-format book in favor of cheaper and more portable sizes. (The British Library.)

Left: Christopher Plantin, *Lusti Lipsi de Amphitheatris*, 1584. Plantin's workshop consisted of some 20 presses employing about 160 men, with a lifetime output of almost 2,000 books. But he also made his printing office a meeting place for scholars, scientists, artists, and engravers.

[Conventions and rebellions] 2.2 Breaking conventions

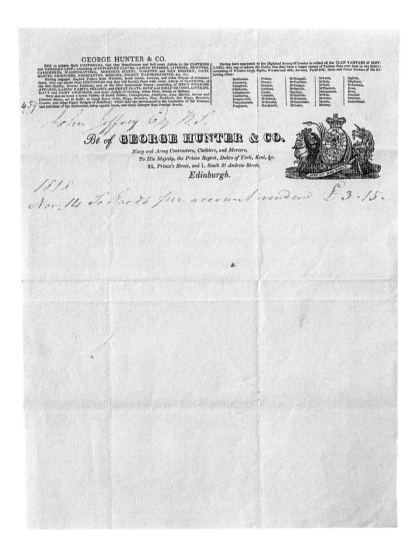

The jobbing printer

The nineteenth century is hugely important not only for the technical, social, and commercial aspects of the development of letterpress printing, but also for the way these innovations influenced its use. It is also important because today, as in the twentieth century, users of letterpress generally work with equipment that, if not actually built and used in the nineteenth century, at least closely resembles models from that period.

Wooden handpresses dominated the printing industry for nearly 350 years, during which time only minor structural modifications were made to their form. However, over a period of about 20 years during the first half of the nineteenth century, iron handpresses completely replaced wooden ones. No sooner had the iron handpress taken over when this too was supplanted by the much faster and more efficient machine or power press. In fact, by the 1890s, the iron handpress was generally limited to pulling proofs of wood engravings, woodcuts, and linocuts.

Automated power presses generated huge sociological change in the UK, mainland Europe, and the United States, but the US led in its desire for speed of output. In an attempt to cut costs, the US developed stronger, heavier, and more accurate machines, powered first by steam and then by electricity. Flat (platen) surfaces were replaced with the introduction of impression and inking cylinders, and these were eventually followed by the curved printing surface, which enabled the high-speed and fully rotary press. Stereotyping – producing a letterpress plate by casting lead in a mold taken from the forme – was a further aid to producing large print runs at speed. A rotary press, fed by a continuous roll of paper – a web press – was first demonstrated in 1865; 10 years later, a four-cylinder perfecting press, capable of printing simultaneously on both sides of the paper reel, was built. As these new machines were introduced, the old iron handpresses gathered dust or were exported to other countries.

Above: Billhead for George Hunter & Co., 1891. The arrangement has a "modern" appearance. The small text at the head is 4·5pt (diamond) and set solid. The open shadow type used for the company name was by Vincent Figgins.

Right: Billhead for Alex. Adam & Co. Although dated 1917, this design is very much in the spirit of the 1880s. It is a rare example of a multicolored billhead: three colors printed with lithography and letterpress printed black only.

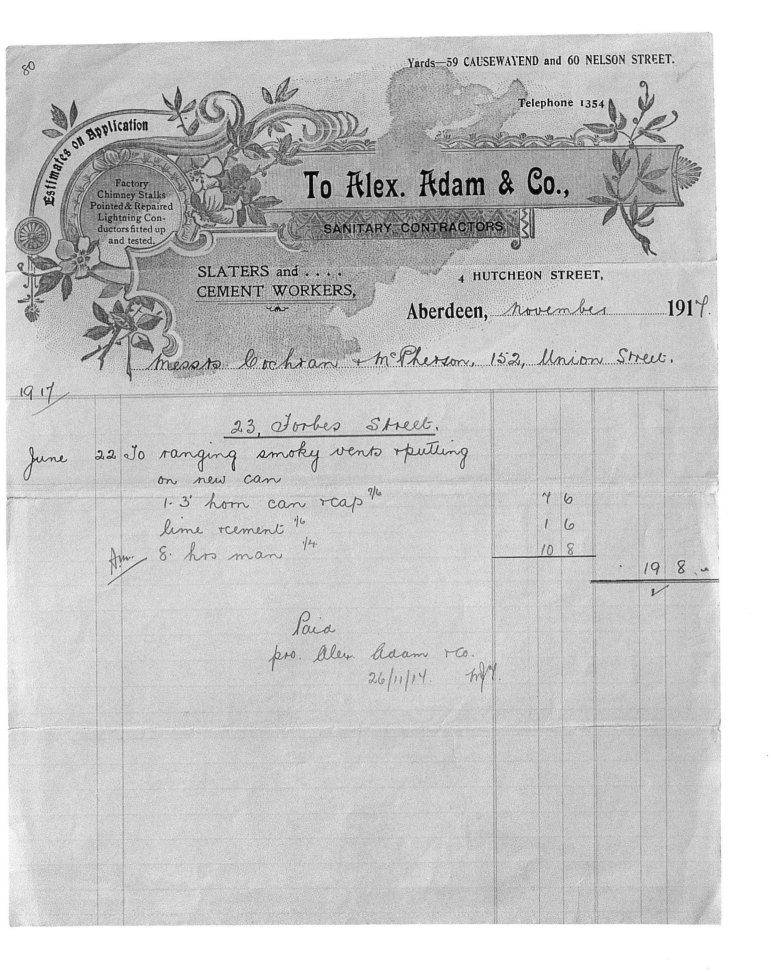

Yards—59 CAUSEWAYEND and 60 NELSON STREET.

Estimates on Application

Telephone 1354

Factory
Chimney Stalks
Pointed & Repaired
Lightning Con-
ductors fitted up
and tested.

To Alex. Adam & Co.,

SANITARY CONTRACTORS

SLATERS and
CEMENT WORKERS,

4 HUTCHEON STREET,

Aberdeen, *November* 1917.

Messrs Cochran + McPherson, 152, Union Street.

1917

23, Forbes Street.

June	22	To ranging smoky vents + putting on new can			
		1. 3' horn can + cap ⁷⁄₆	7	6	
		lime + cement ¹⁄₆	1	6	
Am.		8. hrs man ¹⁄₄	10	8	
					19 8

Paid
pro. Alex. Adam + Co.
26/11/14.

SIXTEEN-LINE PICA, NO. II.

MEND

EIGHT-LINE PICA, NO. III.

FREEHOLD

V. FIGGINS.

Papermaking machines were able to turn out huge reels of paper for rotary presses much cheaper than that produced in sheet form. Unfortunately, this paper was cheaper not only because of mechanization, but also because the rags that had been used were being replaced by pulped wood – initially mechanically, but later chemically pulped – which dramatically shortened its life. Ink manufacturers used cheap, synthetic pigments, despite the fact that they were not always permanent coloring agents. While the costs of these key items were being reduced, others, such as labor, rent, advertising, and distribution, were increasing. Publishers and printers, in an attempt to keep their prices from rising, cut back on production costs, with the result that hasty or careless presswork became commonplace. A preponderance of small type, used principally to save on paper costs, led to lighter inking which only accentuated the poverty of pigment within the ink, the common result being a depressingly pale, distinctly lackluster, gray page of text. It was not until the 1870s that the quality of auxiliary print materials began to improve.

Earlier in the nineteenth century, other forms of letterpress-printed matter had become more commonplace: invitation cards, tickets, banknotes, trade cards, commercial stationery, travel and theater posters, broadsheets and other public notices were, particularly in the larger cities, very much a part of everyday life.[1] The importance of "jobbing printing," both commercially and socially, grew throughout the nineteenth century.

The type designer's craft was emancipated by the growing need for types that were bolder and more obtrusive. The demands of the growing commercial industries, fuelled by the development of transport systems and the beginnings of the mechanization of printing itself, were making inroads into every aspect of printed matter, and the foundries responded. Types that could grab attention were required, and to achieve this they needed an unconventional appearance.

There was great demand for the new display faces in the US. Initially, these were imported from English foundries, but American foundries were quick to imitate and manufacture such designs themselves. By the middle of the nineteenth century, wildly extravagant letterforms, in both metal and wood, were being manufactured: decorative or drop-shadowed, in the form of logs or ribbons, and with the texture of brickwork, cut stone, or polished metal. There was also a tremendous interest in all things exotic. International travel for all was, for the first time, a possibility, and illustrated weeklies were full of foreign, popular, political, and cultural news.

LONDON AND NORTH EASTERN RAILWAY

HOLIDAY EXCURSIONS, 1923

Every SATURDAY

MAY 5th to JUNE 30th inclusive (except Saturday, May 19th)
(For 8 or 15 Days)
Dean & Dawson's EXCURSION TICKETS will be issued to

SHEFFIELD,
DONCASTER, HULL
WORKSOP (FOR THE DUKERIES), RETFORD
GAINSBORO', BRIGG,
GRIMSBY DOCKS
AND
CLEETHORPES

FROM

LIVERPOOL (Central)	MANCHESTER (London Road)
SOUTHPORT (Lord Street)	OLDHAM (Glodwick Road)
WIDNES (Central)	OLDHAM (Clegg Street)
WARRINGTON (Central)	ASHTON (Oldham Road)
WIGAN	ASHTON (Park Parade)
ST. HELENS	STALYBRIDGE
NORTHWICH	GUIDE BRIDGE
KNUTSFORD	NEWTON
MANCHESTER (Central)	HADFIELD

For Times. Fares and full particulars see small bills.

☞ BOOK IN ADVANCE

Tickets and Bills of the above can be obtained any time in advance at any of the Company's Booking Offices and Stations; or from the Company's Offices, Wood Street, Liverpool, 30 Deansgate, 2 George Street, and 16 Peter Street, Manchester. Messrs. Dean & Dawson Ltd., 38, Lord Street, Liverpool 53, Piccadilly, Manchester 51 Petersgate, Stockport, 2, Mumps, Oldham, and the usual Agents.

For further information apply to the District Traffic Manager L & N E Railway London Road Station Manchester the Passenger Manager, Marylebone Station, London N.W.1; or Dean & Dawson's Excursion Offices.

Marylebone Station, London N.W.1
April 1923

Left: Large wood type required for such poster work would be bought from type-specimen books such as this one by Vincent Figgins, London, published in 1832.

Above: Jobbing work extended to posters. Although such work required a very different way of presenting information, it is not uncommon to find conventional punctuation marks.

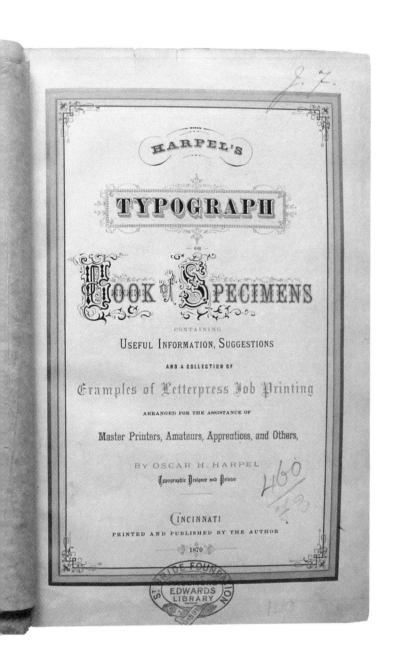

However, a more sober, heavier, and more practicable type came into vogue at the same time. By the middle of the nineteenth century, the sans serif reemerged after its initial appearance in the catalog of London typefounder William Caslon IV, in 1816. Its ability to appear larger than any other type given the same amount of space made it a popular choice for advertisers as competition increased the need for print to "shout" louder, particularly on posters and handbills.

Left: Oscar Harpel's book, *Typograph or Book of Specimens.* This book had a huge influence upon the printing trade of North America when it was published in 1870. It is, essentially, a manual containing technical information, suggestions, and a collection of letterpress jobbing examples. Harpel wanted to reestablish the "art" of printing and by utilizing the technology in new ways hoped that the printer/ compositor could reestablish a creative and independent role. Printed in five colors by Harpel himself, this book was certainly a revelation of the possibilities of letterpress printing.

Below left: Typical American wood display type; big, bold, and full of character. From the Hamilton Wood Type and Printing Museum, Wisconsin. Printed by Dennis Ichiyama, 2003.

This flush of display faces was greeted with disdain by many in the print trade, but today we can appreciate that these faces not only reflected, but also contributed to the character of their times. Edmund Gress described the early American display fonts thus:

"There is a dominant black tone in the types combined with a certain squareness and plainness of form that reflects a rugged and pioneering mood: log cabins, canal boats, black plug hats, black boots, stage coaches, covered wagons, black beards, masted schooners and storms at sea, black frock coats of southern gentlemen, black smoke from funnels and the new steamers. It was a period of strength of character and purpose."[2]

An influential development in display type was the production of type made from wood. Darius Wood, a New York printer, developed a steam-powered router to mass-produce wood type in 1827. In 1834, a pantograph mechanism was added (enabling type to be copied at any size from one master). A profusion of wood type became available. Unlike metal type, wood type–specimen books are quite rare, and printed specimens of complete wooden fonts are even rarer. The large size of many types meant that it was not uncommon for a single character – perhaps filling an entire page – to represent a whole font. Moreover, wood types were rarely given names, the customer ordering by catalog number only.

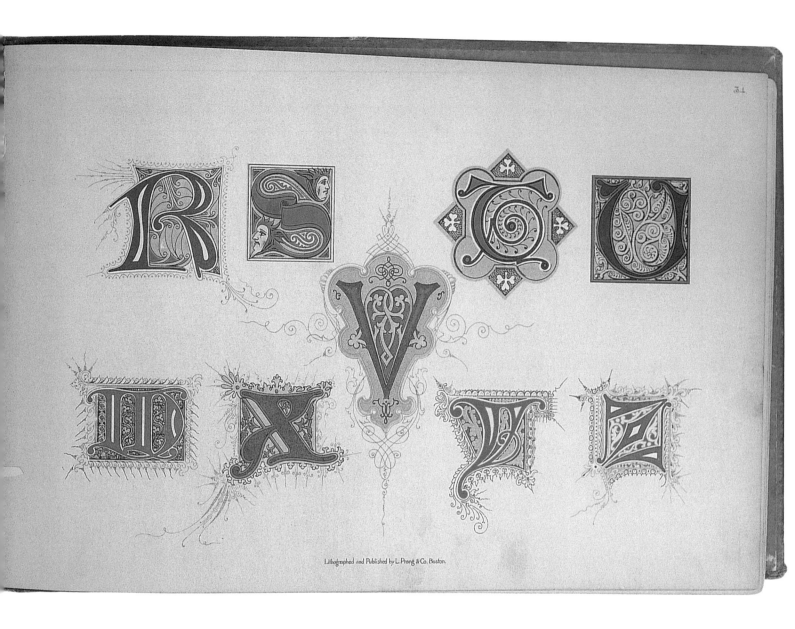

Lithographed and Published by L. Prang & Co. Boston.

Above and right: Prang's *Standard Alphabets*, revised edition, published by L. Prang & Co. of Boston, USA. Boston was a major center of excellence for printing in the latter half of the nineteenth century. The complexity of the work and inventive skills displayed are remarkable. The fact that there was little reference to anything "American" brought such material into disrepute by the early years of the twentieth century.

Following spread, top left: A comparison of two contemporary printing journals of the late 1880s, the *American Model Printer* and *The British Printer*, makes clear the differences in both print quality and typographic design between American and British publications. The quality of the English printing is inferior and so is the paper, but it is the overall design that most clearly differentiates the two.

Following spread, bottom left: The title page to vol. 14 of *The Printers' International Specimen Exchange*, 1893.

Following spread, right: An example from Budapest that "deconstructs" the printed page with panache. From *The Printers' International Specimen Exchange*, vol. 14.

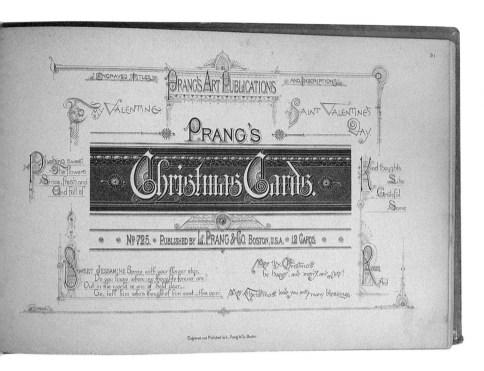

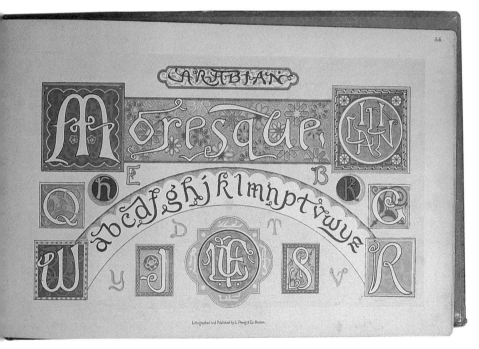

The artistic printer

In the New World of the United States, typographic convention, closely associated with the Old World of the UK and mainland Europe, was, for the first time in over 400 years, being called into question. In the US, there were fewer reservations about, and even considerable enthusiasm for pushing the boundaries of letterpress printing. As in the UK, "jobbing" was the term commonly used in North America to describe such work, but as the commercial potential and prestige of this new market grew, some printing offices, to distinguish themselves from "run-of-the-mill" printers, began calling themselves art jobbing offices, art printers or, most commonly, artistic printers.[3]

Oscar Harpel in Cincinnati, Ohio, published *Typograph or Book of Specimens* in 1870. This manual contained technical information, suggestions, and a collection of letterpress jobbing examples. It was devoted to the *art* of the compositor, rather than the usual, routine details of composing-room skills.

The requirements of the artistic printer were supported by the considerable improvements that had been made in the manufacture of auxiliary items for letterpress printing in the US. Firstly, a huge number of display or "fancy" types had been made available, many of which were elaborately decorated and shaded. These were influenced, in part, by the hand-drawn, ornamental lithographic letters and commercial signage that had been so common for some time. In addition, many and varied typographic borders and embellishments were introduced.

Secondly, the new, mechanized letterpress printing machines could be operated with remarkable precision. Heavier and more powerful, a more accurate register could be obtained with these machines than with any handpress. Running at high speed, these machines also made it economical for the printer to work in many colors for the first time.

Thirdly, the ink manufacturers provided the printer with a much larger range of colors and shades, varnishes, and many-hued bronzes. Ink was better made and, being manufactured in bulk, could be sold at much lower prices. Lastly, paper manufacturers were providing paper that was more consistent in both weight and color than previously available.

The rise of artistic printing in Britain and Germany may be traced to the Great Exhibition of 1851, in London, which generated an interest in all things exotic,[4] and to the Caxton Exhibition of 1877, also in London. Some printers must certainly have obtained a copy of Harpel's book, but the artistic style undoubtedly received its greatest impetus from the establishment of the *Printers' International Specimen Exchange* in England in 1880.

Organized by the typographer Andrew White-Tuer, editor of the journal *Paper and Printing*, the concept was simple but ingenious. Each subscriber, at a cost of one shilling (c. five pence [eight cents]) provided a certain number of typographic specimens (200 for the first issue) representing their best work. These were then collated into sets so that each subscriber received 200 incoming specimens, *all different*, in place of his own 200 outgoing specimens, *all alike*. For an additional charge, subscribers could receive their samples arranged in alphabetical order and tipped into leather-bound volumes. Remarkably, despite the rise of lithography as a major form of commercial printing, a high percentage of the contents of the *Exchange* was printed letterpress.

Following the success of the *Exchange*, a number of leading printers adopted the idea of issuing their own special work-specimen books, published at a nominal price. Such overt, self-publicizing activities were entirely new to the British print trade. A new, more brazen spirit, born not only of competition, but also of the possibility of individuality, had been realized. Imported inks, papers, and printing presses also offered British letterpress printers the chance to compete more effectively at an international level.

However, by the late 1890s, the "rule-bending" era of the artistic printer was suddenly over. The many adherents of the emerging Arts and Crafts movement in Britain and North America lost no opportunity in expressing their utter contempt[5] for the banality of Harpel's arbitrary use of "decorative relics" when compared with the "purity of the fifteenth-century revival" being undertaken by William Morris and the American followers of the burgeoning private press movement.[6]

There were also significant pressures of economics – driven by mechanization – that should not be underestimated. Paying for design was, after all, a new and perhaps not entirely happy experience for most customers. From the 1890s onward, a growing range and variety of mechanical typesetting devices were being patented, each of them introduced as being more efficient in the composing of type than the fingers of the most proficient compositor. A more rational, economic style certainly had its advantages within the commercial letterpress sector.

The physical nature of letterpress and the imagination of the commercially astute printer, however, ensured that remnants of the "artistic" era would remain well into the twentieth century. The few products that managed to survive the mass-marketing and corporate standardization of the 1960s and 1970s are now vigorously protected for their individual and, therefore, valuable "brand heritage."

HARMADIK ÉVFOLYAM

1893

GRAFIKAI SZEMLE

SZAKFOLYÓIRAT A GRAFIKAI IPARÁGAK SZÁMÁRA

A KÖNYVNYOMDÁSZOK SZAKKÖRÉNEK HIVATALOS KÖZLÖNYE

TÖBB JELES SZAKFÉRFIÚ KÖZREMŰKÖDÉSÉVEL

SZERKESZTI
TANAY JÓZSEF

FŐMUNKATÁRS
BAUER J. M.

*

BUDAPEST

PESTI KÖNYVNYOMDA-RÉSZVÉNY-TÁRSASÁG.

Contribution of the Pest Printing Society Limited to »The Printer's International Specimen Exchange« for 1893

The general-manager Sigismond Falk, knight, royal and commercial councellor.

Printed with Kidd's Inks.

TURQUOISE GREEN No. 417 · Letterpress 3/6 ; Litho 4/6.
CAMELIA LAKE No. 243 · „ 3/- ; „ 3/6.

Far left: A full page from the magazine, *The American Model Printer*, 1879, displaying combination decorative borders from George Bruce's Son and Co. of New York.

Top: Two advertisements that appeared in the pages of *The British Printer* during 1898. The style of this work reflects the movement that was to be called art nouveau.

Left: Two specimens of the same piece of jobbing work, the first in the "straight-line style of display, result; flatness" and the second in the "grouping style, result; effectiveness." By these examples, presented in *The British Printer* in 1893, Robert Grayson suggests a more reflective approach to typographic composition. Grayson is generally credited as the creator of the "Leicester Free Style," which is an alternative description for "artistic printing."

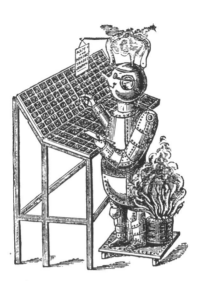

Top left: This drawing illustrates the general consensus, circa 1870, that a mechanical ("robotic") typesetter was feasible.

Top center: *The Monotype Recorder*, vol. 39, 1952, provided a series of "typographic transformations" (before and after examples).

Top right: A book of type specimens and matrix information from Linotype, 1953.

Right: An advertisement printed on the endpapers of *Printing*, H. A. Maddox, 1923, published in the UK by Pitman & Sons Ltd, promoting Linotype and the Miehle printing press.

LINOTYPE AND MACHINERY LTD.

New display type is expensive—in initial cost and subsequently in composition and distribution. And it is new only once

When you have a Linotype you will avoid heavy bills for new display and body founts, your composition charges will be far less, and distribution nil.

The Linotype will give you new type for *every* job—and not merely type but composed type, ready for make-up and printing.

And as regards make-up: Do you know how simple, safe, and speedy it is where Linotype matter is concerned? The machine leads its own matter; and, as every line is a complete unit, much larger quantities can be handled at a time than is possible with movable type.

Unlimited supplies of decorative material can be cast on the machine; lines can be repeated as many times as required, so that a job can be printed as many "up" as required to reduce long runs on the presses.

The Linotype can be equipped to suit your immediate needs. You can install it with one magazine only or as many as eight; with one distributor or as many as four.

These are but a few of the advantages you will gain when you have a Modern Linotype. Come and see the machine for yourself, and bring samples of your work with you.

Every printer appreciates Miehle work—and so does the buyer of printing. Miehle printing does not cost more than ordinary printing, but it commands better prices

The Miehle is prepared for a job more quickly than an ordinary press. The rollers are quickly set, the ink duct can be accurately adjusted to suit formes of any kind, make-ready is reduced to the minimum owing to the scientific construction of the press, and the little make-ready required is quickly effected.

There is no risk in installing a Miehle. It is a sound investment for every printer —a perfect tool and a real asset at all times.

If the work you are now doing is "ordinary," you can raise your standard of printing to the highest level by installing the Miehle.

The Miehle is built in this country, in our Works at Altrincham, Cheshire, and can be obtained only from us

Head Office: 9 Kingsway, London, W.C.2
Works: Altrincham, Cheshire

Manchester 4 Cannon St. Bristol 51 Broad St. Glasgow 197 Howard St. Dublin 17 Sackville Place

Mechanization of casting and typesetting

Ironically, while the influence of the private press movement was becoming international, the last major hand operations connected to letterpress – the casting and setting of type – were being mechanized. Type had always been cast in molten metal, by means of a handheld mold and a ladle. Each piece of type then had to be finished and dissed before it could be set by hand, by the composer. By the end of the nineteenth century, the operations of typecasting and typesetting had been very effectively mechanized.

A number of mechanical casters were installed in larger printing companies. Clowes, in England, for example, produced the five tonnes (c. five tons) of type required to set the catalogs for the Great Exhibition of 1851 on a mechanical caster. The newspaper industry was another voracious user of type, and by the 1880s many newspapers had installed machines capable of typecasting 60,000 characters per hour.

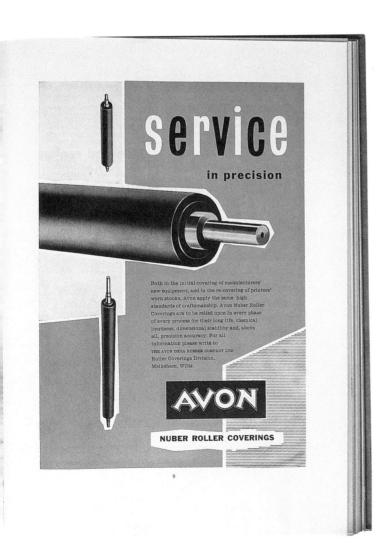

Inventing a method of composing texts mechanically was proving to be far more difficult, however. Early attempts involved using preloaded reservoir magazines of foundry type that could be released, character by character, and placed into position at a command from the keyboard. The main problem was finding a mechanical means of justifying the lines of type once they had been set. During the 1890s, new approaches that controlled the position of the individual matrices so that the type could be cast and set simultaneously were explored. The first practical machine to achieve this, in 1886, was the Linotype.

The Linotype composing machine (the "Merg") was developed by Ottmar Mergenthaler, in the US. It worked by assembling rows of individual matrices and then taking casts of complete one-piece lines, or "slugs," from them. Although it compromised some of the refinements of type design, the Linotype was an almost immediate success in the US, and the first models were installed in English newspaper offices in 1889.[7]

The other kind of hot-metal composing machine is the Monotype, developed by the American Tolbert Lanston.[8] This consisted of two units, a keyboard and a caster, each requiring an operator. The keyboard generates a perforated paper tape (or control spool) which can then be fed into the caster where it is "read" by means of jets of compressed air blowing through the perforations. As the tape is read, matrices are selected and letters and spaces cast.

Although Linotype remained the popular choice of printers in the US and, to a lesser degree, in the UK (by 1915, the Mergenthaler Linotype Company had manufactured 33,000 machines and millions of matrices), the more versatile Monotype machine tended to be the preferred choice of book printers and publishers. Its advantage was that, because each character and all spacing matter were cast as separate units, it was possible to make fine adjustments by hand at any of the later stages of production.

Both of the mechanized typesetter companies skillfully created strong links with their customers by setting up user associations, whose members met and shared their specialized knowledge. The Monotype Corporation further strengthened these links by publishing the highly informative *Monotype Recorder* as well as the *Monotype Newsletter*. These were supplemented by excellent technical bulletins, manuals, and, of course, type-specimen books. Particular attention was also given to producing suitable literature and teaching aids for teachers and students of typography, in the form of posters, specimens, and alphabet tracing sheets. Stanley Morison presided over the commissioning and design of Monotype typefaces and, together with the American-born Beatrice Warde, over the Corporation's informational and technical publishing.[9]

New Clarendon Bold

'Monotype'

New Clarendon

It was essential to both the Linotype Company and the Monotype Corporation that they be able to manufacture matrices for the varied typefaces needed by the printers and publishers who bought their machines. The Monotype Corporation initially viewed its typefaces as commercial fodder for its composing and casting machine. Just as Gutenberg's *42-line Bible* had to prove its value by effectually *matching* the manuscripts that had previously been the norm, so Monotype had to match the appearance of hand composition. This is described in the *Monotype Recorder* (1950). "… all composing-machine companies were compelled to copy designs originated by the founders of movable type for hand composition. Thus, to the date when Monotype composing machines were introduced … the invention of new typeface designs was unpractical, unnecessary, and undesirable."

It is not surprising then, that the first typeface should be Modern, the "standard choice" of type for all kinds of printing at the beginning of the twentieth century. Such a choice also illustrates the isolation, and, to a large degree, the irrelevance of the Arts and Crafts movement and the work of the private presses in the context of the commercial business of printing. Here, the future was now considered to be with science, not art. Commercial printers, perhaps wishing to emphasize this point, took to wearing white coats and calling themselves technicians.

Left: An advertisement for Monotype's New Clarendon typeface which appeared in *The Penrose Annual*, vol. 55, 1961.

Below: A spread from Monotype's *Composition Faces*, a very elegant booklet, aimed at providing print students with basic information about text setting.

Right: An advert (the first of four pages) for Linotype products that appeared in *The Penrose Annual*, vol. 50, 1956.

appearing (as opposed to the actual) size of different faces and the amount of space which they occupy setwise, and–more important than either of these alone– the two considered in relation to one another,* and in relation to the ideal length of line and the amount of interlinear space necessary to comfortable reading of the page. Though almost as much of the success of the design of a printed page lies in a good use of type as a good choice, the really essential thing is choice for the right reason: not primarily for its associations or superficial charm, but for its fitness to do the job in the appropriate conditions and to produce a pleasant and readable page; saving space, if that is what circumstances dictate, without either crowding or uncomfortable reduction in the appearing size of type in relation

to the page size and length of line. Too long or too short a line; too much or (especially) too little interlinear space can hinder the reader as much as an ill-designed type, and may seem to be forced upon anyone attempting to design a page in an ill-chosen typeface.

The other circumstance for which type designs have to cater is that of the paper surface and the process of reproduction being used. In the pages following, the features which lend themselves readily to one paper or process or another have been indicated, but it may often be the case that extra care on the part of the printer and designer can overcome difficulties and a first-class job may be produced using what might seem to be an unsuitable face.

The printers of this booklet have been faced with just such a problem: that of printing 30 specimens of different typefaces on a paper which, though it suits many, cannot be the ideal one for all of them.

* See table of ratios on the 1963 edition of the 'Monotype' broadsheet *How and why type faces differ.*

CONTENTS

The page numbers referred to below are shown as the folios to the crown 8vo specimen page settings, though this involves the use of an even (verso) number on a page whose margins were designed for a recto page.

Notes on Specimens

On the following pages the specimen characters shown on the right are mainly printed from display sizes of the face shown as a page specimen, and from related faces. In some cases, however, composition sizes have been blown up photographically to illustrate particular points or because no sufficiently large size exists. These are marked with an asterisk. Specimen characters for Old Style have been set on a 'Monophoto' Filmsetter, and

those for Century in the similar Century Schoolbook.

In the crown 8vo page settings, the amount of copy which fits into a page is not necessarily a reliable guide to the space-occupying qualities of the face in which it is set. In many cases the choice of another size and leading would have produced an equally readable page.

The text for these settings has been taken from *The Crystal Goblet* by Mrs Beatrice Warde.

CENTAUR

One of the earliest forms of roman type (upon which late 19th- and 20th-century designs have been based) is the Venetian letter of Nicolas Jenson (1470). It inspired William Morris's design of the Golden Type for his Kelmscott Press and served as a model for Bruce Rogers's Centaur, which, like Jenson's roman, owes a good deal to pen-drawn letters. Undoubtedly the finest showing of Centaur is in the Oxford Lectern Bible where it is used to superb effect in the 22-point large-composition size. It is a face that is light in colour and appears at its best when printed by letterpress on an antique paper. As it has long ascenders and descenders, not much leading is required. Considered in relation to its appearing size it is a wide face, so that it is unsuitable for books where economy of space is a consideration, and for which, in any case, its air of leisurely ease might well be out of place.

THE CRYSTAL GOBLET

if the letters, however pretty in themselves, do not combine automatically into words; if the fourth consecutive page begins to dazzle and irk the eye, and in general if the pages cannot be read with subconscious but very genuine *pleasure*, that type is intolerable and that is all there is about it. It must be wiped out of the discussion. There are bad types and good types, and the whole science and art of typography begins after the first category has been set aside.

The second generalization is, briefly, that the thing is worth doing. It does genuinely matter that a designer should take trouble and take delight in his choice of typefaces. The trouble and delight are taken not merely 'for art's sake' but for the sake of something so subtly and intimately connected with all that is human that it can be described by no other phrase than 'the humanities'. If 'the tone of voice' of a typeface does not count, then nothing counts that distinguishes man from the other animals. The twinkle that softens a rebuke; the scorn that can lurk under civility; the martyr's super-logic and the child's intuition; the fact that a fragment of moss can pull back into the memory a whole forest; these are proofs that there is reality in the imponderable, and that not only notation but connotation is part of the proper study of mankind. The best part of typographic wisdom lies in this study of connotation, the suitability of form to content. People who love ideas must have a love of words, and that means, given a chance, they will take a vivid interest in the clothes which words wear. The more they like to think, the more they will be shocked by any discrepancy between a lucid idea and a murky typesetting. They will become ritualists and dialecticians. They will use such technically indefensible words as romantic, chill, jaunty, to describe

3

The derivation of Centaur from calligraphy is shown in the diagonal stress and slight angularity where the stroke changes direction. Note the calligraphic character of the serifs and the diagonal cross-stroke of the e (the easiest angle for a pen). Compare pen-drawn letters. ▸

deg
de
!?5

Punctuation and figures are also calligraphic in character.

EM

Even where actual strokes are not particularly reminiscent of calligraphy the leisurely spaciousness of the proportions reflects its influence.

IN

Variety of serif form and lack of ruled regularity in the straight strokes are seemingly almost casual but really carefully related to the classic proportions of the letter forms.

GPQ

In the italic (designed by Frederic Warde after a type of Ludovico degli Arrighi, 1524) calligraphic flicks and flourishes are even more frequent. Note the serifs on G and P, the single sweeping line of Q and the diagonally cut-off middle stroke of w. Compare pen-drawn letters. ▸

fwz
PQ

A study of alphabet lengths of different faces of the same point size might give a misleading impression that Centaur is a narrow face which is economical in use. Actually the x-height parts of the lower-case letters are of generous width. The long ascenders and descenders reduce the *effective* size.

hop

◂ Centaur 252, 12 point, 1 point leaded

[Conventions and rebellions] 2.3 Reviving standards

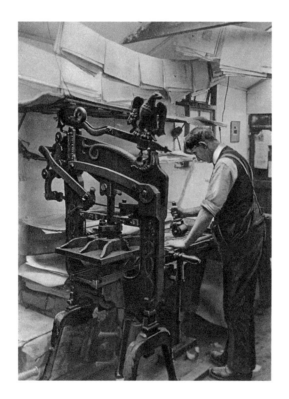

The printing press invented and constructed by Applegath and Cowper, *The Times* engineers, in 1827.

Above right: Fine letterpress printing in the studio of the Golden Cockerel Press, based in Berkshire, UK. Precise date unknown.

Below right: In 1827, *The Times* installed a printing press that could print from 4,000 to 5,000 copies an hour. The machine required eight "attendants," four to lay the paper on and four to take it off when printed. The *craft* of printing had already become largely irrelevant.

The Arts and Crafts movement

William Morris and the Arts and Crafts movement dominate consideration of any twentieth-century craftwork, and letterpress is no exception. The movement was given its name and achieved public recognition with the founding of the Arts and Crafts Exhibition Society in Britain in 1888. Morris and the others in the movement were involved in the whole range of "minor arts" (Morris' words) as well as books and all of their associated crafts – bookbinding, letter cutting, engraving, calligraphy, and printing.

In Morris' opinion, type design and letterpress printing had been in decline since 1500. He considered Plantin, created in the mid-1500s, "poor and wiry," the typography of Baskerville misguided, and Didot and Bodoni as reaching the depths of "sweltering hideousness." These views were not shared in mainland Europe, and certainly not in France and Italy, where Baskerville was much admired and Didot and Bodoni were, and still are, national icons. However, in the UK during the 1870s and 1880s, the commercial sector was either pandering to the Victorian taste for melodramatic pseudomedievalism, or the technically brilliant, but vacuous work of the artistic printers. Morris' own tastes tended toward romanticism; type with the strongest possible hint of its calligraphic origins, and with medievalism as its inspiration.

Morris had been involved with publishing projects since 1866. These early works were printed by the Chiswick Press, but created little interest. This was not so much because of his dissatisfaction with the quality of the printing itself – Chiswick was one of the best commercial presses in England at the time – but rather because of Morris' lack of commitment. In fact, it was not until 1888 with the incentive of having "a new craft to conquer" that Morris began to think *seriously* about books.

and he wondered at her word, and a new hope sprang up in his heart that he was presently to be brought face to face with the Hostage, and that this was that love, sweeter than their love, which abode in him, & his heart became lighter, and his visage cleared.

CHAPTER XII. THEY LOOK ON THE KING OF THE GLITTERING PLAIN.

O now the women led them along up the stream, and Hallblithe went side by side by the Sea-eagle; but the women had become altogether merry again, & played and ran about them as gamesome as young goats; and they waded the shallows of the clear bright stream barefoot to wash their limbs of the seabrine, & strayed about the meadows, plucking the flowers and making them wreaths and chaplets, which they did upon themselves and the Sea-eagle; but Hallblithe they touched not, for still they feared him. They went on as the stream led them up toward the hills, and ever were the meads about them as fair and flowery as might be. Folk they saw afar off, but fell in with none for a good while, saving a man and a maid clad

79

Inspired by a lecture of Emery Walker's in November 1888, where he had seen enlarged letterforms projected onto the screen, Morris used photography to record and enlarge pages from Jenson's *Pliny* of 1476. A similar process ensued when he was drawing his first type, Golden. Burne-Jones' ink drawings were also transferred to wood using photography. All recurring initials and decorations were printed from electrotypes. The printing press used by Morris was still commonplace in many commercial letterpress workshops, and the types drawn by Morris were cast by machine because he could see no advantage in casting by hand. Despite all this, part of the Morris legacy was the supposed antipathy to mechanization, whose "evils" continued to be discussed by the followers of the Arts and Crafts movement, interminably, well into the 1930s.[1] This was clearly not the case; Morris was not averse to using any means, as long as they enabled him to achieve his goals.

The books of Morris' Kelmscott Press were neither dogmatically traditionalist nor modernist. The fact is, they were quite unlike anything associated with printing as it was known and practiced at that time. They were designed, printed, and bound to the very highest standards that Morris could achieve. No effort was spared in finding the right materials.[2] Morris worked to please himself and took as much time to produce his books as was necessary. For instance, it was his conviction alone that led him to gothic types; typographic conventions of the day (Bodoni being the "automatic" choice for book work, for example) were irrelevant. The first Kelmscott book, *The Story of the Glittering Plain*, was printed in January 1891. Its impact was immediate and immense. The general agreement, by the middle of that decade, was that the Kelmscott Press, and its edition of *Chaucer* (1896) in particular, represented the most splendid book production since printing began.

The importance of Morris' work as a printer was not in his style, but in his example. By taking apart and rebuilding the process based upon best practice, letterpress printing took root in an entirely new way. In the late 1890s and early 1900s, the great international revival in letterpress printing began, fuelled by political and social idealism. Embracing the mechanization of the print process, for many, was to play an essential part in ensuring that print matter reached those who needed or deserved it most. Morris had made print, and the nature of print, a social issue. He saw no reason to dilute the quality (or reduce the cost) of his books to make them more accessible. On this issue Morris explained, "I wish indeed that the costs of books were less … [but] if we were all socialists, things would be different. We would have a public library at each street corner, where everyone might see and read all the best books, printed in the best and most beautiful type."

Above: *The Story of the Glittering Plain* **was the first major project to be printed by William Morris' Kelmscott Press, in 1891. The types used were new designs by Morris. Golden was based on the type cut in the first 50 years after the invention of movable type, and the work of Nicholas Jenson in particular.**

is people, over Israel: now therefore hearken thou unto
of the Lord. Thus saith the Lord of hosts, I remember that
Israel, how he laid wait for him in the way, when he came
Now go & smite Amalek, and utterly destroy all that they
not; but slay both man and woman, infant and suckling
nel & ass. And Saul gathered the people together, & numbe
two hundred thousand footmen, and ten thousand men
aul came to a city of Amalek, and laid wait in the valley.
the Kenites, Go, depart, get you down from among the Am
troy you with them: for ye shewed kindness to all the chil
they came up out of Egypt. So the Kenites departed
alekites. And Saul smote the Amalekites from Havilah,
Shur, that is over against Egypt. And he took Agag the
tes alive, and utterly destroyed all the people with the ed
Saul and the people spared Agag, and the best of the sh
and of the fatlings, and the lambs, & all that was good,
rly destroy them: but every thing that was vile and ref
yed utterly. ¶ Then came the word of the Lord unto Sam
teth me that I have set up Saul to be king: for he is turn
wing me, and hath not performed my commandments. An
el; & he cried unto the Lord all night. And when Samuel
ul in the morning, it was told Samuel, saying, Saul came
old, he set him up a place, and is gone about, and passed
to Gilgal. And Samuel came to Saul: and Saul said unto
of the Lord: I have performed the commandment of the Lo
, What meaneth then this bleating of the sheep in mine
f the oxen which I hear? And Saul said, They have broug
malekites: for the people spared the best of the sheep an
fice unto the Lord thy God; and the rest we have utt
Samuel said unto Saul, Stay, and I will tell thee what
me this night. And he said unto him, Say on. And Sam
wast little in thine own sight, wast thou not made the
rael, and the Lord anointed thee king over Israel? An
a journey, and said, Go and utterly destroy the sinners
ight against them until they be consumed. Wherefore t
bey the voice of the Lord, but didst fly upon the spoil
ight of the Lord? And Saul said unto Samuel, Yea, I h
of the Lord, & have gone the way which the Lord sent
Agag the king of Amalek, and have utterly destroye
the people took of the spoil, sheep and oxen, the chief
uld have been utterly destroyed, to sacrifice unto the L
l. And Samuel said,

days, then thou shalt go down quickly, & come to the place where thou didst I Samuel 20
hide thyself when the business was in hand, and shalt remain by the stone
Ezel. And I will shoot three arrows on the side thereof, as though I shot at
a mark. And behold, I will send a lad, saying, Go, find out the arrows. If I
expressly say unto the lad, Behold, the arrows are on this side of thee, take
them; then come thou: for there is peace to thee, & no hurt; as the Lord liveth.
But if I say thus unto the young man, Behold, the arrows are beyond thee;
go thy way: for the Lord hath sent thee away. And as touching the matter
which thou and I have spoken of, behold, the Lord be between thee and me
for ever. ¶ So David hid himself in the field: and when the new moon was
come, the king sat him down to eat meat. And the king sat upon his seat, as at
other times, even upon a seat by the wall: & Jonathan arose, & Abner sat by
Saul's side, & David's place was empty. Nevertheless Saul spake not any thing
that day: for he thought, Something hath befallen him, he is not clean; surely
he is not clean. And it came to pass on the morrow, which was the second day
of the month, that David's place was empty: & Saul said unto Jonathan his
son, Wherefore cometh not the son of Jesse to meat, neither yesterday, nor
to day? And Jonathan answered Saul, David earnestly asked leave of me to
go to Beth-lehem: and he said, Let me go, I pray thee; for our family hath a
sacrifice in the city; and my brother, he hath commanded me to be there: and
now, if I have found favour in thine eyes, let me get away, I pray thee, and see
my brethren. Therefore he cometh not unto the king's table. Then Saul's anger
was kindled against Jonathan, & he said unto him, Thou son of the perverse
rebellious woman, do not I know that thou hast chosen the son of Jesse to
thine own confusion, & unto the confusion of thy mother's nakedness? For as
long as the son of Jesse liveth upon the ground, thou shalt not be stablished,
nor thy kingdom. Wherefore now send & fetch him unto me, for he shall surely
die. And Jonathan answered Saul his father, & said unto him, Wherefore shall
he be slain? what hath he done? And Saul cast a javelin at him to smite him:
whereby Jonathan knew that it was determined of his father to slay David.
So Jonathan arose from the table in fierce anger, & did eat no meat the second
day of the month: for he was grieved for David, because his father had done
him shame. ¶ And it came to pass in the morning, that Jonathan went out
into the field at the time appointed with David, & a little lad with him. And he
said unto his lad, Run, find out now the arrows which I shoot. And as the lad
ran, he shot an arrow beyond him. And when the lad was come to the place
of the arrow which Jonathan had shot, Jonathan cried after the lad, and said,
Is not the arrow beyond thee? And Jonathan cried after the lad, Make speed,
haste, stay not. And Jonathan's lad gathered up the arrows, and came to his
master. But the lad knew not any thing: only Jonathan and David knew the
matter. And Jonathan gave his artillery unto his lad, and said unto him, Go,
carry them to the city. And as soon as the lad was gone, David arose out of

381

The private press movement

The "revival of printing" movement was made up of people like Morris who came to the craft from outside the printing trade. Their sole aim was to produce beautiful printing, with the Kelmscott Press very much their inspiration. Such a private press of that period might be defined as "an enterprise sustained by a person of means, and of taste and ability, who produces books for his own pleasure, frequently with a newly commissioned proprietary typeface, and, usually, with one or more employed journeymen. Books were set by hand and printed on dampened, handmade papers, and customarily bound in vellum." [3]

The fine letterpress printing and bookbinding of the British private presses found followers across the world, particularly in the Netherlands, Belgium, and especially Germany, where the Bremer Presse and the Cranach Presse [4] retained very close ties to Kelmscott and the British private press movement. Unfortunately, the rich and extensive range of production of the first three decades of the twentieth century can only be hinted at here.

In the US, Morris had quickly gained many admirers, particularly in the cultural centers of the northeast. Heavy-handed, blotchy black type with fantastic ornaments could be found in most American type-specimen books in the latter 1890s. These were made for the ready market among printers who bought themselves thick paper and a quantity of red ink with which to print "beautiful books."

However, much to their credit, other American typographers found ways of applying craft ideals to commercial work that used machine composition and powered printing machines. Daniel Berkeley Updike, Bruce Rogers, Frederic Goudy, W. A. Dwiggins, Will Ransom, T. M. L. Cleland, and Frederic Warde all worked for most of their careers as freelance typographers and/or typeface designers. High standards of design and letterpress printing were achieved, with serious books receiving design solutions perfectly appropriate for, or expressive of, their content.

Like their counterparts in North America, a common approach also began to appear in Europe, as the freelance typographer became a regular in the production of printed matter, working in industry, but reserving a sphere of noncommercial production for higher design aspiration. Teaching part-time to supplement unpredictable income also became common practice. A practical knowledge of letterpress, and an understanding of the working practices of the printer remained essential to the typographer.

quasi-cursive Roman Capitals have been designed to match. This practice has, however, been carried to excess; the slope of Italics and their cursiveness have been much overdone. In the absence of punch cutters with any personal sensibility as letter designers, with punch cutting almost entirely done by machine, the obvious remedy is a much more nearly upright & non-cursive Italic, & for Capitals the ordinary upright Roman. Even with a nearly upright Italic, the mere presence of the Italic a e f and g alters the whole character of a page, & with a slight narrowness as well as a slight slope, the effect is quite different from that of a page of Lower-case. ¶ The common practice of using Italics to emphasize single words should be abandoned in favour of the use of the ordinary Lower-case with spaces between the letters (letter-spaced). The proper use of Italics is for quotations & foot-notes, & for books in which it is or seems desirable to use a lighter & less formal style of letter. In a book printed in Italics upright Capitals may well be used, but if sloping Capitals be used they should only be used as initials—they go well enough with Italic Lower-case, but they do not go with one another. ¶ We have, then, the three alphabets, & these are

the printer's main outfit; all other sorts of letters are in the nature of fancy letters, useful in inverse proportion to the importance and quantity of his output. The more serious the class of book he prints, the wider the public to whom he appeals, so much the more solemn and impersonal and normal will be & should be his typography. But he will not call that book serious which is merely widely bought, & he will not call that a wide appeal which is made simply to a mob of forcibly educated proletarians. A serious book is one which is good in itself according to standards of goodness set by infallible authority, and a wide appeal is one made to intelligent people of all times and nations.

¶ The invention of printing and the breakdown of the medieval world happened at the same time; and that breakdown, tho' hastened by corruption in the Church, was chiefly caused by the recrudescence of a commercialism which had not had a proper chance since the time of the Romans. The invention of double-entry book-keeping also happened about the same time, and though, as with modern mechanical invention, the work was done by men of brains rather than men of business, it was the latter who gained the chief advantage.

e2

Top: A mark composed of type ornaments by Bruce Rogers, USA, circa early twentieth century.

Far left: Page from the *Doves Press Bible*, 1903–5. printed by TJ Cobden-Sanderson and Emery Walker in black with red, with typesetting by JH Mason. Doves Press books were without illustration or decoration. An exception was made, in this book for Edward Johnston's occassional calligraphic initials (not shown). Most books printed by the Doves Press were printed in the same format, all with the same typeface, in one size only. St Bride Print Library.

Left: Eric Gill's *An Essay on Typography* begins "The theme of this book is typography and as it is affected by the conditions of the year 1931. The conflict between industrialism and ancient methods of handicraftsmen which resulted in the muddle of the nineteenth century is now coming to its term. But tho' industrialism has now won an almost complete victory, the handicrafts are not killed and they cannot be quite killed because they meet an inherent, indestructible, permanent need in human nature."

Right and below: *Genesis*, printed by the Nonesuch Press in 1924. The Nonesuch Press was established the year before by Francis Meynell and had a policy of using established commercial presses to keep down the prices of its limited editions. The wood engravings (12 in all) are by Paul Nash.

Far right: A title page from W. A. Dwiggins' edition of Edgar Allan Poe's *Tales*, published by R. R. Donnelley & Sons Co. in Chicago, in 1927.

THE EDITION IS LIMITED TO THREE HUNDRED AND SEVENTY—FIVE COPIES ⋆ THE CUTS ARE PRINTED FROM THE WOOD AND THE TEXT IN RUDOLF KOCH'S NEULAND TYPE ON ZANDERS HAND—MADE PAPER BY THE CURWEN PRESS FOR THE NONESUCH PRESS ⋆ THIS IS NUMBER 92

I THE VOID
II THE FACE OF THE WATERS
III THE DIVISION OF THE LIGHT FROM THE DARKNESS
IV CREATION OF THE FIRMAMENT
V THE DRY LAND APPEARING
VI VEGETATION
VII THE SUN AND MOON
VIII THE STARS ALSO
IX THE FISH AND THE FOWL
X CATTLE AND CREEPING THING
XI MAN AND WOMAN
XII CONTEMPLATION

GENESIS
TWELVE WOODCUTS BY PAUL NASH WITH THE FIRST CHAPTER OF GENESIS IN THE AUTHORISED VERSION ⋆ THE NONESUCH PRESS SOHO MCMXXIV

IN THE BEGINNING GOD CRE—ATED THE HEAVEN AND THE EARTH ⋆ AND THE EARTH WAS WITHOUT FORM AND VOID

Long-term collaborations between typographers and publishers flourished. In Germany, F. H. Ehmcke worked with Eugen Diederichs; Paul Renner with George Müller; and E. R. Weiss with Insel Verlag and S. Fischer Verlag. There was also Giovanni Mardersteig at the Officina Bodoni, which published immaculate, but expensive editions. Mardersteig later made the transition into work for mass-production as consultant to an early paperback venture, Albatross Books. The success of this publishing venture was a major influence upon Allen Lane in his setting up of Penguin Books in 1935. In the late 1940s, Lane invited Jan Tschichold to act as Penguin's Typographic Director.[5]

By the end of World War I, craft was commonly seen as a cultural and intellectual cul-de-sac, perceived as the antithesis of the growing modernist movement, particularly in mainland Europe. By now, most typographers who believed in the same political and social aims as Morris saw their partnership with mass-production as an essential means of improving "common" standards. Those who remained committed to maintaining the handcrafted object argued that "to be *truly* modern one must be *anti*modern."[6] This attitude explains, in part, why craftspeople during the interwar years, and especially during the 1920s, clearly considered their activities to be forward-looking – revolutionary even – rather than backward-looking.[7] A bohemian attitude did, indeed, stand out against its time. To be sensitive and fine was to fight for the survival of real and good traditional values against mockery, misunderstanding, and, often, downright persecution. It was not only the crass, middle-class "vulgarians" (otherwise known as modernists), but also the working classes who were seen to be the enemies. This left the private presses isolated and, for the most part, bereft of purpose. With the demise of the Doves Press, printing ceases to be relevant in any publication concerned with the development of craft in the twentieth century.

Once the printing industry had become thoroughly mechanized, how to remain relevant was an issue that should have affected all of those who remained committed to hand composition and to fine printing. However, unlike practitioners of other crafts (ceramics for instance), the private presses withdrew from contemporary cultural debate, producing books that, generally, were not intended to touch upon everyday life.

[Conventions and rebellions] 2.4 Against the establishment

Artist's books and book arts

Livres d'artiste[1] began to appear in France in the last quarter of the nineteenth century. Comparisons are commonly drawn between the *livres d'artiste* and William Morris. However, in France, while there was certainly the will to produce books of the very finest quality, the rationale for doing so was entirely different. The Third Republic (1871–1940) rapidly industrialized and urbanized France, producing prosperity and a growing bourgeois class. Among the consequences of this affluence was the formation of societies of bibliophiles who revived an interest in French book production and with this, French illustration, both of which had, undoubtedly, been in general decline.

Signs of change had been signalled by the publication of *Le Fleuve* (Paris, Charles Cros, 1874), which had eight small etchings by Edouard Manet. During the 1890s, there followed a printmaking revival. The publisher and art dealer Ambroise Vollard was of singular importance in this regard. His first book, Verlaine's *Parallèlement*, was illustrated with large, marginal lithographs by the young Pierre Bonnard, and the text was letterpress-printed by the Imprimerie Nationale.

Letterpress in this context rarely offered anything new to the medium, placing the emphasis on the artist. A notable exception are the books of Ilia Zdanevich (Iliazd). His work provides a link between the avant-garde work of the futurists in Russia (1910–1923), and a later period of production, following World War II, when he was established in Paris. Under the imprint 41°, his books involved the work of poets and major artists of the day, including Ernst, Miró, and Giacometti, while Picasso collaborated with Iliazd on nine books. However, Iliazd, as designer and publisher, bravely gave the typography – inevitably letterpress – a prominent, more considered, and less predictable appearance, and a role regularly on a par with the image.

Right: *Le Courtisan Grotesque*, published in Paris in 1974, is one of Iliazd's last works. The text is by an obscure seventeenth-century writer, Adrien de Montluc, and the illustrations are colored etchings by Joan Miró. Although Iliazd worked repeatedly with all the major artists of his time, he himself made every effort to remain anonymous. The typographic virtuosity involved in composing the text in this way is easily overlooked.

Above: *La Fin du Monde* (The End of the World), Editions de la Siréne, Paris, 1919, with stencils by Fernand Léger. The text is written and arranged to suggest a film script.

ES

DE SORTE

PARTAGER LEURS E

& FAIRE BONNE CHERE P

VESQUIRENT LEURS ANS

ANS ESPROUUER PAS VN MAL

E COURTISAN EUT VNE

ALLER VOIR LA COUR

ES ROYS DE L

DE LA FE

LUSIEURS

OZS DE

UR DRESSER SON

IT SIX BARBES

Above: A personal card designed by Fortunato Depero, using letterforms from his name, in the futurist style, circa 1927. Russian futurism was a marriage of poetry and art. Unlike Western avant-garde movements, magazines were not the main thrust of Russian futurist publishing. Instead, artists created limited-edition books comprising prints, paintings, and calligraphy.

The avant-garde

During the 1920s, while the private press movement was in its prime and arguing for a return to orthodoxy, others were utilizing letterpress to play an essential role in a revolt against the orthodox. Several ideologically overlapping movements were involved, all with a mission to assault the comfort of the established and predictable cultural and social norms.

For printed communication, letterpress *was* the establishment. More than any other print process at the time, it could also reflect the refinement of language. There really could be no better means of displaying the determined rejection of all established forms of communication than by hijacking its oldest and most traditional medium and using that to express another, entirely opposite cause.

Not surprisingly, this impulse for the innovative use of letterpress printing came, again, from people outside the printing trade. In fact, they were not even from the growing profession of typographic design. They were artists intent on disrupting all of the familiar patterns that make life predictable and controllable, including those upon which the notions of art itself were established. The common link between the futurists in Italy, Spain, and Russia; the vorticists in England; the constructivists in Russia; the activists in Hungary; and the dadaists internationally was a contempt for rational outcomes. It is not surprising then that the results achieved by these artists were completely different from anything that had ever been produced with letterpress before.

The machine-made wood and metal types were appropriated by the futurists et al for their familiar orthodoxy and authoritative character, which the artists undermined by arranging them in entirely unorthodox ways. Even the identity of the letters themselves was exploited for potential new meanings. Coming from outside the print establishment, these artists had little interest in standard practices; in fact, standard practice, with all its archaic associations, was exactly what they intended to break down.

The futurists called the abstracted and revitalized textual matter that resulted *zaum*, which roughly translated means "beyond" or "outside reason." The conventions relating to reading were dispensed with, allowing words to be taken out of their normal context, so the reader could focus upon their sounds.

Top: Pages from *Blast*, no. 1, edited and designed by Wyndham Lewis. The ideals behind vorticism were barely distinguishable from those of the Italian futurists, although Lewis did not accept Marinetti's romanticized view of mechanization. *Blast* had only three issues.

Above: A spread from *Merz*, no. 16/17, 1925. This issue included a typographic showcase of advertising work by Kurt Schwitters for Pelikan Inks. This unconventional use of type in a commercial context was a radical departure and highly influential.

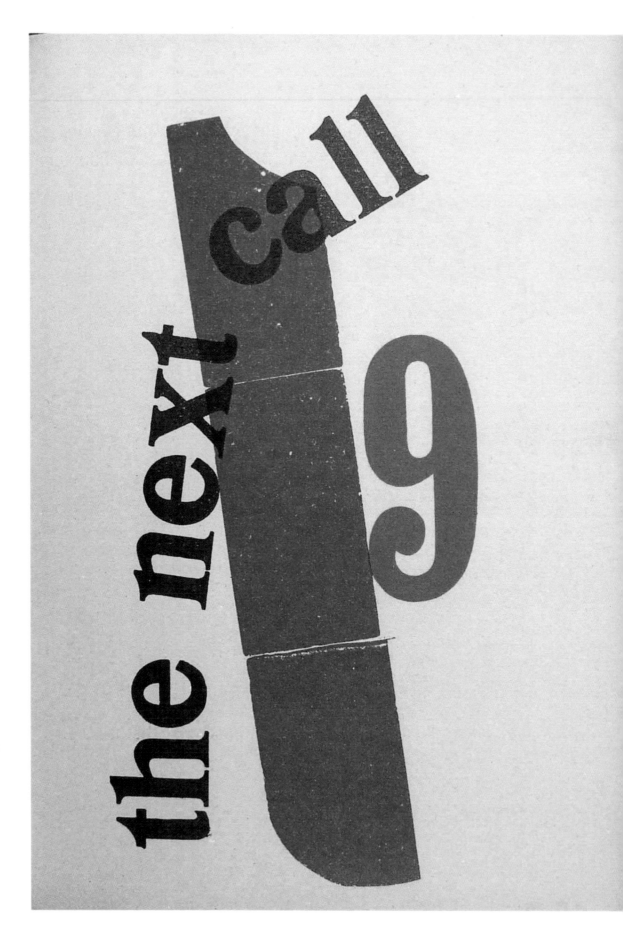

Right: *The Next Call*, begun in 1923, in Gröningen, the Netherlands. The nine issues of this magazine were a sustained challenge to conventional design, made all the more poignant by the fact that it was edited and designed by a "commercial" printer, H. N. Werkman. In 1923, influenced by the avant-garde movment, he decided to start a publication with the aim of bringing together his interests in abstract painting and commercial typography. Werkman wrote most of the text, which he generally set using sans-serif wood letters. With the whole project designed and printed in-house, Werkman maintained absolute control.

The precious status of art and the accepted mundanity of life were considered unacceptable, so the avante-garde artists set about dissolving the distinctions between the two. Using the most common medium, letterpress, for the purposes of art was, therefore, entirely appropriate. Material was typically designed to resemble the contemporary magazine, and printed in large numbers, with no pretensions, onto cheap paper. The texts, however, were often visceral. The point being emphasized was that this material was for everyone and, incidentally, it was also art.

After the Russian Revolution, the irrational came to be replaced by a more geometric, structured abstraction suggestive of functionality. This return to basic elements, to be used in a new direction, was known as constructionism. In Germany, this work was formalized between 1919 and 1934, in the workshops of the Bauhaus school, after an initial period inspired by the Arts and Crafts movement, Bauhaus director Walter Gropius embraced industrialization.

Bauhaus typography achieved a highly recognizable style built on clarity and order, particularly in the work of Moholy-Nagy, Herbert Bayer, and Max Bill. At the same time, this approach was being explored in the Netherlands by Piet Zwart, among others, in the de Stijl movement.

The modernist ideology was formulated in schools of art and design, and provided clear guidelines that quickly became the new convention. Business became international in scale, with design playing an integral part. Meanwhile, printing was being relegated to a subsidiary role.

Below left: A cover of advertising arts magazine *Gebrauchsgraphik*, 1930. The Editor, Dr. Frenzel, believed that advertising should be used intelligently because "it is the public's artform."

Below right: An ad. from *Gebrauchsgraphik*, 1930. A fascination with machines and advances in technology meant photography played an increasing role in graphic communication.

Commercial printing and commercial artists

In the years following World War I, the printing industry was acutely aware that many of its clients were employing "commercial artists." This description was often apt, since a large number of the commercial artists commissioned to provide work for advertising, magazines, books, etc., were, in fact, artists who also did "commercial" work. Since printers themselves were not trained in the visual arts, this was understandable, but it was *not* acceptable that the commercial printer was losing control of his work. Commercial artists often knew little of the printing technology (at least, this was a common printer's complaint) and were certainly unaware of the working methodology of the industry.

Art schools at this time provided a very different learning experience from that of the printer, and this might have led to considerable animosity between the two. From this period on, the term "artist," used by a printer, was usually intended as a slur on the commercial artist's or designer's character, and on their work!

Things became far worse when the "commercial" or "professional" typographer began to emerge. Generally attached to advertising or publishing companies on a freelance basis, these individuals were deeply despised because they were taking away a very significant part of the craft from the printer. Their expertise, certainly in the eyes of the printer, who had inevitably served as much as a seven-year apprenticeship, was questionable. Professional typographers, lumped with all the others judged to be encroaching upon the printer's territory, were called "artists" as a way of expressing absolute contempt for these "flashy little stylists." [2]

As the advertising agencies, publishers, and other larger companies used "nonprinters" to design and organize their printing needs, the printer regularly found him- or herself in the position of being little more than a "hod carrier" while the designer had become the "architect." [3] The independence of the typographer was established during this period by designers such as Max Bill, Paul Renner, and Jan Tschichold. These individuals, however, had little influence on the general appearance of *everyday* printed matter until after World War II. The growing political tensions across Europe were influential in causing resistance to such work crossing national borders, particularly in the UK.

The printing industry was, by now, smaller than before the turn of the twentieth century, certainly in terms of numbers employed, but increasingly efficient automation meant that the output was still increasing, and socially, print was growing in influence. In an attempt to maintain and, perhaps, even regain lost commercial ground, the printing industry was eager to promote itself as being vibrant, full of fresh ideas and new technologies, and even as having a creative, open attitude. It did this through utilizing its own medium – print.

Above: This poster, designed by Hans Leistikow, was included in the first edition of the Futura type-specimen folder. Futura was designed by Paul Renner for the Bauer Type Foundry in 1927. Renner went to great efforts to adjust the characters to make it as readable as possible. The Bauer Type Foundry did an excellent job promoting the new face.

Top right: Vincent Steer, *Printing Design and Layout*, published by Virtue & Co., London, in 1934.

Bottom right: The influence of design and its consistent application was, by the 1930s, well understood by companies trading on an international scale. The link between the power and consistency of mechanization and efficiency is repeatedly made.

Numerous books appeared on an annual basis. These were full of articles describing the merits of new print processes, new papers and boards, and inks. There were also illustrated articles concerned with advertising strategy, the design and function of layouts in explaining print ideas to clients, and even ways to make typography interesting. There was also advice on maintaining control over the end product when employing the skills of commercial artists – in other words, on how to defend the craft of printing.

This response, however, came far too late and had little effect, apart from the production of some of the most magnificent printing manuals ever produced. The "graphic designer" had officially arrived, but at the cost of the printer who, at that point, effectively lost the title of typographer.

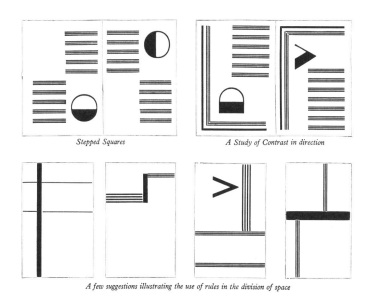

Stepped Squares *A Study of Contrast in direction*

A few suggestions illustrating the use of rules in the division of space

Right: A poster printed letterpress using rubber plates. One of the advantages of rubber plates was that they could be successfully used on paper stock with a rough surface. Unfortunately, these watercolor inks were not lightfast so they could not be used for poster work or show cards.

COLOUR SCHEMES

WITHOUT TEARS

THE EVOLUTION of colour schemes is not the sole prerogative of the creative artist. There is no reason at all why the print-buyer should not work out for himself perfectly satisfactory colour schemes, provided he has mastered certain rudiments of colour theory. It may be counter-argued "Why should the print-buyer bother to work out his own colour scheme when he will ultimately have to employ an artist to convert that abstract colour scheme into a concrete design?" This argument will come only from an artist himself, or one who has never employed artists. Every print-buyer and advertising manager has had experience of the artist who simply cannot interpret one's wishes unless expressed with detailed exactitude. Such general instructions as "something bright and cheerful," "something dignified" or "something modern" mean precisely nothing to him. There are many advertising men who are perfectly capable of designing sales literature, indicating type and illustrations with precision and an excellent sense of composition. Such men, though nothing of artists, know exactly what they want, and see a clear mental picture of the finished piece of print. It is only logical that they should visualise the colour scheme along with everything else. The super-imposition of an alien colour scheme would very likely work havoc with their conception.

SO MUCH in reply to the contention that only artists should be allowed to devise colour schemes. Now for method. Let it be acknowledged at once that the method which is about to be described is open to attack on the grounds that it is "unscientific." Admittedly, it is, but it certainly works, and it is quite scientific enough for men like Professor Munsell. Moreover, it is based on the three-primary colour theory which is fundamental to the three-colour letter-

136

137

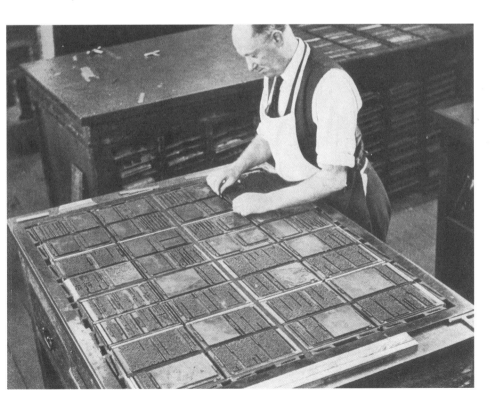

Above: A spread from *The Print User's Year Book*, vol. 1, 1934. While the potential for new kinds of work for new markets was being trumpeted, printers were still receiving a training that was type-led and rule-governed. To produce the kind of "artwork" reproduced here would require the printer to hire the services of a "commercial artist." After World War II, the graphic designer emerged and this aspect of "planning for print" was taken out of the printer's hands.

Left: A compositor making up a 32-page forme on an imposing surface, circa 1950s.

Independent publishing 3.1 Craft and control

"*Matrix* contains all the things I like to read about – if only someone would go to the trouble of doing it. Unfortunately no one does, so I have to do it myself." *John Randle*, *Whittington Press*

Right: In many ways, the Whittington Press is the archetypal British private press, housed as it is in an extended eighteenth-century gardener's cottage in the Cotswolds village of Whittington. It has a composing room, a room for the FAG proofing press and paper store and, finally, additional space for the Monotype casters and keyboard. *Matrix* **is possibly their best-known publication, appearing annually.**

Far right: *A Miscellany of Type* **compiled at the Whittington Press, published in 1990.**

Motivation

The culture of design is generally at odds with speculative methods of working. Such work is unpredictable and economically risky. To reduce the risk, most design is done in collaboration with others, including marketing and production managers, and the client. Opportunities for self-expression are limited.

A few designers have established a discernible "look" in their work. This is sometimes aided by cultural or political affiliations,[1] or by carefully cultivated associations with clients who require a less conventional approach from the designer – typically, fringe theaters, music venues, art galleries, etc. Such clients are sought because they also require a less prescribed solution.

This approach represents a degree of self-centeredness that contradicts the concept of the graphic designer as the faceless facilitator. However, in the end it affects only the appearance of the work, and although appearance does influence an audience's initial response, it plays only a supporting role. If the designer wants more control, they must also become the author.

last letter to me a...
of 1980 contained a...
es, I will try to get
omething about the
s of printing at Pig
d first asked him a
r when he was ed
vid Jones manusc
ame The Roman O

...KING WITH ERIC GILL

ext job. Very sadly
eeks after that lette
no proper records c
Pigotts and what snippet
to cull from here and th
gravatingly incomplete.
of Rene that for all his v

talk and conversation he rare
recalled his early years. He v
question readily enough and
him more. He was born in 1

His father taught at Universities in
believe, in India. At Ampleforth he w
an open classical scholarship to Orie
he was well known for his prodigiou
the part of Portia in The Merchant o
owing to the actor's illness. The C
obituary notice, records 'He gave

One of the principal differences between design and authorship is the degree to which one can deal directly with content. Typically, the author clarifies the issues and arguments. The designer is then engaged to communicate the resulting statement. In such cases, the designer is clearly at the service of the author. The author also has considerable power because of the freedom of expression the process of writing allows. While writing (and language in general) is bound by conventions to an unprecedented degree,[2] it is, paradoxically, still possible for the author to feel entirely free, unbounded by the means and the process of writing.

This is because written and oral language are rigorously taught, and constantly practiced. In contrast, visual communication is rarely touched upon between preschool and graduate-level education. For this reason visual communication, to work efficiently, generally requires clarity rather than complexity. Uniqueness slows down the communication process. For the most part, therefore, design is normally required to be conventional, unless the designer is also willing to become the publisher.

The process of design has, to a large degree, been protected from the outside world. There are advantages in maintaining a certain amount of secrecy in any profession, but the danger is that the profession can appear to be disconnected from the implications of its work. It might be just my imagination, but isn't graphic design often the profession chosen by writers for characters who are immature, self-obsessed, and/or socially inept?

For those frustrated by the idea of graphic design being simply a service profession,[3] independent publishing offers the opportunity to explore ideas rather than just reacting to other people's. The sense of engagement that publishing provides is the major incentive for independent publishing.

Left: Cover design for Peter Koch's *Parmenides,* **translated by Robert Bringhurst, using a newly commissioned typeface, Diogenes, by Christopher Stinehour.**

Above right: *Herakleitos* **in Greek, right, with an English translation by Guy Davenport, left.**

Below right: Peter Koch, *Diogenes Defictions,* **1994. Illustrated is the "cardboard" edition.**

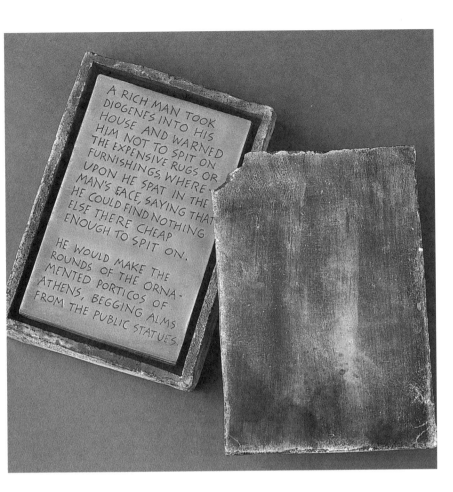

They said to the wolf, 'For what art thou following these poor little sheep?' He replied, 'The dust they raise is good for poor little eyes.'

While his nose looks to heaven his legs are in the water
He caused the bird to fly away and then went running after it.
There are no fans in Hell.
Like a storm in the shop of a glass dealer.

A heart free from care is better than a full purse. Love is the companion of blindness. A blow from a lover is as sweet as the eating of raisins.

Loose me from pillar to pillar, perchance it may bring freedom.
Like the laughter of a nut between two stones.
Take me by the hand today, I will take thee by the foot tomorrow.
Entertain the Bedouin and he will steal thy clothes.
Strike the innocent that the guilty may confess.
I asked him about his father. 'My Uncle's name is Shugh,' he answered.

You are like the bear, neither to be milked, led in the procession, nor ridden.
A tyrannical sultan is preferable to constant quarrelling.
Govern the rabble by opposing them.
He is going to do his pilgrimage in a dog's journey.
Weapons ready and good sense absent.
The tithe of his own camp does not rejoice.

Take a piece of mud, strike it against the wall; if it does not stick, it will leave its mark. Rub a loaf with a loaf, no doubt of the crumbs appearing.

The worms of the vinegar come from the vinegar.
A ready blow with cash is better than eighty-thousand dirhams of promised future payments.
He is like a dry reed which seeks the company of the fire.
Rather endure the flatulencies of the camel than the prayers of the fishes.
A fraud is not perfect unless it be practised on clever and cunning persons.
In proportion to the length of thy garment stretch out thy legs.

Na thyng is so good as to lyue iustly and at lyberte, for fredome and lyberte is better than ony gold or syluer, wherof Esope recerceth to vs suche a fable. There were frogges whiche were in dyches and pondes at theyr lyberte; they alle to gyder of one assente and grete drede and ferd moche. And after they approched to theyr kyng for to make obeyssaunce vnto hym. And whanne they perceyued that hit was but a pyece of wood, they torned agayne to Jupiter prayenge hym swetely that he wold gyue to them another

of one wylle maade a request to Jupiter that he wold gyue them a kynge. And Jupiter beganne therof to mecuylle. And for theyr kyng he casted to them a grete pyece of wood, whiche maade a grete soune and noyse in the water, wherof alle the frogges had

kynge. And Jupiter gaf to them the Heron for to be theyr kynge. And thenne the Heron beganne to entre in to the water, and ete them one after other. And whanne the frogges sawe that theyr kyng destroyed and ete them thus, they beganne tendyrly to wepe

A noir blanc I rouge
U vert O bleu: voyelles,
Je dirai quelque jour vos naissances latentes:
A noir corset velu des mouches éclatantes
Qui bombinent autour des puanteurs cruelles,
Golfes d'ombre;

candeurs
des vapeurs et des tentes;
Lances des glaciers fiers, rois blancs,
frissons d'ombelles;

I pourpres, sang craché, rire des lèvres belles
Dans la colère ou les ivresses pénitentes;
U cycles, vibrements divins
des mers virides,
Paix des pâtis semés d'animaux, paix des rides
Que l'alchimie imprime
au grands fronts studieux;
O Suprême Clairon
plein des strideurs étranges,
Silences traversés des Mondes et des Anges:
O l'Oméga,
rayon violet de Ses Yeux!

QUIS DESIDERIO...?

LIKE MR. WILKIE COLLINS, I, too, have been
asked to lay some of my literary experiences
before the readers of the *Universal Review*. It
occurred to me that the *Review* must be indeed
universal before it could open its pages to one
so obscure as myself; but, nothing daunted by
the distinguished company among which I was
for the first time asked to move, I resolved to
do as I was told, & went to the British Museum
to see what books I had written. Having re-
freshed my memory by a glance at the catalogue,
I was about to try and diminish the large and
ever-increasing circle of my non-readers when
I became aware of a calamity that brought me
to a standstill, and indeed bids fair, so far as I
can see at present, to put an end to my literary
existence altogether.

Far left: One of the oldest and most
revered of the contemporary British
private presses is the Rampant
Lions Press, based in Cambridge.
Currently run by Sebastian Carter,
this press was founded by
Will Carter and produced its first
book in 1934. Sebastian joined his
father in the 1960s and the press
now specializes in fine editions.
A Printer's Dozen is, in fact, 11
spreads from unrealized books
designed and printed by
Sebastian Carter.

Left and above: The Libanus Press,
Quis Desiderio..?, with engravings
by Phillida Gili, 1987. This press
is run by Michael Mitchell in
Marlborough, England. This book
is described as "The author muses
on authorship and looks and
compares the loss of a favorite
book in the British Museum to
the loss described by William
Wordsworth in his poem, *Lucy*."

40 texts, many newly translated,
from the Russian by Paul Schmidt

VELIMIR

KHLEBNIKOV

FUTURIST &
ZAUM POEMS

typographical designs, composing
by hand, printing from metal types,
and engravings by Michael Caine

I **see** right through you, Numbers.

I see you in the **skins of animals,** ⊖‡≶‡

coolly p r o p p e*d against uprooted oaks.*

YOU offer **us** a **gift**⊂⊃ unity betw**en**

th*E* snakey MoVeMeNT ⬧⬡‡⬦⬧⩾⬧‡⬦⬧⬧

of the **backbone of** the **universe** a N D

TH E **DIPPE** R **DANCIN** G **overh**e a**d.**

You help **us to** s**ee** *centuries as a FLASH*

of laughing t⓪e⫫⅃. See my wisdom-**wide**

▮▮▮⫶▮▮▮⫶⫶▮⫶▮▮▮N E D *EYES.*

Recognise W*b*AT I w**I**LL B*E*

when **I**ts *divid*end **I**ṣ *ONE.* ✳✳✳

JOUR DE SAINT-VALENTIN

WYSTAN HUGH AUDEN

LULLABY
══
BERCEUSE

A keepsake from Michael Caine
decorated with two original prints

EDITIONS PAYROPOLIS PARIS 1998

❋ ❋ ❋ ❋ ❋

Étends ta tête endormie, mon amour,
Tendre sur mon bras félon ;
Le temps et les fièvres
Confisquent leur beauté

Lay your sleeping head, my love, *Aux enfants graves, et la tombe*
Human on my faithless arm; *Scelle leur court passage ;*
Time and fevers burn away *Mais que dans mes bras jusqu'au point du jour*
Individual beauty from *Repose cette vie*
Thoughtful children, and the grave *Mortelle, coupable, mais pour moi*
Proves the child ephemeral: *La beauté même.*
But in my arms till break of day
Let the living creature lie,
Mortal, guilty, but to me
The entirely beautiful.

L'âme et le corps n'ont pas de bornes :
Aux amoureux, qui se couchent
En sa douce descente, enchantée,
Dans leur frisson familier,

Soul and body have no bounds: *Profond est le message qu'envoie Vénus :*
To lovers as they lie upon *De sympathie surnaturelle,*
Her tolerant enchanted slope *D'amour universel et d'espoir ;*
In their ordinary swoon, *Alors une intuition éveille*
Grave the vision Venus sends *Au cœur des glaciers et des rocs*
Of supernatural sympathy, *L'extase charnelle de l'ermite.*
Universal love and hope;
While an abstract insight wakes
Among the glaciers and the rocks
The hermit's sensual ecstasy.

Certainty, fidelity
On the stroke of midnight pass
Like vibrations of a bell;
And fashionable madmen raise
Their pedantic boring cry:
Every farthing of the cost,
All the dreaded cards foretell,
Shall be paid, but from this night
Not a whisper, not a thought,
Not a kiss nor look be lost.

Certitude, fidélité
Sur le coup de minuit s'envolent
Comme battements de cloche
Et de pédants bouffons
Lancent leur litanie :
Jusqu'au dernier centime,
Toutes les cartes redoutées le disent,
Le prix sera payé, mais dès ce soir
Pas un soupir, pas une pensée,
Pas un baiser ni un regard ne doit être perdu.

Beauty, midnight, vision dies:
Let the winds of dawn that blow
Softly round your dreaming head
Such a day of sweetness show
Eye and knocking heart may bless,
Find the mortal world enough;
Noons of dryness see you fed
By the involuntary powers,
Nights of insult let you pass
Watched by every human love.

c. 60 Chambord Gras

SCHAM BORED

c. 72 Giraldon Gras

GIRA LDON

c. 60 Nicolas Cochin

COCHIN

c. 72 Cyrillique bois

ЄРБВЩЮЦИФ КНЕХГЫОЈШ ДУЄЊПЄЙЖТ СЛАМЯЧ

c. 168 Runic condensé

RUNIC

Above left: Michael Caine, *Futurist and Zaum Poems*. A series of broadsheets based on the futurist texts of Velimir Khlebnikov, translated by Paul Schmidt.

Below left: Michael Caine, *Lullaby Berceuse*, written by Auden.

Above: *Caractères Typographiques*. One of a series of type-specimen sheets displaying often rare examples of type found by Caine in and around Paris.

The Typography Workshop offers intensive short courses
conceived to enable art directors
 graphic designers
 artists
 & printmakers
to work with letterpress materials and printing equipment

Each workshop consists of five Mondays
10am to 5.30pm

During the summer, courses are held
throughout the months of July and August.
Monday to Friday inclusive.

*At the conclusion of each course one of the following
will be invited to discuss the work:*

Dennis Bailey RDI, Bailey & Kenny, London
Phil Baines, London
Derek Birdsall RDI, Omnific Studios, London
Ken Campbell, London
Matthew Carter RDI, Carter & Cone Type Inc., USA
Peter Davenport, Davenport Associates, London
Ivan Dodd, London
David Ellis, Why Not Associates, London
Richard Hollis, London
Terry Jones AGI, ID magazine, London
James Mosley, St Brides Printing Library, London
John Rushworth AGI, Pentagram, London
Harri Peccinotti AGI, Paris
Philip Thompson, London

KING'S CROSS
ST PANCRAS

BOWLING GREEN LN.

Unit 313
31 Clerkenwell Close
London EC1R 0AT
Telephone 0171
490 4386
Facsimile 0171
490 0063

CLERK ENWELL CLOSE

FARRINGDON RD.

HOLBORN

CLERKENWELL

GREEN

CLERKENWELL RD.

FARRINGDON

Circle line
Hammersmith & City line
Metropolitan line
Thameslink (BR)

St John's Gate

Smithfield Market

St Bartholomew's
Hospital

Curriculum

Method and organisation of work
 workshop limitations: letterpress
 workshop organisation and rules
 bibliography and literature advice

Basic elements and tools in hand setting practice
 printing types
 word spacing material
 leading material
 furniture
 rule material
 typographic signs

Dimensional systems
 non-standardised systems
 standardised systems in relation to development in industry
 point system
 standard line

Workshop work
 type cases
 lay of cap and lower case
 lay of doubles case
 space and leading cases
 rule cases
 special requirements for setting
 methods of setting

Method of proofing
 tying up
 imposition
 cleaning materials
 introduction to proofing press
 make-ready possibilities

Corrections
 standard corrections
 corrections in the metal

Presses with flat surface and flat printing surface
 development
 lever joint (albion etc)
 platens: movement
 clamshell
 parallel movement

Presses with flat forme and cylindrical platen
 development

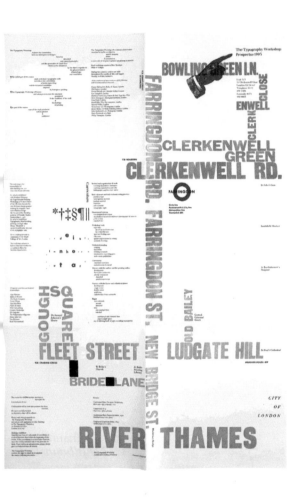

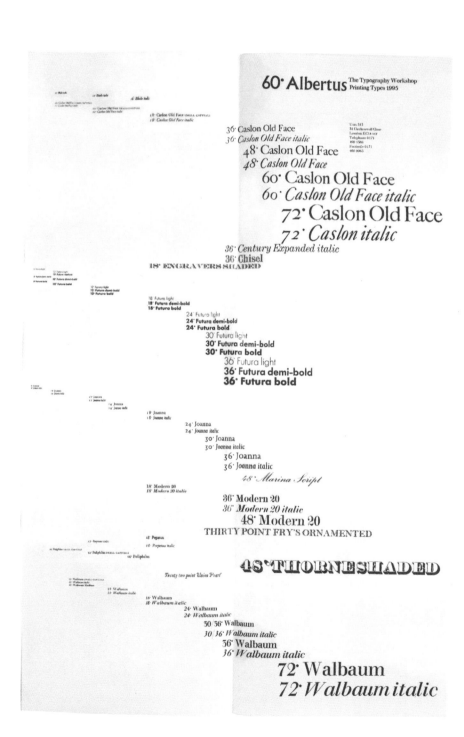

All images: The prospectus for Alan Kitching's typography workshops. Since he completed his six-year apprenticeship as a compositor, in the 1950s, Kitching has seen letterpress change from being the standard to being an "archaic" activity, a transition that has liberated the way letterpress is used. Kitching can encourage his students to explore whatever aspects of the medium are of particular to interest them.

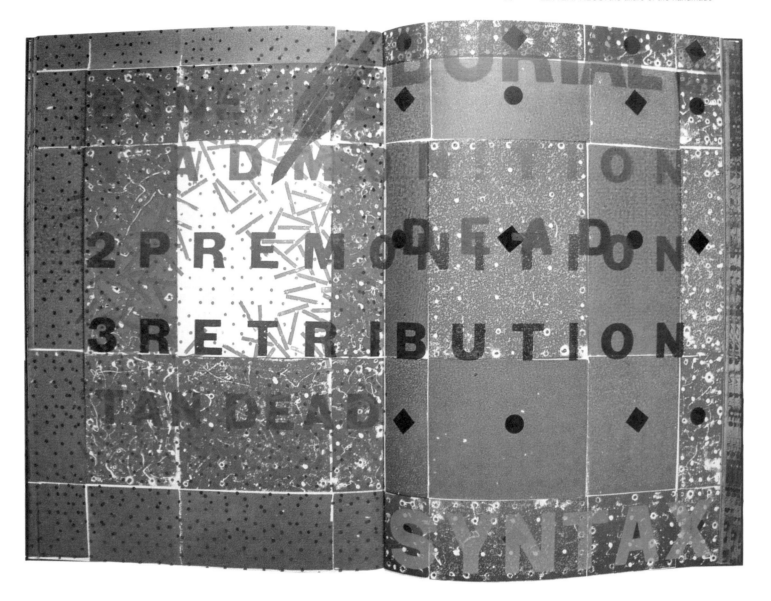

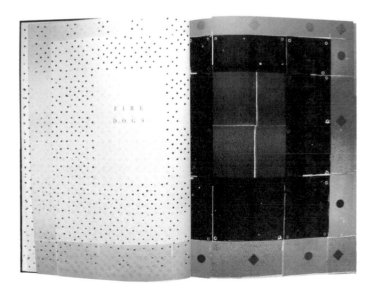

All images: Ken Campbell, *Fire Dogs*, 1991. Multicolor letterpress employing handworked zinc plates, type-high nails, and sandpaper with interspersed text. The type is Monotype Spartan, Stephenson Blake Bodoni, and various wood letters. The text includes brief Biblical quotations and six poems by Campbell. *Fire Dogs* was started during the first Gulf War.

Individuality

There has been a deluge of designer monographs recently, along with books that celebrate individual designers within a company or organization. In effect, these companies are acting as the author *and* designer, although they tend to restrict their subject matter to graphic communication. This is not a new phenomenon: Pentagram have been publishing their "little black books" – an idiosyncratic series of booklets reflecting individual designer's interests – since the 1960s. These are all the more interesting because they are not always related directly to matters of design.

A small number of individual graphic designers have also become very influential publishers; Lars Müller (Switzerland), Rudy VanderLans (US), and Robin Kinross (UK) spring to mind. But few graphic designers have gone that one step further and become the printer as well. Not surprisingly, the few who have broken down *all* the barriers between the various activities required in the making of books and other printed matter are the individuals who have the best opportunities to push the potential of what print is capable of achieving. A few aim to do exactly that.

In the meantime, there is a long tradition of artists making books by taking on all these roles: from the avant-gardists through to Fluxus, the experimental publishing movement of the 1960s and 1970s. It should be noted that some of this work will have been done by people who are graphic designers, but books which are entirely self-generated tend to be grouped under the generic term "artist's books." Designing is commonly defined as "planning"; following this, graphic designers plan for print. Artists commonly control the whole process, from concept to printed object.[4]

Another group, in many ways very similar to the book artists, is the private presses (though I suspect that in each group there are many people who would adamantly deny this). The private presses (often also referred to as "fine" presses) generally place a great deal of emphasis upon the quality of their printing, which is often of the highest standard. The content of their books, certainly in the US and UK, tends to focus on the history and craft of printing. Their methods are traditional, as are the materials and processes they employ. Unlike the artist's books, the fine-press book tends to be rather unassuming in character, but again, not exclusively so.

Exponents of both genres include an eclectic mix. All explore the nature of publishing, examining both its production processes and, on occasion, new aspects of dialogue and narrative to meet the needs of very specific texts. While this may be the purest form of "graphic" authorship, it always surprises me how few graphic designers there are working in this field. This may simply be due to the lack of opportunity, or to the perceived "amateur" aspects of the genres themselves. This is a problem that graphic designers must address, for there is nothing in terms of production values, typographic expertise, or sheer invention that is questionable (although one does not often get all three of these essential aspects at the appropriate standard in the same completed project).

Below left: In many ways, Alan Tarling's Poet & Printer Press is the purest form of private-press work. These small booklets are entirely without presumption, printed with care but without any notion of "saving the craft from oblivion." You know that these booklets exist to preserve the words, not the print.

Right: Uta Schneider and Ulrike Stoltz at Unica T, *Shake A Speer*. This book confronts four sonnets by William Shakespeare with additional texts from anonymous sources, such as love potions, and a newspaper report on marketing aborted human embryos for cosmetic purposes, 1987/1988.

Below right: Uta Schneider and Ulrike Stoltz at Unica T, *Das Linienbuch*. The concept was to allow a line to proceed from a dot, have it joined by other lines to expand, then gradually open and dissolve to end as sparingly as it began. The intention was that this work should and could be read as a musical score.

enorme
männl.
Ausstrahlung
naturverb.
Geschäftsführer
zärtl.
ritterlich
Schütze
Hausmann
sicheres Auftreten
wirkl. nett
sportl.-musisch
sehr charmant
eleg.
souverän
in gesich. Position
dkl. Typ
sehr hoh. Einkommen
kultiviert

**also das wachs zerfleuzzet bei dem für, und als daz für glüwet, also müzze
ir herze, ir plut, ir leber, ir miltze und ellen ir lider erhaizzen** und
prinnen und zefliezzen umbe min minne, und müg weder slaffen noch wachen
— sie gedench an mich.

gute Existenz Vorst...

vital
viel Format & Niveau

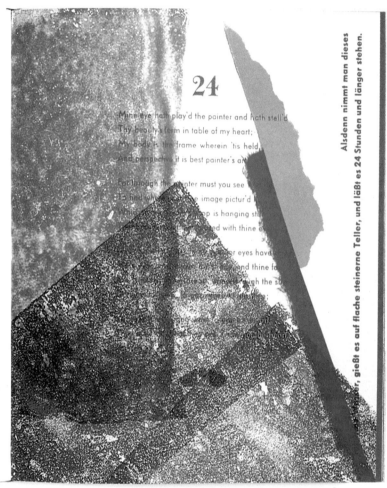

24

Mine eye hath play'd the painter and hath stell'd
Thy beauty's form in table of my heart;
My body is the frame wherein 'tis held,
And perspective it is best painter's art.

For through the painter must you see his skill,
To find where your true image pictur'd lies,
Which in my bosom's shop is hanging still,
That hath his windows glazed with thine eyes.

Now see what good turns eyes for eyes have done:
Mine eyes have drawn thy shape, and thine for me
Are windows to my breast, where-through the sun
Delights to peep, to gaze therein on thee;

Alsdenn nimmt man dieses ..., gießt es auf flache steinerne Teller, und läßt es 24 Stunden und länger stehen.

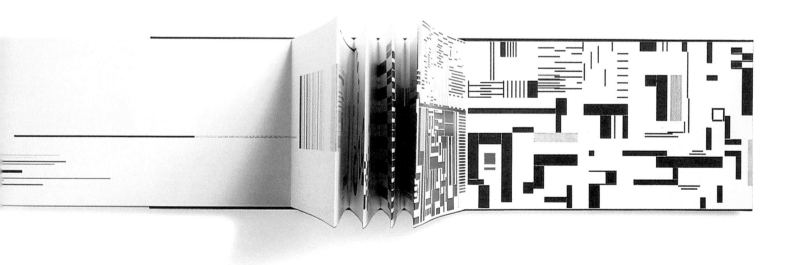

Anansi

Well. Om dedly worrid an upshet.
Om ded ungry forabitta fresh.
Om thinkin.

An om in ope agen. Eshpither swiminin
ole with Shiger.
Shiger keepish shtripeson, takeallish inshide
tripeshout. Ded big steamin eap. Loada fresh.
Big kyat shwiminin shlopinin, lighter shomuch.
Eshpither shtayinout.

Om eatinish tripesh.

Wheedlin off, eavy. Monkeysh doneit,
shinginin all roundaboutit.

Me life book ish gon be call 'Anansi, Man and Spider'.
-- Parrot's ghost-writing it, all
in proper words. He would, wouldn't he?
Expecting a big advance, Parrot is. I've
had that already; got a wheeze for having his
royalties too. World rights. He can
do all the TV bits.

Time come I shpin up over. Do me Yabbit mutter, me
big Shikkenawk mutter anall.

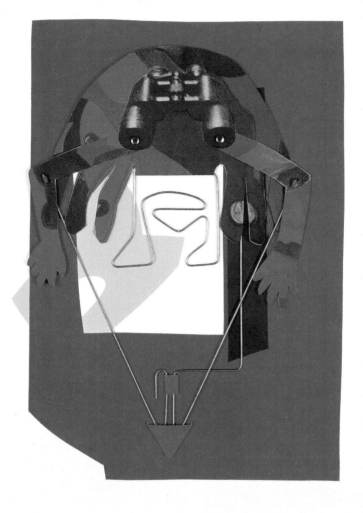

Above and right: *Anansi Company*,
published by Circle Press, consists of
13 screen-printed, removable wire-
and-card puppets. The text was
printed letterpress using 14pt
and 18pt Walbaum.

Far right: *Cooking the Books*, Yale
Center for British Art, 2002. Pages
were printed and then dipped in
warm wax.

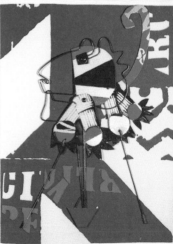

[Independent publishing] **3.2 Craft and commerce**

Right: Four small booklets published by Curwen Press, Plaistow, UK, under the general title, *The Ariel Poems*.

Far right, top: *Fleischman* 12pt (D) roman (number 65) and italic (number 66).

Far right, bottom: *Typefoundries in the Netherlands*, published in 1978, is arguably De Does' greatest typographic achievement. It was the last book produced completely by letterpress at the Enschedé printing house.

Control

Why should the designer, or the artist, also become the printer? In practice, the designer (or artist) hopes that the workmanship of the printer will be good, but, of course, it is the commercial printer who decides whether it will be good or not. Inevitably, all jobs are much the same to the commercial printer.

Any business runs effectively if each job has a relatively similar outcome. Asking even for slight adjustments will quickly sap the printer's patience because they will inevitably be time-consuming, making the job less profitable. Even printers whose enthusiasm for their craft is still strong enough for them to work on more "demanding" projects cannot allow presses and workers to stand idle while the designer ponders choice of paper and hue of ink. No situation illustrates better why being your own printer is an advantage, both creatively and practically. Independence is freedom from the vagaries of other people's priorities.

Clearly, printing one's own work has advantages, but why letterpress printing in particular? First of all, letterpress technology is simple and purely mechanical. Maintenance is very low-tech and largely a matter of common sense. Meanwhile, the technology of lithographic printing has evolved radically over the past 20 years so that it now embraces computer technology at every level. The industrial scale of production, and the resulting lack of adaptability, have made this medium not only exorbitantly expensive, but also inappropriate to the exploratory nature of the individual publisher.

But the reason for the popularity of letterpress is that it offers control; it is an empowering experience. When the printed sheet comes off the press it should look exactly the way you want it to look. Yet, try as you might, the next sheet will not be an exact replica. The letterforms, color, and texture may be precise, but the process remains in flux – frighteningly so at times.

ABCDEFGHIJKLMNOPQRSTUVW
XYZ&ÆŒÄÇÉÈÊËÓÖÜŁŚŢŤŽŹIJ
abcdefghijklmnopqrstuvwxyzijſ
æœctfbﬀﬁﬂﬃﬄﬅﬆ ß ﬃ ﬄ
áàâäãąćčçéèêëęíìîïītńñóòôöõŏǫ
úùûüũŭşţźż
.,;:!?*-—()[]/§†❄1234567890
ABCDEFGHIJKLMNOPQRSTUVWXYZ
ÆŒÄÉÈÊËÖÜ

ABCDEFGHIJKLMNOPQRSTUVW
XYZ&⅋⅌⅍ÆŒÄÇÉÈÊËÖÜIJ
ABCDJMNPQR
abcdefghijklmnopqrstuvwxyzhvwijſ
æœctﬀﬁﬂﬃﬄﬅﬆ ß ﬃ ﬄ
áàâäãçèêëēȩłìîïītñóòôöṍq̀ĝ́úùûü
.,;:!?-()[]*

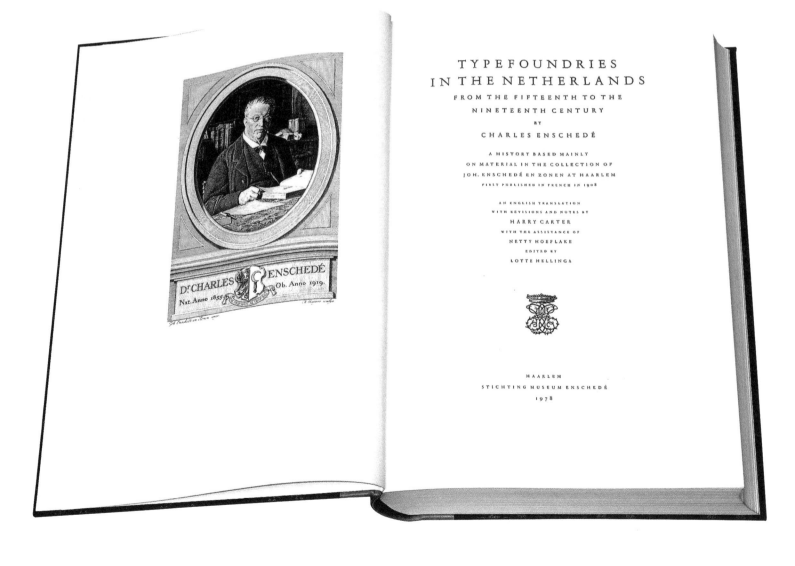

Allen

Madrid

The bull fight
The Gong Nightclub
Spanish beauty competitors

getting up before ... drome before te... Beau Nash but from ... various platitudes ab... mountains, 'You reali... understand that, don't ... versation with a French... his meaning by saying th... words, he would start ta... instance, he watching the bu... to our curious mechanic ... into the ring, eh, and the ti... side eh,' or, 'Now we go hom... drink, eh, one glass beer each e... The 'eh' at the end of each ph... with a nasal emphasis to make i... stood by a Frenchman. Perhaps ... habit was saying, 'Nice girl, eh,' ... eh,' and stopping and looking at ... seen anyone make such a comple... fool of himself over girls as Allen di...

The first night in Madrid *he ... at he wanted to go to bed with a ... decided, since he had, as usual, ... where, taking part in a Spanish be... more, and more discreetly r... sidling slowly from girl to girl ... ed a waiter and said 'You ... eh, that corner, eh she ... eh, tell her come here ... with acceptance, eh.' The ... t, Allen continued to repe... pressing barmen ... mity, but also he child... ance. When he should re... shear that I want t... ago but the ...*

Allen

Madrid
Saville

Mayday riots

...and (illegible).

...**ille**, I having slept some of the ...**...**ediately surrounded by olive ...**...echanics** in blue dungarees, not ...**...** caps like Scotch soldiers. I demanded ...**...**d speak French and before I had fin-...**...**ing stepped forward eagerly a long-...**...**ve-green, soft complexioned boy with long, ...**...**wn hair, trying to push his cap off. He fixed ...**...** huge green eyes and asked me to go with him ...**...** the weather report. He talked and talked and we ...**...**ed in the wide corridor of a wireless building in ...**...**orish style, with an operator visible through an ...**...**en door on one side tapping morse which flashed ...**...**nd buzzed on a valve board which was visible ...**...** through a doorway on the other side of the corridor.

... Here he stood, staring hard into my eyes, smiling ... slightly, telling me about his French mother, his Ger- ...**ude** man father and when there was silence he seemed to ...**ough** be still talking... he stared so with his light smile...the ...**stru-** corridor was white and the sun was smiling on bluey- ...**mother** white buildings outside, and on orange trees, and the ...**d talking** instruments were shiny and clean. Allen, blast him, ...**seemed to** came back to my mind, I imagined him pissing against ...**d; I cursed** the clean white walls of the freshly painted buildings, ...**shly painted** spitting onto freshly raked gravel and saying to some- ...**freshly raked** one who I hoped would not be listening 'orange trees ...**hoped wouldn't** eh, very good eh, they not yet ripe eh, not so good eh?' ...**y good, eh?, they** If there is a shower say its raining, if it is hot say its ...**h'. – If there is a** hot eh, if it is a long way say its far eh, if there is a wind ...**say it's hot eh?, if it** say it blows, eh, or if a mist say its misty eh. But don't ...**there is a wind say it** miss a good natured comment, it can't fail to transmit ...**say it's misty eh?. But** a feeling of get-together, and you never know what ...**ment, no matter** getting together may bring; possibly a drink, a free lift ...**a** in a car, a girl in the evening or anyway a fresh one to ...**So back we went with our weather report, ...** as slowly as we could.

Friday 3rd Madrid
taxi to drome 16pta
pension bill Thursday
night 40pta
tips at Seville 10pta
(Arrive Tangiers.)
taxi from drome 50fr
telegram (Allen) 40fr
telegrams 55fr
payment on traveller
cheques 15fr
drinks 20fr
evening 150fr

All images: *Morocco*, David Jury, published by Foxash Press, 2004, UK. Underappreciated until quite recently, Humphrey Spender's photographic contribution to the history of the modern social documentary has quietly grown in stature. His most significant work was done in the 10 years from 1932 to 1942 and took off with his work for Mass Observation. However, in 1934, while on the payroll of the *Daily Mirror*, Spender was sent to Morocco on an open-ended mission, the results of which were never published. Luckily, he also kept a diary which he rewrote on his return. This book reproduces a number of the photographs taken and *both* versions of the diary. (The second version was a "clean" version.) The texts run parallel to allow direct comparisons.

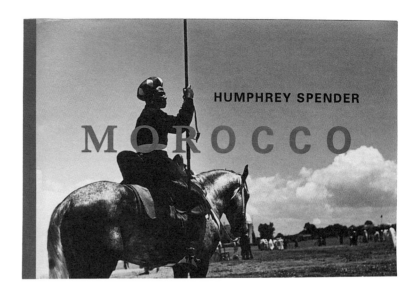

HUMPHREY SPENDER

MOROCCO

Technologies

I always find entering a large commercial printing company an exciting experience. The lithographic, computer-driven, rotary, 10-color, perfecting, folding, perforating and trimming, and collating machines, as large as a generously proportioned house, cannot help but inspire awe in the visitor. Their intricacy, physical mass, and effortless power seem to sum up everything that is good about human ingenuity and technical endeavor.

It would be easy to argue that what makes letterpress distinct from mass-production digital technology is that the latter has become so predictable. But, of course, it is not the technology itself that is predictable, but the way it is used. Limitations are self-imposed and justified by the need for standardized working methods in order to optimize expediency and make a profit. With the advent of lithography in 1798, its supporters criticized letterpress for having the same drawback. Today, an argument in favor of supporting letterpress is its potential to provide variety and an unexpected diversity of form and texture – precisely that used by supporters of lithography in the early nineteenth century. Almost any process can provide a surprising amount of flexibility if the person using it has the inclination and the time to explore its potential.

Letterpress equipment is so readily available because the ever-evolving print industry has valued it as useless. The kind of handpresses commonly used today were cutting-edge technology in 1830, but already superseded by 1860. Rejection by the industry is now very much a part of the kudos that surrounds these beautifully made tools and presses. They were built to last because they were conceived to be the workhorses of powerful industry. Letterpress users today generally ignore the fact that these presses were not designed for the kind of work their new owners aspire to, but to fulfill a more mercenary attitude to work that had consciously contrived to bring about the very conditions today's users deplore.

Today's handprinters describe their aim as recovering the right to realize, by their own skills, printed matter of precision and substance. Mastering the equipment is the easy part – knowing what to do with it, and why, is far more important, and generally more difficult. But difficult is good. Without addressing these prepress fundamentals – motivation and design – both the process and the result will be no more than a pretence.

Below: John and Orna Designs, cover of the catalog for an exhibition called Woven Image: contemporary British tapestry (London, 1996).

Right: John and Orna Designs, cover of the catalog for an exhibition called Richard Tuttle, Grey Walls Work (London, 1996). The number of colors was minimized in order to invest in die-cutting using adapted letterpress equipment.

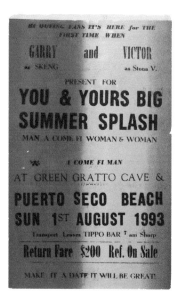

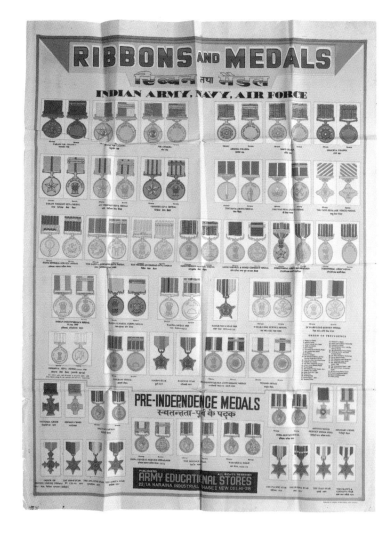

All Massive!! ALL Crew Hear This WHEN

K.C.G. Promotion Fr. New York IN ASSOC. WITH

HURDEL, GIDEON, DONNA, CILVE

as BLACKS as STIFFY The Typist as Stitchie

present a night called KILL DEM ALL

& COME BACK ALONE

At: CIRCLE B FARM Road Side Dist.

ST. ANN

On: Saturday 23rd January, 1993

FEATURING:

BASS ODYSSEY

St. Ann Champion Sound HI-POWER

With Thinner 1, Pat, Bugs & CREW

V/S METRO-MEDIA

THE YEAR TO YEAR SOUND HI POWER
WITH SKY JUICE, WEBBER & CREW
FIRST 10 LADIES FREE LIVE VIDEO

ADM. $40 TAPE MAN $50

Ref- On Sale SECURITY TIGHT, Be There

Top, far left: Molynes Multi Printing Co., Jamaica.

Top, center and right: The front and back of a poster which has clearly been printed onto the "back" of spoils from a previous job. From the Tim Lewis collection.

Bottom, far left: A traditional Indian example of print and, in particular, handmade paper, a craft reputed to have been practiced in India since 300 BC. This example was printed by Vakil & Sons Private Ltd from blocks. The design is by Vinod Pithadiya.

Bottom left: A broadsheet published by the Army Educational Stores, New Delhi, and printed using rubber plates and metal type at the Gemini Press, New Delhi.

Left: Poster, roughly A3 (c. 11¾ x 16½in) in size, from the Molynes Multi Printing Co., Jamaica. The vibrancy is joyful both to read and to look at.

...CASTIN
CUTTING
ESQUES A
OWERS ON
BODIES, SO
PRINTER CO
HANDLE TH
AS IF THEY W
RE CAST LET
ER FORMS.

EARLY TRANSITIONAL
Fournier

Both images: *Early Transitional*
is one of a series of personal type
specimens from the typographic
workshop of Kelvyn Smith.

Content

The slowness of the handicraft process, and particularly the high cost of the materials and binding, tend to dictate that the prices the fine presses ask for their books are high. This simple fact is the major reason for the general public's perception of fine presses as being elitist. Once such an impression has been established, it is then easy for critics to add "out of touch and largely irrelevant."

The fine presses are particularly prone to this criticism. However, in mainland Europe a preponderance of independent presses, often described as "printer-artists," avoid high costs precisely because they want their work to be bought and read by the widest possible audience. This egalitarian approach can often be seen in the way the text and images are utilized. Type (often unconventionally set) and image (often woodcuts) tend to be integrated. In Germany, where such work predominates, this is called *wortbilder* (word pictures). The texts are likely to be contemporary poetry or the printer-artist's own words. Nonfiction books of bibliophile interest (for example, typography, printing history, or press bibliographies), which feature so prominently in the output of most UK and North American presses, are rare in Germany.

The bindings show a similar difference in style and approach. Most German handpresses do their own binding as part of a whole book concept. Fine-press publishers commission their illustrative work from recognized exponents; the most popular are wood engravings, but they might be in any medium. Similarly, fine-press books are sent out to be finished by professional binders, who usually bind them in the traditional manner, with leather or half-linen covers and marbled or patterned endpapers.

In the UK and the US, many presses have tackled content by making it relevant to the interests of those people who are also interested in fine printing. These are *commercial* undertakings and their creators know what they can sell.

Above: Despite Germany's great typographical heritage, many of the contemporary letterpress printers generally place the emphasis on *what* is being communicated and *why*, rather than *how*. The nature of the grain and knot in the wood is echoed in the quality of line employed by Wilfried Bohne in this woodcut.

Right: Eric Ravillious, wood engraving, Double Crown Club menu, 1935. (St. Bride Printing Library.) Eric was able to make decoration something substantial and intelligent as well as beautiful when, at the height of modernist idealism, decoration was distinctly out of favor.

Left: For two years, Schneider and Stoltz (Unica T) worked on interpretations of readings sponsored by the Deutsche Akademie für Sprache und Dichtung Darmstadt. Every month the academy organizes a reading for authors. Each of the first 12 issues (November 1986–October 1987) consisted of nine folded sheets (36 pages) housed in an envelope. Texts were always hand-set, sometimes with additional techniques for the images. This spread, *Meiner Mutter* (To my Mother), is by Eva Zeller. It uses hand-set type, photocopying, stitching (with a sewing machine), and a footprint.

Below: In the second year, November 1987–May 1988, Schneider and Stoltz experimented with the legibility of text, dissolving linear structures in favor of a more pictorial approach, combining letterpress and photocopies. Each issue during the second year consisted of seven sheets. This spread, *Odenthals Küste,* is by Jürgen Becker. It uses hand-set type, printed onto transparent foil, then crumpled and photocopied with two-color letterpress printed onto the photocopy.

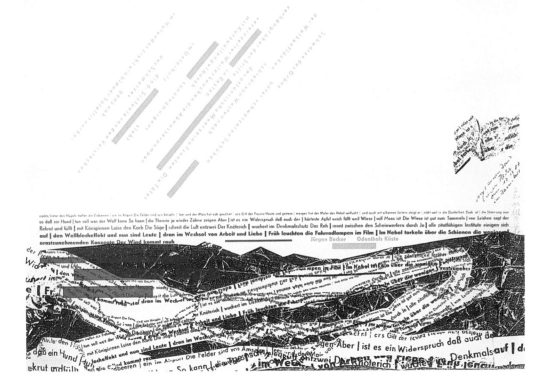

Above and right: johnson turnbull is a London-based design consultancy. Their interest in letterpress extends to having wood and metal type on the premises as well as a small press which they utilize whenever appropriate. This often means artwork is produced by pulling a print on the proofing press and then scanning it to form a digital document. The two items illustrated are the cover of a self-promotional book and their individually numbered stationery range.

johnson **turnbull**

STUDIO 22 PENNYBANK CHAMBERS 33-35 ST JOHN'S SQUARE LONDON EC1M 4DS
T 020 7608 3324 | F 020 7490 8716 | studio@johnsonturnbull.co.uk | www.johnsonturnbull.co.uk

N° 00388

Letterpress printed in an edition of 1000

We must always remind ourselves this: philosophy is an art form, a literary genre like poetry and fiction. The philosopher moves his concepts around on the page, just like the novelist manipulates his characters, he's certainly not producing science. But everything indicates that it is an art form in deplorable decline.

In a 21st century obsessed with utility, philosophy seems to be permanently confined to the dusty corridors of academia, where a handful of pale nerds spend their days tirelessly twisting and turning technicalities inherited from Hegel or Kant. And nobody in the outside world cares one iota. From a creative point of view, the art of philosophy seems dead.

But academia is hardly the right place to look for literary creativity; philosophy is actually doing just fine under various guises in the most surprising places. Remember that whenever we step outside the confines of our regular world view and start to question ourselves and our habitual perceptions of things, we instantly start doing philosophy. We establish a meta level, we think about thinking in a language about language.

Consequently, philosophy can, properly understood, capture the attention of a huge audience. It just isn't marketed very well at present. That could change quickly, however. We just need to remove three major misconceptions.

1. Philosophy is not an academic discipline. To take a professor of philosophy for a philosopher proper would be like regarding a professor of literature as a novelist or poet. Only rarely do these two separate functions coincide. This means, of course, that most of the relevant philosophy today is produced outside university departments, where they rather do the history of philosophy in the form of endless commentary.

A practical rule of thumb is: if a book has footnotes in it, it is anything but philosophy. It is an academic text, not art. Proper philosophy should have no more footnotes in it than fiction or poetry (Eliot is the exception that confirms this rule).

2. Philosophy is not science. Scientific rules simply do not apply. Philosophy proves nothing, and the utility value is zero, as is the case with poetry and fiction. In fact, the whole idea that human actions should be valued according to the amount of utility they produce, is itself a philosophical idea, called utilitarianism, in desperate need of philosophical scrutiny.

3. Philosophy is going big! Not in the sense of becoming omnipotent and dictating in detail how people should live their lives and build their societies. That would just amount to old-fashioned political ideology.

But big rather in the same sense that Big Science is big: aiming for a grand theory of everything. Which in the case of philosophy means a grand theory uniting the individual and collective subjects. And let's not forget that whatever Big Science comes up with, it will need Big Philosophy to work out and define the new and expanded world view that would have to accommodate a scientific theory of everything.

The philosophy of the last century, from Nietzsche via Wittgenstein to the postmodernists of the 1980s and 1990s, should be viewed as one big deconstruction project, an endeavour to expose the weaknesses and contradictions of the rationalist paradigm and the remaining legacy of the Enlightenment. But now we've reached the end of the line. There is nothing more to deconstruct, and we must not be too timid to start reconstructing. So philosophy is now beginning to move in a different direction, redefining what it means to be human, or even trans-human, in a world of interactive communication and virtual communities.

This new development should actually come as no surprise. The whole deconstructionist rage of the last century makes perfect sense when you think it if as a big house-cleaning the day before the party guests arrive. With all the shortcomings of rationalism removed, philosophy is back in good shape, ready for new adventures. And as always in the history of philosophy, the new direction is one that nobody would have expected, least of all the discarded and gloomy postmodernists themselves. The new generation of superstar thinkers – like Slavoj Zizek, Brian Massumi, Simon Critchley, and The Scandinavians – take their cues from newscasts, movie scripts and quantum physics rather than from the annals of old philosophy.

Every major transformation of information technology has, given time for absorption, caused a revolution of the mind. The reason why the ancient Greeks were able to establish philosophy as a discourse was certainly not some sort of outstanding intelligence, but simply that the organisation of society – mainly determined by the dominant mode of communication – created the first social class in history with sufficient time and means to reflect on human existence in debate and in writing. So the Greeks took what had been imported from Egypt, Babylonia and Persia, and created a new art form. Philosophy had arrived.

The next revolution occurred in Europe in the 17th and 18th centuries. The invention of the printing press had changed the feudal society completely and gave birth to a whole new class, the urban bourgeoisie, and a new demand for information and social critique. The result was the shock to the system of thought since then referred to as the Enlightenment.

And now, with the arrival of interactive information technology, the framework for social power structures and thought patterns change drastically. While the mass media obsess over the all-new gadgets, philosophy is interested in the social and cultural implications of interactivity. Nothing could be more important, since the revolution in technology inevitably will bring about a crisis of traditional values, politics, social institutions, etc. It's already happening, and it's called globalisation.

Economic and financial globalisation must be followed by a globalisation of culture and politics, since the concept of a national culture is becoming increasingly irrelevant and national politics increasingly impotent. This is the impulse for the art of philosophy to leave the deconstructionist phase behind, to start making sense of all the rapid changes, to speculate on the shape of the global political order and to give it some credibility. Add to this the ongoing revolution in scientific fields like cosmology, quantum physics and biology; we are entering a new enlightenment, and Big Philosophy is where it is all coming together.

BIG PHILOSOPHY by Alexander Bard

Philosopher, lecturer, author, music composer, producer, pop star and Scandinavia's most successful breeders of trotting horses, Bard is clearly a man of many talents. His first book, *Netocracy*, a meta-historical treatise which argues that historical shifts are determined by major revolutions in information technology, was an international bestseller. After studying the ancient Zoroastrian religion of Iran and India for seven years, Bard became only the second Westerner to convert to Zoroastrianism in 1993.

Above: When talking about a new project, Vince Frost of Frost Design will invariably say "I wanted to print it letterpress but …" Type in Frost's work, regardless of the eventual print technology used, inevitably has a powerful, physical presence. Of course, this is pronounced when he has the opportunity to use "the *real* stuff." The strapline for new magazine *Zembla*, 2003, is "fun with words" which is equally applicable to its content and form. For Vince Frost this was an opportunity to create 'graphic design at full volume."

Following spread, left: Karolina Ciężkiewicz, cover for *Death Sentence for the Pharaoh's Horse*, Warsaw, 2003.

Following spread, right: Schneider and Stoltz at Unica T printed onto translucent and opaque papers for the effect on these spreads.

There is nothing cosy about artist's books. According to Mœglin-Delcroix, it is the responsibility of the reader "to bring not only a creative attitude but creativity in and of itself. Not only [do artist's books require] a liberated reader facing the book but a free person facing the world." Indeed, the relationship between author and/or artist and reader is so often the subject of the book, a situation regularly compared with the theater and the relationship there between actor and audience, that it requires both reader and artist to be constantly on guard for the unexpected.

Somewhere between these two are a number of presses that are attempting to print original material in a way that is intelligent, responsive, and provocative, while matching the technical brilliance of the fine presses. There is no reason why one aspect of a publishing project should suffer for the sake of another. Poor printing remains poor whether the printer is trying to be conservative or innovative. Although good printing is more difficult when the printer is trying to do something different, this clearly cannot, in the end, be used as an excuse. Similarly, economics aside, the technical brilliance of the fine presses is so often wasted: "There is always the danger of fine presses being more interested in how they print rather than what they print."[1]

die neue architektur ist formlos und doch genau defi-
niert, daß heißt, sie unterwirft sich keinem festgelegten
ästhetischen formentyp. sie besitzt keine form (wie die
zuckerbäcker sie benutzen) in der sie die sich aus prak-
tischen anforderungen ergebenden funktions-
flächen ...
theo van doesburg 1924

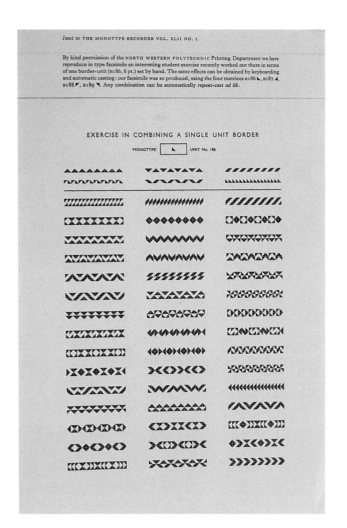

COMBINATION ORNAMENTS

End papers, overall patterns and ornamental units can be built up in any combinations, and in any number of colours, with accurate register

Top, far left: Insert from *The Montype Recorder.*

Top left: A detail from Bram de Does' *Kaba Ornamenten*, Spectatorpers, 2002.

Bottom left: Spread from the *Print User's Year Book*, 1935.

Right: Michele Januzzi, one of 12 sheets which made up a calendar. Produced while a college student, circa 1991–1992.

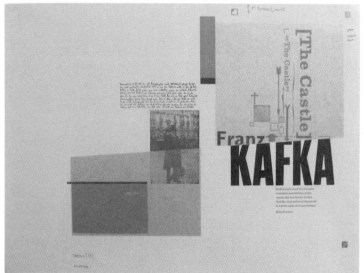

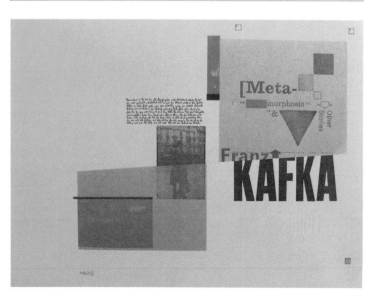

Automation

Being different is one of the reasons that many practitioners, advocates, or collectors of letterpress use to justify why letterpress matters. However, there is no essential reason why handmade products should be different from many of those produced by an automated print process, as long as the automated process produces work of the highest standard.

Contrary to some expectations, the appearance and feel of commercial letterpress printing can be so similar to good, contemporary, automated lithographic printing that it is hard to tell them apart. Lithography was the cutting-edge technology. Certainly, the lack of indentation in the paper would have been considered most impressive, magical even.

It is not surprising then, that letterpress printers felt the need to imitate the "kiss" of the lithoplate against paper, leaving nothing except the transferred image, *on* rather than *in* the surface of the paper. Papers that had a harder, more resistant surface – ideal for the needs of lithographic printing – also gained popularity with letterpress printers because their lack of surface texture allowed for a cleaner, more precise transfer of ink from metal letter to paper with a minimum of pressure.

Left, top, center, and bottom: Three book covers from a set of nine, designed and printed by Kelvyn Smith, for Random House Publishing, 1997. Shows front, back, and spine.

Below left: Checking the alignment and dimensions of a newly imposed forme with a combined microscope and lining-up gauge.

Below right: The Monotype casting machine. Checking that the machine is producing characters of the right height and that the molten metal is of the correct temperature, 1950s.

The major improvement in offset lithography, some 50 years ago, was due to radical developments in the associated ink technology, particularly to pigment density. The requirement of lithographic ink to be transferred from a plate to a blanket (roller) before it is finally transferred to the paper means that today's ink contains a high level of pigment to ensure that its color is not diminished in the process. The gray, anemic pages of text and flat halftones associated with lithographic printing are long gone.

What are the criteria for judging good-quality letterpress printing? With such a wide range of users, there can be no simple answer. To a large extent, each user establishes their own standards. However, for the *commercial* letterpress printer, little has changed as far as standards are concerned. Each letter should be sharp in outline, and presented evenly in color.

SYMPOSIUM
OF PLATO

ΠΛΑΤΩΝΟΣ
ΣΥΜΠΟΣΙΟΝ

TRANSLATED BY TOM GRIFFITH
ENGRAVED BY PETER FORSTER

The Whittington Press has in mind another book of Hellmuth Weissenborn's wood-engravings, which have lain in wait at the Press since his death in 1982.

Risbury, Herefordshire

THE GRAPHIC ROUNDTABLE

Top: A book cover and spine by Michael Mitchell, printed and published by the Libanus Press, for a bilingual edition of *Plato's Symposium*.

Above: An invitation to "the Knights and Ladies of the Graphic Roundtable of San Francisco" to attend a social event, 1964.

Left: Printed ephemera from the Whittington Press.

A characteristic of poor letterpress printing, particularly when printing onto a rough paper (which requires a little more pressure to ensure an even, flat color) is that the corners of lettershapes tend to appear slightly rounded. This "soft" appearance is commonly caused by overinking, or by too much pressure, but it can also be caused by worn type. Type will eventually wear down. It is also easily damaged if dropped, or if a heavy object is set on top of it.

Sound letterpress printing denies its physical properties. The characters should sit "in" the paper (if the paper is soft), but their image should not protrude to the other side of the page. If the paper is hard, then the letterpress-printed image will appear to sit "on" the paper. This lack of cohesion between paper and image, on the whole, shows letterpress at a disadvantage when compared with good-quality lithographic printing.

All of this illustrates, firstly, how closely the contemporary conventions of typography and printing are still bound by the primal technology of letterpress, and secondly, how successful mass-production printing processes have been at mimicking the

appearance of good-quality letterpress printing. For over 500 years, letterpress was the dominant medium of print (or graphic) communication, and it has determined the way typography looks and functions. It is now inconceivable that typography and print will stray far from what letterpress made it.

The reason for setting up machine technology was to achieve what could be achieved by hand, but more efficiently. The standards of perfection expected of machines were set by human imagination and handbased skills. Perfect, highly regulated outcomes are as natural an objective as more personalized, free standards.

Away from the norms of the commercial letterpress printer, others look for alternative standards and thrive on breaking letterpress away from its traditional use. This attitude often extends to the workplace itself. It is not uncommon for new letterpress users to store materials in ways that reflect their own personal working methods and expected outcomes. For instance, arranging wood type not according to font, but instead, arranging examples of just one character in a given point size in each drawer. A drawer full of Os, all of different design, clearly functions as a series of images rather than letterforms, transforming what was the compositor's tray of sorts into something more akin to an artist's palette.

Below right: Illustration from the catalog of Day & Collins Ltd (UK), circa 1920s. This cabinet is capable of holding 36 cases with room for the usual four cases on the top. The sides and back would have been paneled with wood, the case rests are iron.

Bottom left: The new (1952) Monotype department of the Oxford University Press (OUP), set up for automative working methodology. From *TypoGraphic* no. 52. (Photograph courtesy of the OUP archive.)

Bottom right: Peter Koch's studio, arranged for contemplative work.

Far right: Type cases usually have a slot in the handle in which a label can be neatly placed. Some of these drawers, clearly from various cabinets, have no handles, so the owner (Justin Knopp) has devised his own alternative system.

FIG. 16.

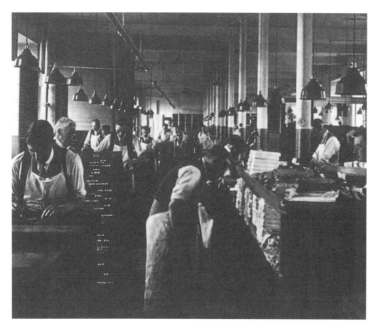

OLD STY Grotesque
Sans Cond. SANS COND.
sans
grot
GRO
Wide Grot
W. Grot
123 Gill Bold
grot

A VICTORIAN MASTERPIECE FOR THE 21ST CENTURY

THE ROYAL ALBERT HALL

A landmark publishing event is set to celebrate the completion of the Royal Albert Hall's eight-year, £70 million development programme. For the first time in its 132-year history, the extensive archives of Britain's pre-eminent arena of entertainment and enlightenment will be revealed, in an elegant 160-page illustrated book.

Available end of October 2003.

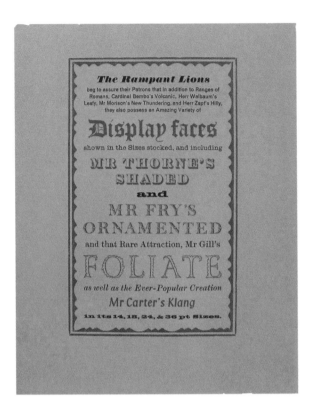

Far left: Alan Kitching, 2003. Poster for the Royal Albert Hall's development program.

Left: Rampant Lions Press type-specimen sheet of display types, from *Portfolio Two*, 1974.

Below: Christmas card designed and printed by Ross Shaw and Jonathan Kielty, 2003.

Commercial letterpress

Today, on entering a commercial letterpress-printing workshop (as opposed to its lithographic equivalent), there is often a sense of leisurely amateurism. This is an entirely false impression, but the point is that while various machines might be clattering away, everyone is generally insistent on taking pains, on not compromising, and such methods require time for thinking. This is how John Grice describes a recent visit to a letterpress-printing and typesetting company:

"The premises are tucked around the back of an [industrial] estate, an old mill site with many old and varied buildings now in a variety of uses. In the door and up the concrete stairway, and then you hear it, that unmistakable clicking and clacking, thumping and pumping. You feel it in the floor. It sounds like 10 men at work. You enter and the sound is more urgent. You smell the hot metal, the oils; it is a real place of work, but where are the 10, you may think? In fact, three men work here. [The caster room] is the source of sound and smell, of unstoppable working. It contrasts markedly with the quiet of the repro space. The overall impression on entering the workshop is of its order. Working surfaces clear and clean, yet the workshop is packed to the full, racks and cases brimming. There are spares for the machines stowed in every spare space, high up or below. In running a Monotype plant these days, one has to search for, and squirrel away, all forms of spare parts."[2]

Compare this with the following description by Walter Tracy of his first job, in the 1930s, working at Clowes UK, which had previously been one of the largest printers in the world, with over 500 employees.

"The building had been in use for over a century. All the floors were wooden and much worn; we were conscious of the knots in the planking as we moved about. The interior walls were distempered white, which soon turned a dull yellow. Bits of plaster often fell into our typecases."

Later, Tracy describes a regular event that took place when the Government's Stationery Office would subcontract Parliamentary work, and Clowes would undertake the setting and printing of the latest revision of a Bill. This meant overnight work. A few days' notice would be given, allowing time for the Monotype casters to produce galleys of case sorts, caps, lowercase, small caps, figures, and punctuations, for the compositors' cases.

"On the appointed day, we reported at eight o'clock in the evening to the ground-floor composing room – perhaps 10 journeymen and a couple of senior apprentices. The work was entirely hand-setting; machine keyboarding, and then casting and makeup would have taken too long. We were assigned a frame, and spent a half-hour or so filling all the compartments in the upper and lower cases with the newly cast sorts. Then we waited. If copy did not arrive by ten o'clock there was a muttered "They're sitting late" – with a suitable curse on the honorable Members. When at last the noise of the dispatch rider's bike in the yard could be heard, we braced ourselves. The clickers hurriedly divided the copy into takes, 20 lines or so in each, and we got to work. It was hard. If we were too slow there would be an angry call from the makeup hand – no pleasure at say three o'clock in the morning, with the fingers of the right hand and the thumb of the left painfully raw from the hours of handling the sharp-edged type. By about six o'clock the pages had been imposed and the formes delivered to the several pressmen who had been standing by. We waited for the clicker's 'Cut the line,' and hurried out, still dazed, into the early daylight, breakfast, and a few hours' sleep." [3]

Such anecdotal evidence quickly diminishes the notion of "the good old days" of letterpress. Printing has always been a demanding way to earn a living, and the activities of contemporary individual presses, running essentially to provide pleasure and fulfillment to the user, are, of course, entirely different.

Even as early as 1890, craftsmen were lamenting the decline of the printer's status. In the flurry of new inventions the book printer, as is so often the case, lost in both social standing and pay. At the end of the nineteenth century, the printer's experience was that of being replaced by labor-saving machinery, very similar to the experience of printers and compositors in the mid-twentieth century. The following was written in 1890: "Gutenberg would have been amazed could he have foreseen the consequences of evolution in the printing business. In his day printing was little, but the printer was great. In ours, printing is the mainspring of our civilization … while the printer is – well, he is relegated to the domain of a common wage worker, and that would be enough to horrify the father of typography." [4]

Today, the smaller commercial printer appears to be running out of options. Even the copyshops that threatened their survival are struggling to compete with the inexpensive office copying equipment that is now available. Even the larger printing companies are having to diversify into digital ink-jet printing for short-run posters, banners, or one-off printed and mounted exhibition boards. Meanwhile, for the commercial letterpress printer, *everything* remains exactly the same.

ANDREW DOUGLAS

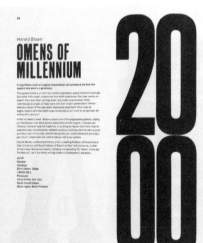

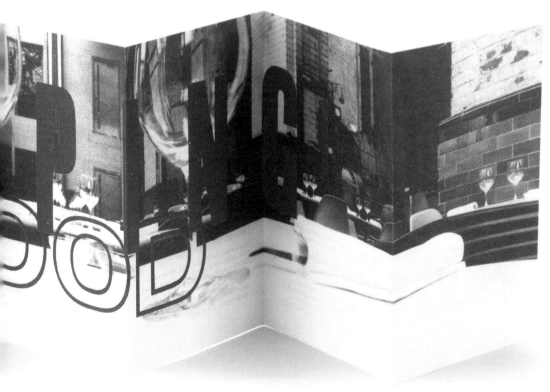

Top left: Corporate identity design for Atlas by Frost Design. Frost Design has long been known for its use of letterpress as a means of providing additional "volume" to commercial print.

Above: Frost Design produced this catalog for the publishing house Fourth Estate in 1997. It was unusual at the time not only because it was printed entirely letterpress, but also because the company requested that their catalog featured no book covers. As Frost said, this 'allowed us to create themed images of our own."

Left: The Wapping Project is a restaurant, performance studio, and gallery located in the East End of London. Illustrated here is the menu for the restaurant. (A poster for this venue can be seen on page 19.)

[Independent publishing]

Left: IM Imprimit is accommodated in a three-story building previously used as a warehouse.

Below: The walls are not thick but, essentially, the floors are soundly supported by metal girders and there are plenty of windows on all floors.

Right: Intercharacter spacing requires a certain amount of ingenuity. Here, boxes hold 10, 18, 30 and 12pt "hair" spaces. The hair space is, theoretically, one-twelfth of an em, but in practice, varies in thickness. These might be made from lead, brass, card, paper, or tissue of various thicknesses, often the difference being no more than a fine layer of printed ink.

3.3 Craft and technology

Materials

The concept of "craft" tends to be interminably linked to materials. What it means to stay true to the essence of any craft is usually focused on two related aspects. The first is the idea that the essential character of all materials should be respected; typically, wood should look like wood. The second is that all materials take, or can be made to take, certain forms or shapes easily (naturally) or directly. The argument follows that such unforced shapes are *natural* to the material and are, therefore, the *right* shapes.

Such values have been central to traditional craftsmanship in Japan for centuries. In the twentieth century, Scandinavian designers and craftspeople famously used natural, local materials – particularly wood, conspicuously and to beautiful effect – in the building of houses, furniture, and a huge range of other basic artifacts.

The ideals of truth-to-materials and rightness of shaping have in common the concept that all materials have a specific nature that is made up of inherent properties. Both suggest that the utilization of the materials of any craft should celebrate those inherent properties. In other words, you should not deny the identity and character of your materials!

However, much of the aesthetic and sensual pleasure we gain from looking at, for example, figurative sculpture, comes from the fact that soft and flexible things are often expressed in a hard and rigid material. Describing flesh or drapery in carved stone was, for centuries, the prime way an artist could demonstrate his consummate skills; dominating a material – denying its essential characteristics – to the extent of creating the illusion of it *appearing* to be its physical opposite.

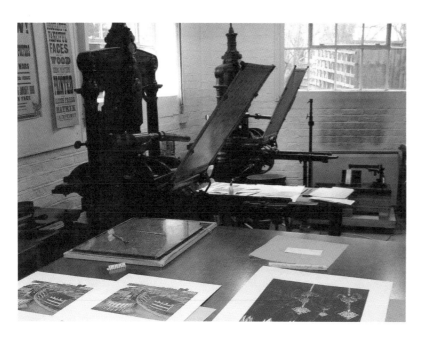

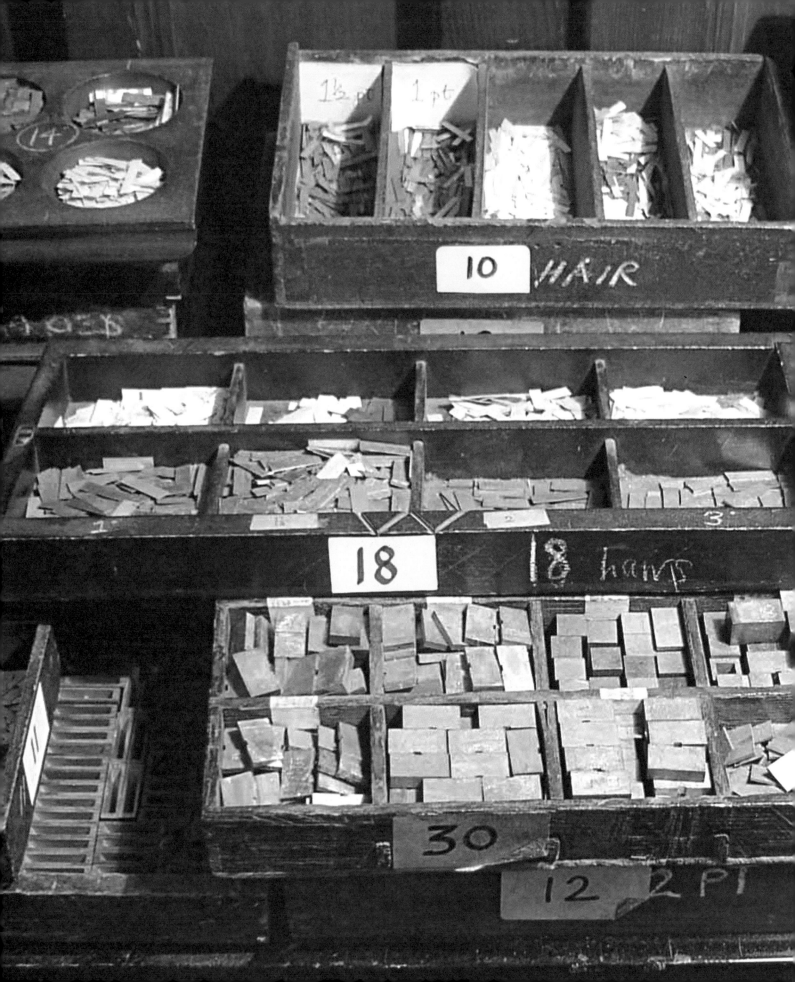

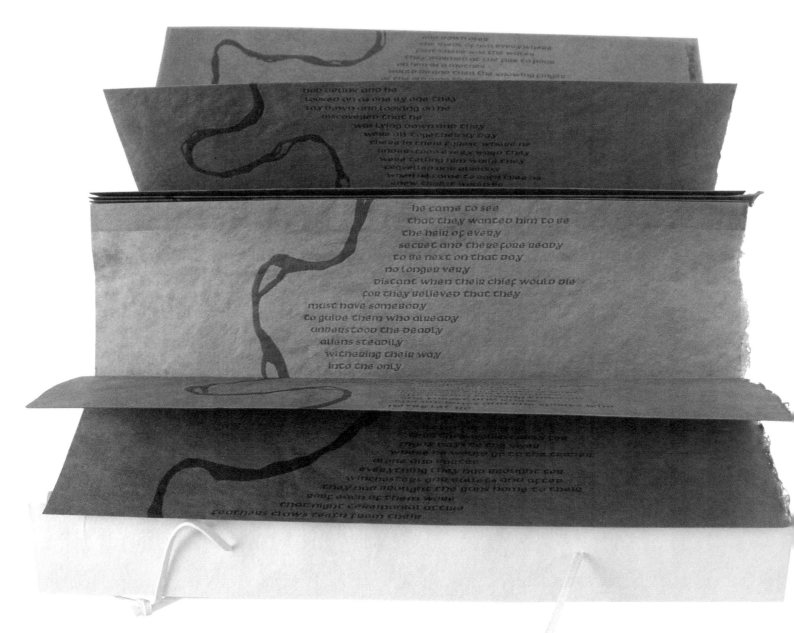

Above: Carole Campbell's Ninja Press, *The Real World of Manuel Córdova*. This special edition of the poem by W. S. Merwin was set using Samson Uncial on handmade paper. The concertina folds allow the 43 stanzas of the poem to be read one at a time, or opened to reveal the whole poem –15ft (c. 4.5m) in length. The river was printed using photopolymer relief plates.

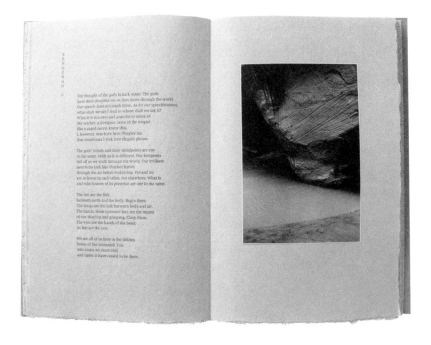

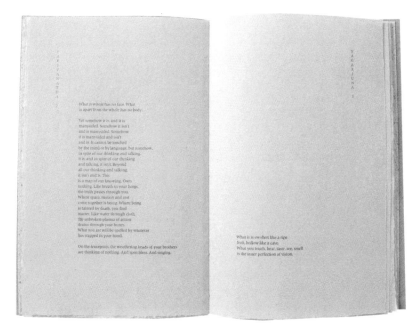

It is no coincidence that when compositors and printers began to voice the opinion that what they were doing might be "art," their work was attempting, often successfully, to deny the physical properties of the materials and processes of letterpress. The conventional geometric constructions upon which letterpress generally functions were also rendered invisible by the ingenuity of the compositor, aided by the ingenuity of type foundries that provided a plethora of decorative elements which allowed the compositor to proffer the illusion of being able to "sketch in metal."

Artistic printers offended traditionalist tastes because, essentially, they were "denying the identity of their materials" in both their means and their intended outcomes. Even at its height, artistic printing was criticized from within the industry. John H. Mason, criticizing the influential journal *The American Printer*, is typical. "So printers and advertisers aren't content to use print as God Almighty meant it to be used – quietly and honestly – but strain the beautiful instrument into discordant forms that repel all finer minds, and bring the craft into contempt. What regard or dignity has the printer nowadays ?"[1]

The suggestion is, what works best is that which works in harmony with all the (God-given?) typographic elements: the shapes and forms, the materials, and the means of process, all of which were designed to be used in strict accordance with the conventions of manuscript/book layout prior to 1450, and with Gutenberg's invention of movable type. One of the marvels of movable type was that it could achieve such a result using a material so cold and inflexible as metal. Gutenberg was able to disguise the inflexible character of his materials to provide a lucid, flowing page of text, while his letterforms arise naturally from the calligraphic letterforms that characterized the sacred and learned manuscripts of his day. His craftsmanship, to say nothing of his ingenuity and determination, was, without question, of the highest order.

With letterpress, "natural" can be confused with "conventional" or "traditional." To ensure efficiency (above all other considerations), the way letterpress was used in a commercial context became very highly regulated. Mason's criticism that the typography of *The American Printer* was ungodlike – unnatural – is, in fact, simply saying that it is unconventional.

Above, top and bottom: Carole Campbell's Ninja Press, *The Book of Silences*. A book of poems by Robert Bringhurst, 2001, using Meridien with photographs by Carole Campbell.

Progress

During the 50 years following Gutenberg's *42-line Bible* – up to about 1500 – printing remained a high-risk activity in the sense that the outcome was, to varying degrees, unpredictable. Because everything was handmade, the processes were slow and the editions were small. But there is a sense of adventure as well as celebration in this early printed work. Once the risk factor had been overcome, the businessmen moved in, working methods became routine, and conventions were established. It is no coincidence that to William Morris, the years prior to 1500 saw the best of printing.

Morris wanted to return to the "craft" values of printing by reestablishing the pioneering spirit of its first 50 years. He questioned every aspect of the materials and processes used. In so doing, he was creating a situation where the process was exploratory and the outcome, therefore, far less predictable. Any activity in which the outcome has a high degree of predictability – a primary objective for automation – quickly loses its right to be termed a "craft," and when the craftsperson loses personal control over the outcome, they lose the right to be called a craftsperson.

Technological development reshapes work processes, attitudes toward craft, and occupational status. The two major innovations to hit the compositor's and printer's world were the introduction of mechanical typesetting, or hot metal, in the 1880s, and the advent of computer-aided photocomposition, or cold type, which began in the late 1950s and developed into digital technology in the 1980s. Both of these deeply influenced the craft of letterpress, and, at a commercial level, digital technology left it redundant.

A craft that appears to have little chance of revitalization develops traditions within traditions. Individuals with comparable occupational experience attribute significance to their shared, past world, complete with its own language, techniques, tools, materials, and standards. Retelling stories (true or not) about work processes in a different time, using a different technology, they describe attitudes about perceived standards and general handicraft skills. With a major change in technology, conventions are more easily questioned and standards are more easily ignored. The past, and what was achieved at that time, can be distorted by nostalgia.

The terms craft, handicraft, and even handmade are certainly historical or social rather than technical. Today, they tend to be used to refer to any kind of workmanship that could have been found before the Industrial Revolution. This was not William Morris' idea of craft. He was not opposed to the machine as such. What concerned him was the lack of ownership and control the craftsperson suffers when the making of an object is broken down into a set of discrete actions in order to speed up the process of production. With lack of ownership, the craftsperson quickly loses his or her status and becomes "a mere part of the machine."[2]

Letterpress itself is a highly sophisticated system, and, with additional effort from the printer, is also capable of tremendous flexibility. But there is no doubt that any divergence from the way it was originally designed to be used can be time-consuming. However, it is these very problems – or rather, the solutions to these problems – that enable the user to take the medium forward and maintain its relevance. Anything short of this may be worthy, but can it be called craft?

The simple answer is yes, but, of course, there will inevitably be levels of craftsmanship reflecting the sophistication of the tools and, more importantly, the use to which they are put. Such judgments must be applied to each project on an individual basis. Tools play a vital role in almost all craft activities. The essential element of a craft is that it remains something you can do for yourself, but clearly, the sophistication of the tools – the printing press or machine – will influence the nature of the working process and vary the degree of regulation upon the work.

Right: The Doves Press, *Areopagitica*, 1907. Simplicity and unity are the key characterisitics associated with the Doves Press. W. R. Lethaby stated the thinking behind the Arts and Craft movement in "Art and Workmanship," which appeared in the first issue of the *Imprint*, 1913.

Below: Letterpress composition was often more akin to illustration than typesetting. Perhaps this was the reason some thought it appropriate to call such work "artistic printing." However, in this example, the printer is self-consciously using a selection of types commonly used by the artistic printers, but in a manner that entirely dispenses with their normal application. From *The British Printer*, September/October, 1898.

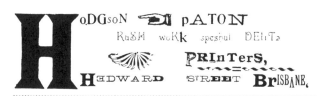

THEY WHO TO STATES AND GOVERNOURS OF

THE COMMONWEALTH DIRECT THEIR SPEECH, HIGH COURT OF PARLAMENT, or wanting such accesse in a private condition, write that which they foresee may advance the publick good; I suppose them as at the beginning of no meane endeavour, not a little alter'd & mov'd inwardly in their mindes : Some with doubt of what will be the successe, others with feare of what will be the censure; some with hope, others with confidence of what they have to speake. And me perhaps each of these dispositions, as the subject was whereon I enter'd, may have at other times variously affected; & likely might in these formost expressions now also disclose which of them sway'd most, but that the very attempt of this addresse thus made, and the thought of whom it hath recourse to, hath got the power within me to a passion, farre more welcome then incidentall to a Preface. Which though I stay not to confesse ere any aske, I shall be blamelesse, if it be no other, then the joy & gratulation which it brings to all who wish and promote their Countries liberty; whereof this whole Discourse propos'd will be a certaine testimony, if not a Trophey. For this is not the liberty which wee can hope, that no grievance ever should arise in the Commonwealth, that let no man in this

8

World expect; but when complaints are freely
deeply consider'd, and speedily reform'd, the
utmost bound of civill liberty attain'd, that w
looke for. To which if I now manifest by the
sound of this which I shall utter, that wee are
in good part arriv'd, and yet from such a st
advantage of tyranny & superstition groun
our principles as was beyond the manhood
man recovery, it will bee attributed first, as
due, to the strong assistance of God our d
next to your faithfull guidance and undaun
 does, Lords and Commons of *England*. N
tis looks extreeme the diminution of his glo
honourable things are spoken of good men &
Magistrates; which if I now first should
doe, after so fair a progresse of your laudab
& such a long obligement upon the whole R
your indefatigable vertues, I might be justly
among the tardiest, & the unwillingest of t
praise yee. Neverthelesse there being three p
things, without which all praising is but C
all flattery, First, when that only is prais d
vitally worth praise: next, when greatest lik
are brought that such things are truly & real
persons to whom they are ascrib'd, the oth
for what praises, by shewing that such his es
pwasion is of whom he writes, can demo
he flatters not; the former two of these I
tofore endeavour'd, rescuing the employ

b

Standardization

The development of all trades has tended toward increasing the workman's power to regulate, enabling him to standardize the outcome. This in itself is usually a desirable development. As with the ceramicist making a set of tableware, or the carpenter constructing a set of chairs, standardization is a consequence of good printing and can only be attained with high levels of skill. The "color" (or tone) of the printed area of each page of a document should be the same, just as the color at the head of the page should be the same as at the foot of the page. Similarly, 72-point titling characters should appear to be the same color as footnotes set in 6 point. All of these considerations, and many more, are part of the necessary standardizing nature of letterpress work. Such work tests the printer's skill and sensibilities to the full.

This standardization – a self-imposed, regulated standard within a given project – may be easier to achieve on an automated press such as a Wharfedale than a handpress such as an Albion or Columbian, but nevertheless, the activity of a person attempting to achieve, maintain, or even raise the standards of their work must, surely, be called a craft.

However, it is also far easier to maintain such standardization when the machine is being used in a conventional manner. It is inevitable that if the printer attempts to achieve something unconventional, standardization will be more difficult to maintain.

Letterpress technology redistributed the skills of the scribes through machines, systems of production, and systems of information, to the compositors, printers, and a myriad of skilled workers whose activities and products supported the print shops. By this process, technology is rooted in craft, but is different from craft. When a letterpress printer claims that he possesses a craft, he is claiming that he has autonomy in a field of knowledge. For the printer, tools and other labor-saving devices do play an essential role, but, importantly, the craftsperson remains the master of the craft. With letterpress, the craft of the process is diffused into the tools and machines of reproduction. It is then just a small matter of knowledge…

Compare the computer with the letterpress process. Much of the power and attraction of computer technology is that it enables you to do things without the need to understand how they are achieved. This clearly cuts out an enormous amount of knowledge. Required knowledge, based upon tacit understanding, was considered essential to anyone using type prior to computer technology. Today, the designer is in the hands of engineers and programmers who provide the means – perfectly adequately in my view – but not, of course, the knowledge. The critical asset required of all designers, but too often missing, is the knowledge (as well as, in a commercial context, the time) with which to supplement or override the raw nature of those flecks of light that the engineers and programmers have bought, via the software, to the monitor. It is not craft as handicraft that defines contemporary craftsmanship, but craft as knowledge, empowering the designer to take charge of the technology.

Regulation (repeatable, standardized values) once had a high value, due to its rarity, that it no longer has; free workmanship (intuitive, reflecting the individual character of the maker), once common, has gained in value due to its rarity today.

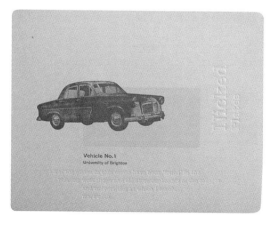

Left: Over the years, Kelvyn Smith has taught typography and letterpress printing at numerous colleges. Shown is his *Nicked Plates.* Blind embossed on each card is the admission "All the plates in this series have been 'found' in the printing workshops and old store cupboards of the colleges and universities at which I teach."

Right: Kelvyn Smith and Jeremy Tankard, *Tata Awareness Study,* for Wolff Olins Research, UK, 1997.

Tata awareness study

34.

13 43

52

07 51

97

aware

%

[Independent publishing]

Above: Robin Price, *The Journey of the Guitar: A Portrait of Pepe Romero,* 1999. Set in Bodoni Book with the titling face *Stradivarius.*

Right: Wayzgoose Press, Australia. A page from *Dada Kampfen um Leben und Tod,* **based upon Jas H. Duke's homage to the Dadaists. The Wayzgoose Press is run by Mike Hudson and Jadwiga Jarvis.**

Status

It is not surprising that designers, given the necessary instincts of creativity and integrity, together with commercial prowess and opportunism, take such an interest in the social status of their profession. Just how seriously design is taken by the general public and its major institutions – the establishment – is crucial, because without their respect and confidence, designers cannot expect to be commissioned to produce work for them. Craftspeople are, no doubt, similarly conscious about their standing and how their work relates, or is perceived by the public to relate to other forms of visual production. But because they generally work independently, they are less reliant upon the vagaries of national and international fiscal and popular cultural trends.

The boundaries between art, design, and craft are blurred. However, in the hierarchy of occupations concerned with visual communication, higher cultural status is generally conferred upon activities where the end product is nonfunctional. All else, apparently, is sullied by the moral implication of commercial necessity – compromise. (Even artists, no matter how unconventional their work, will be accused of selling out if someone is willing to buy their work!) [1]

For designers and, to a lesser extent, craftspeople, the debate about status and identity tends to be inextricably linked with the extent to which conventions can be stretched while remaining accessible – functional – within a capitalist society. For most design projects, the status and scale of the client, and the fees involved, are inversely proportional to the level of conventionality insisted upon. [2]

Many of the major cities around the world have separate museums dedicated to craft, design, and art. Consumerism is inescapable and self-perpetuating, and the designer's role tends to place the design professions at the center. This, of course, is where design needs to be because it requires the patronage of the establishment.

DADAUSTRALIA!

DADAUSTRALIA

as we never opened the book
we never misread it

OR WHAT WE HAVEN'T DONE YET

OR WHA TW EHAV EN' TDO NEYET

THINK WESTERN
there
must
be a
harder
way

and we couldn't read anyhow
and were blind and deaf as
well as mute

and it's not so much we're still waiting for

DADA
we're still waiting for

BEAUDELAIRE & RIMBAUD & MALLARME
for DADA to smash

if it was going to smash anything

& COCTEAU & J.R.BECHER to smash
if it was going to smash anything

producible is the group
ideal and the ideal is
the progressive toward
material unselfconsciousness
eliminating the
fallacial auto-
suggestion phenomena
of Past and Future
to the infinity of
design of the
Eternal Now

cessation of individual
capabilities of being swept
activity plus sex-segregated
maintenance of self-
there is a confabulation
decentralisation of
physical activity are like
other landed property are of little

The craftsperson, on the other hand, plays a relatively minor role in our consumer society, and the lack of economic and commercial pressure, even if this results in a lower status, is generally considered to be an acceptable trade-off.

So far, the rhetoric of designers has had little effect on the general status of design. There has been a tendency in some major art exhibitions to include printed material – in the form of books, leaflets, magazines, and posters – to provide contextual support. It is entirely positive that the influence of graphic designers and craftspeople in defining and molding social culture is being recognized, but the fact that such material is shown in art galleries should not be taken to suggest that its status, in relation to art, has changed. I fear that status has less to do with culture or quality, and more to do with opportunist economics. The monetary value of printed matter will never match the monetary value of art on walls. If it ever did, then, I suggest, craft would become art (and rest assured, what the craftsperson might think of this would be completely irrelevant) since the sole purpose of conferring higher status is to maximize monetary investments.[3]

Traditional letterpress printers are generally happy with this situation. However, those seeking to utilize letterpress as a means of achieving a less conventional outcome might prefer a more public dialogue as an opportunity to question general perceptions. Such a dialogue might be a useful motivational or creative factor in their work. Book artists who use letterpress are far more concerned with their own persona and how this might be reflected in their work. They are, of course, artists and, as such, require a forum, a public space in which they can show their work. It is also preferable that the space has been specifically designed for such events so that the appropriate status can be conferred upon the work displayed. This kind of ostentatious display does not align easily with the traditional, distinctly utilitarian concept of craft. And yet, not surprisingly, such work *is* attracting attention and is putting letterpress into the craft journals again.

There are those who consider that lack of recognition is a positive advantage. "Becoming a recognizable, definable part of 'the art establishment' leads inexorably to spokespeople, definers, interpreters, facilitators, and, sadly, critics."[4] Being answerable to no one is a key reason for many taking up independent publishing in the first place, but contact with the world beyond bibliophiles, even if this were to mean suffering the occasional bite of the critic, might encourage a body of work capable of biting back.

Letterpress is, or certainly was, the most traditional of crafts, in the sense that it aimed to produce a highly functional object. Having such a clearly defined objective and preordained appearance distanced it from art. The supremely functional aspect of letterpress also ensured its low social status. After William Morris had succeeded in making quality a political, moral, and social issue, printing quickly returned to its previous state of invisibility. Indeed many were, and still are, attracted to letterpress (and other forms of printing) because of its ability to convey information free of extraneous comment or interpretation, "quietly and honestly."[2]

All images: Robin Price, *Slurring at the Bottom: A Printer's Book of Errors*. This work uses rejected press sheets from Price's previous projects. Ten artists, working in blind collaboration, added their work. New texts were printed on to half of the prepared sheets, and the other pages are overprinted and altered in various ways: with block prints, phototransfers, collage, cutouts, stitching, and drawing.

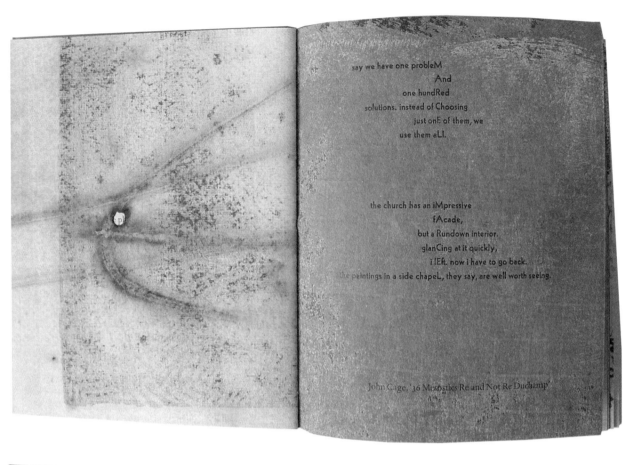

say we have one probleM
 And
 one hundRed
 solutions. instead of Choosing
 just onE of them, we
 use them aLl.

 the church has an iMpressive
 fAcade,
 but a Rundown interior.
 glanCing at it quickly,
 i lEft. now i have to go back.
the peintings in a side chapeL, they say, are well worth seeing.

John Cage, '36 Mesostics Re and Not Re Duchamp'

bad cut back side

The ... an Everson Reading

PART ONE: *The Transcription by Sidney Berger* of the poetry reading by
William Everson at the University of California, Davis, on May 16, 1975

PART TWO: *Remembrances of Other Everson Readings* by James Schevill, Lee
Bartlett, Robert Bly, Diane Wakoski, James Laughlin, Frances Tompkins,
Morton Marcus, A.V. Krebs, Robert Hass, Clifton Ross, Lindsay Hill,
Robert Creeley, Gary Snyder, *and William Everson*

ROBIN PRICE, PUBLISHER TOWN, CONNECTICUT

g to illustrate
visual
on graphic
communication

influences

Krimpen Bertho
ner
Hermann
Hans Schmoller

Ladislav Sutnar

t Schwitters J
Jan Tsch
Piet Zwart
uitema Willem Sandberg
rik Werkman Henryk
Karel Teige Herbert Bayer
Laszlo Moholy-Na
heo van Doesburg
El Lissitzky
Alexander Rodche

Design and art

The function of design in letterpress is to provide appropriate solutions and an efficient process, but the pleasure of observing the elements combine and assert a new identity offers unexpected alternatives. The aim is to get things *right*. This entails flexibility. Enthusiasm, play, and imagination are highly beneficial attributes in the designer. Such qualities will mean inefficient use of time, but this is the prerogative of the letterpress printer; to have direct contact and control limited only by knowledge and skill, at every stage, from initial sketch right through to packing and shipping.

Letterpress users, more often than not, work alone. A visit to any average-sized, commercial lithographic print company will clearly illustrate the difference between printing as craft and printing as mass-production. "… the absence of leisurely amateurism from which all great art finally springs – that being an insistence on taking pains, not compromising, and the rest – is the most frightening thing here."[6] This is not entirely fair. The compromise, where it exists, is not at the printing stage. Commercial printers will do whatever is asked of them. In fact, the general quality of mass-production printing is technically very good, and certainly requires that the printer takes pains. However, compromises do occur at earlier stages, when the designer is required to work within the parameters that enable the automated print process to work to maximum efficiency, by keeping to standard formats, materials, and finishes.

The drift toward art is also illustrated by the fact that many book-arts courses emphasize concepts rather than making. Ideas, it is argued, have an existence quite separate from making. Book arts would appear to be the perfect medium for "conceptual crafts" – a ludicrous contradiction in terms – and, as such, align with fine art rather than with crafts.

In traditional (nonconceptual!) craftwork, the means of communication is developed along with, and during, the process of making. The traditional craftsperson will, therefore, find it difficult to explain what is happening. It is, after all, a physical activity, a combination of thinking *and* doing. Indeed, how can there be invention without direct manipulation of materials?

Craft is bound up with the tacit knowledge gained in such activities. These can easily be demonstrated, but not so easily explained. Because they are difficult to describe, they cannot be easily theorized,[7] so it is difficult to support or defend them using the conventions of spoken and written language. And, while the *results* of the activity can be clearly demonstrated and presented, this, unfortunately, is often not enough for those seeking explanations. Further problems occur when such people approach the book arts, fine arts, or even designers for answers and in so doing, miss entirely the integrity of the authentic craftsperson.

"Authentic" or "real," in our consumerist society, tends to mean honest, sustainable, and/or uncontaminated. Authentic is also often used as a euphemism for labor-intensive activity and there is, therefore, a general expectation that the product will be more expensive. To add emphasis to the fact, the letterpress printer who wishes to make a point about authenticity will pack the press, ensuring that the type is pressed well and truly into the paper – and almost out the other side – to ensure, beyond all doubt, that even the uninitiated reader will realize that he is holding something different. Such presswork treats letterpress as a novelty. A typical justification is that "a hard, penetrating strike expresses type in its essential virtue, sculptural, as it is in construction and application."

Left: Kelvyn Smith, *Twentieth-Century Chart.* "A typographic representation serving to illustrate important visual influences on graphic communication." It comprises 23 sheets and is split into four core sections – designers, typographers, writers and poets, and artists – each with a page and chart of their own. The charts are concerned with hierachy, contrast, and connection with the emphasis on imaginative rather than empirical information.

Below: This is letterpress. (Photograph courtesy of Andrew Dunkley and IM Imprimit.)

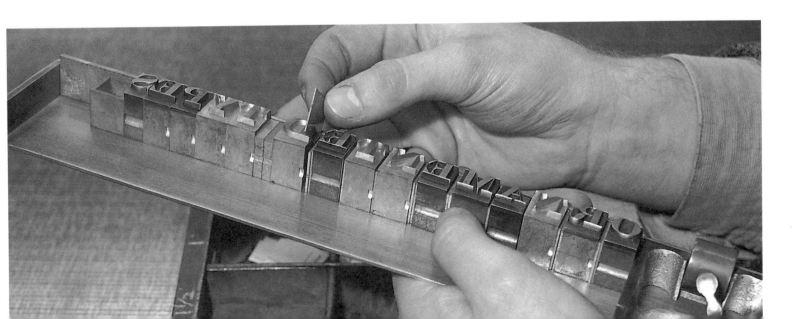

4

Craft and education

4.1 The integrity of craft

"Students are encouraged to use letterpress in innovative ways, often feeding the results into other media such as photography by scanning into the computer or onto film."
Susanna Edwards, *designer and educator*

Above and right: Footage of letterpress material filmed by Susanna Edwards.

Far right: One of the first commissions Susanna Edwards received was to design the cover of *baseline*.

Tangible information

Digital information makes the concept of an "original" document difficult to comprehend. Plagiarism has become such a prominent issue in education because any sense of originality is imperceptible in a medium where everything appears the same. There is no sense of ownership, and no sense of age or place.

A printed document shows its age not only through the deterioration of the materials from which it is made, but also through its design and the methods of production used to make it. The influence of print technology on appearance and feel – the choice of materials, type, and images, and the design of all these printed elements – provide an essential part of understanding the time and context in which the document was written.

Print also represents a conclusion. "Fit to print" markedly separates the acts of designing and writing, activities that are always revisable and open-ended, from the final, finished, *printed* statement.

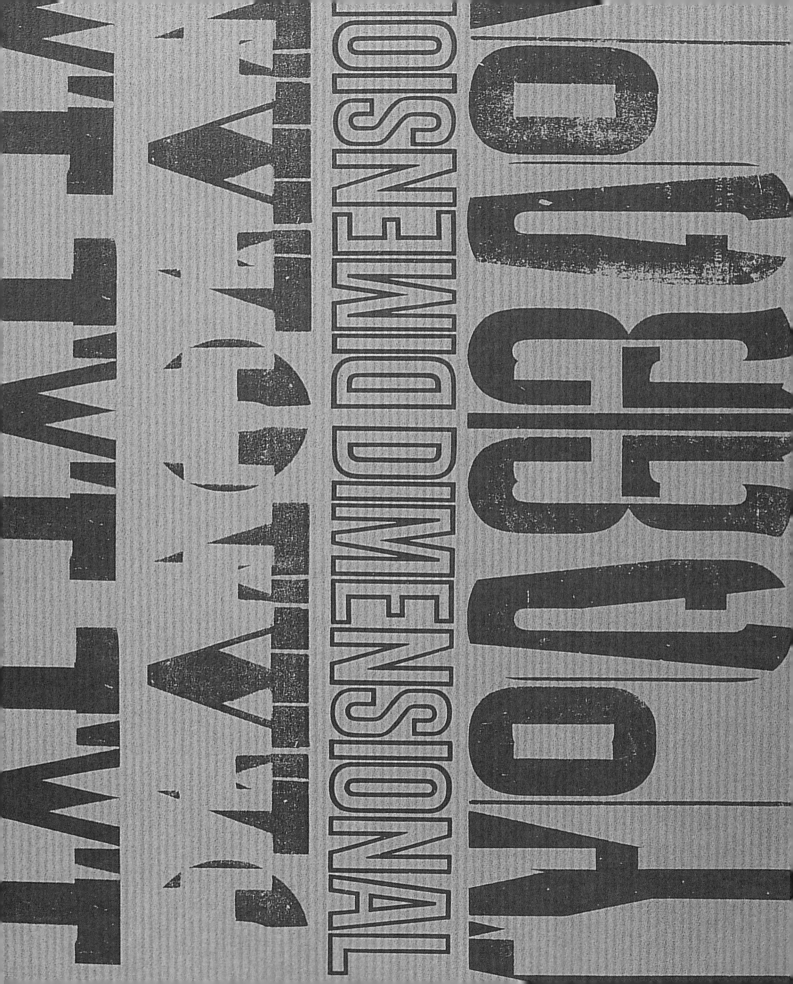

Above: Technical printing queries answered, circa 1940s.

Left: A spread from *The Monotype Recorder*, 1952. "Typographic transformations", as exemplified in a "before and after" collection of recent publications.

Below: A spread from *Techniques of Typography*, written and designed by Cal Swann. Lund Humphries, 1969.

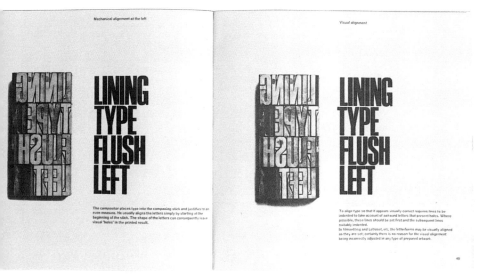

Presentation of information

Observing the current generation of design students surrounded by digital information technologies, I believe their perception of "books" is different from that of a student three decades ago. The numerous bookshops in every city and town have hardback anthologies and monographs that are better printed and certainly more opulently illustrated than most available in the 1960s and 1970s. However, many more books – by far the majority that are bought by students – tend to be smaller-format, text-only books. These are characterized not only by narrow margins, poor printing, and poor paper stock, but also by their tendency to collapse and break apart the very first time they are opened.[1] In other words, for design students, the book rarely offers the sensual pleasures of the well-designed, well-printed and well-bound volume of our ideal. More importantly, rather than embodying the relative permanence and sheer solidity so apparent in a well-made object, books today too often embody the ill-designed, fragile, and short-lived.

The danger is not that the ideal of the "book beautiful" might be lost, but that its possibilities will be neglected and an inferior form of it taken for granted and accepted without question.

Another issue concerning design students today is that while language is a central feature of typography it does not, formally, play a role within the specialist education of most graphic designers. Instead, for the typographer, the craft of writing (or at least the ability to recognize and appreciate it) is usually acquired separately from that of their initial, specialized, visual education. It seems, at the very least, a little perverse for typographers to perform their craft of making type readable without ever concerning themselves with the nature of how the words themselves communicate.

This lack of knowledge of written language, and how it functions, deeply influences a student's ability to function as a typographer. If the purpose of commas, colons, semicolons, periods, apostrophes, hyphens, en and em dashes etc., are not recognized, it is not surprising that the visual appearance of these in relation to their adjacent characters is rarely given any consideration. After all, how many graphic design (or even typographic) students are proficient in the rule-governed uses of punctuation marks, diacritical signs (accents), and grammar? Or know how to check and annotate proofs? This lack of any concern for typographic detail is based on ignorance, not laziness, and it is right and proper that such material should be included in any program concerned with any form of graphic communication.

Type Research Unit
at Middlesex University

Introduction

For five-hundred years letterpress was the primary method of setting and printing information. Superseded by offset lithography in the last century and through typographic developments such as photo composition and the rapid onslaught of the digital revolution — letterpress is now perhaps a subtle grey tint of the 'Black Art' it once pertained to be.

With the extinction of much of the materials and equipment used in the letterpress process, educational establishments are perhaps the only place this technological dinosaur survives.

Fortunately Middlesex University was one such establishment and, although severely neglected, the letterpress workshop contained a collection interesting and rare equipment with which to produce printed matter.

After a complete overhaul the workshop, with small classes in mind, was divided into four primary areas; design, composition, make-up and printing.

Directory of Punctuation

Tracey Pearson
27.11.01

Asterisk*

asterisk, n. & v. — n. a symbol used in printing and writing to mark words etc. for reference, to stand for omitted matter, etc. — v.tr. mark with an asterisk. [Middle English via Late Latin *asteriscus* from Greek *asteriskos*, diminutive of *aster* 'star']

The Concise Oxford Dictionary, 9th Edition

An asterisk after a word or sentence indicates that further information, or a reference, may be found in a footnote.** They are placed after all punctuation except an em-dash and a closing parenthesis. If the matter referred to is within the parentheses. If there is more than one reference on the same page where a footnote is called for, a dagger or other reference mark is used. If more are needed, double marks are used.

Basic Typography, A Design Manual

A superscript, used primarily to mark referends and keywords in European typography, it is widely used to mark a person's year of birth (as the dagger substituting for a cross, is used to mark the year of death). In philology and other sciences, it is used to mark hypothetically reconstructed or lost forms. The asterisk takes many forms. It appears in the earliest Sumerian pictographic writing and has been in continuous typographic use for at least 5000 years.

The Elements of Typographic Style, Robert Bringhurst

In philological works an asterisk* prefixed to a word signifies a reconstructed form; a dagger signifies an obsolete word.

References in the text to footnotes should be made by superior figures, which are to be placed outside the punctuation or quotation mark. Asterisks, superior letters, etc., may be used in special cases. The dagger and the other signs should be used in mathematical works, to avoid confusion with the workings.

Hart's Rules for Compositors and Readers at the University Press Oxford.

For a table containing only of words; superior numbers may be used as reference marks (though even here letters are quite usual); for a table that includes mathematical or chemical equations, a series of arbitrary symbols may be used, because of the danger of mistaking letters or exponents. When more symbols are needed, these may be doubled and tripled in the same sequence.

The Chicago Manual of Style

*The figure of a star used in writing and printing as a reference to a footnote.

The Shorter Oxford English Dictionary on Historical Principles.

**The footnote is always preceded by an identical reference mark.

Above and right: *Directory of Punctuation* is the result of letterpress typography classes conducted by Kelvyn Smith. The objective was to produce a directory of existing standards concerned with the correct meaning and visual representation of puctuation. The student's research was collated and edited, using a prearranged grid. Each student then hand-set and printed one page providing definitions and examples.

Left: Kelvyn Smith teaching at Middlesex University, UK.

Directory of punctuation Michael Kontos March 2001

Exclamation mark!

The Exclamation mark is a specialised version of the full stop. It signals strong feelings or urgency, and is used at the end of the an emphatic utterance or phrase:
Get out of my house!

An exclamation mark is usually found after an interjection:
Sh! Hey!
Be quiet! Ugh!

Multiple exclamation marks are to be avoided in print. They usually indicate a rather desperate attempt to pep up a tired piece of text and are much loved by writers of comic strips and tabloid press headlines:
Eeeeeek!!!! Kerplonk!!!!

Bloomsbury Grammer Guide
Gordon Jarvie

Of the Exclamation mark there is little to be said except that its use should be confined to genuine exclamation:
'Heavens above!', 'Hi, you!.

Occasionally a sentence that has the form of an ordinary statement will bear an Exclamation mark when the sense demands: e.g.'
He actually climbed up on to the dizzy parapet and balanced himself on one foot!'.

But the merely gushing exclamation mark—'When we got home, we found the most lovely tea awaiting us, with hot buttered toast, scones, and lots of devonshire cream!'—is to be avoided; and the doubling, or even trebling, of exclamation marks for the sake of extra emphasis is a vulgarism.

Mind the Stop
G V Carey

To challenge the inevitability of these experiences, some art colleges have retained letterpress equipment and some have reinstalled it. A few of these colleges also offer courses in bookbinding, papermaking, and paper engineering. The purpose is not, normally, to teach students traditional methods of working or even the benefits of craft or technology. Rather, and perhaps surprisingly, it is to emphasize creativity more effectively. The fascination that letterpress holds is simple to explain: to a student, computers are commonplace, whereas letterpress is so old it's new.

The fact that letterpress is no longer the industry standard is a huge advantage. It means the student can concentrate on the basic requirements of visual communication rather than attempting to produce an equivalent of commercial graphic design. Indeed, the working methodology will provide an entirely different perspective. Working within uncharted territory can be a huge aid to creativity, providing opportunities to develop new creative strategies for the practice of design.

The independence offered by letterpress, plus, of course, the physical interaction – the "building" of a page of text – brings the student much closer to the subject of the text and to the remarkable richness and variety of forms and symbols that give the text sense. The sense of ownership thus gained by the student has the effect of arousing curiosity for the true meaning of some of the smallest elements used in written and printed texts.

Since all punctuation marks must be individually handled and positioned, it is not surprising that their precise function will be queried. Inevitably, the first question will be, "Am I sure this has to be included"? The second will always be "why"? The simple fact is, no one wishes to do more work than is absolutely necessary.

To provide this experience as part of an educational curriculum is not difficult. It is not even expensive; letterpress is economical and recyclable. However, what must be determined at the outset is the role of letterpress in relation to digital technology. Initially, letterpress works best when directed to address compositional problems containing such basic typographic elements as scale, contrast, balance, and alignment. While handling and positioning metal and wood type, the students are making decisions concerning font, type size, line length, character spacing, and leading. The student is able to produce, both economically and quickly, not an approximate visual but the *finished* product.

Left: Relief printing using any of the letterpress handpresses provides powerful visual statements with an immediacy unmatched by any other means. (Tutor, Phil Baines.)

Above and right: Just how playful and irreverent letterpress can be is shown by these images of Susanna Edwards, exploring the words "50 years of contemporary arts."

Right: The processes associated with letterpress are as beguiling as the result. The marks left behind by oil, ink, and cleaning fluids, as well as the telltale evidence of thinking and planning left by pencil or scalpel, can be too alluring to resist for a student previously used to "cutting and pasting" by keyboard and mouse. Such material evidence can appear mannered to those who are involved on a day-to-day basis in craft activities, but, in education, these working sheets are a valuable record that augments and clarifies both the physical and intellectual processes of design. (Tutor, Phil Baines.)

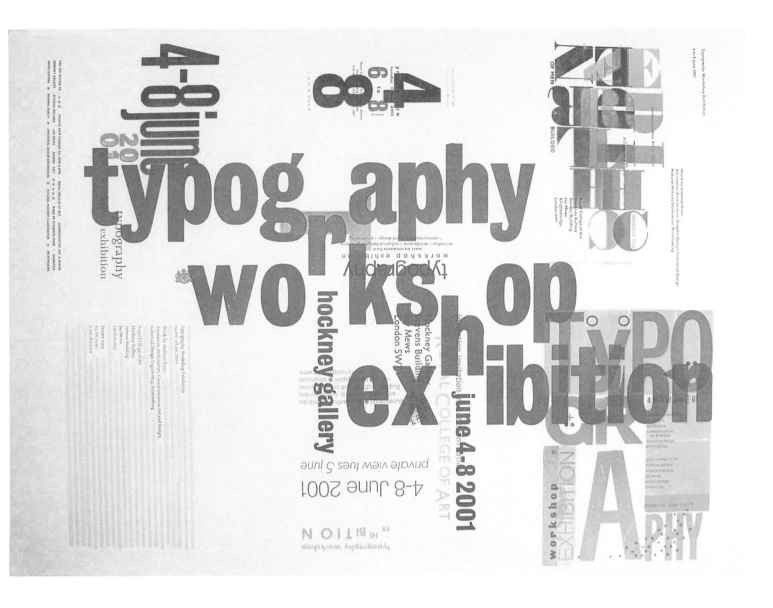

Above: A poster to promote an exhibition of work produced in Alan Kitching's typography workshop. The poster had a second purpose; it could be trimmed to provide six different invitations. A student collaborative effort, 2001.

Left: Another invitation to an exhibition of student work, this time designed by Alan Kitching.

[Craft and education]

4.2 Appropriating craft

Controlling standards

Paradoxically perhaps, the technology of letterpress has the effect, certainly initially, of cutting down the range of options. The physical effort of making even the simplest of changes, for example, adjusting line endings or changing the amount of leading, is a prospect just daunting enough to make the student ponder all the implications of such a change *before* they begin. (Such changes take seconds with digital technology and are often made without thought or reason.) This is not, in the end, a restriction. Rather, the physical interaction with the medium compels and drives creative and inventive thinking; the physicality of letterpress ensures that the act of design is an intellectual activity.

This physical and intellectual link is thoroughly explored by Edwards, Lockheart, and Raein.[1] "The physicality involved in the setting of type allows students to acquire new insights, utilizing different learning skills which have a more direct physical impact on the student's imagination and memory. The metal type has the distinctive tactile qualities of weight, texture, and smell, and forms the basis of a multi-sensory learning experience. The tactile sensation of setting type allows for a range of intuitive investigations leading to experiential learning."

In the same article, the task of setting 7pt digital type on the computer screen and setting 7pt metal type in letterpress is compared. In letterpress, the student's intentions are refined by the decisions that he or she makes during the physical setting of metal type *at its actual size*. Such decisions are influenced by the readability of the text, its awkwardness of handling, and its relationships to other texts, and by judgments made about inter-character and interword spacing. The computer workstation, on the other hand, engages the student on a more detached level: the use of the magnifying tool takes away any genuine sense of scale.

J e

an

R ob

erts

17 may 1937

0800 G Joan Holste ad

0915 got up e arly and

had brea kfast and got dress

ed 1130 Washed the

ot up early 12 pots

23 Dressed 1240 Auntie a

rrived 1320

and eat 1330 Got up and washed She

prepared dinner 1420 Af ter dinner, I helped my A

untie to wash the pots

1515 My auntie cam e and we went to town to bu

y a dress 1630 We went h ome on the bus and then had our tea

1650 We went to the park a

nd played with the baby 1720 We arr ived home again and had our supper, but

I couldn't eat much because I had a heada

he 1925 I took the baby to bed

mins 0 12 24 36 48 60

Far left, top and bottom: *The Torch*. The Birmingham School of Printing under the leadership of Leonard Jay, regularly published a "booklet" containing specimens of work done by students attending printing classes. This issue is from 1931–1932. The specimens, two- and three-color letterpress and full-color lithography, are exemplary. There are, of course, no signs of the process through which this work was achieved because such a sign would, quite rightly in this context, represent poor craftsmanship.

Left: Darren Hughs, 1997. *In Darkest England* is a document comprising a boxed set of 21 loose sheets principally printed letterpress. The subject is Mass Observation, an anthropological study undertaken in Lancashire, UK, between 1937 and 1939. This sheet, one of eight done by students and visiting lecturers, was completed while Darren was a student at Colchester School of Art and Design, UK.

Thinking while designing

The use of software encourages dependency upon the prescribed routes that have been conceived by the program's creators. These are the same routes used by everyone else. The fundamental difference between the use of letterpress and the use of computers is the process; the route taken through the use of computers does little to encourage forward planning or to stimulate the contemplation required throughout the design process.

Users of letterpress will quickly recognize its formal elements and gain a practical understanding of their functions. This knowledge, and the elements themselves, encourages contemplation. The result is that the student is continually presented with fresh and unexpected incidents, all of which need to be solved by design. The subconscious knowledge this provides empowers the student to take charge of the technology when working on the computer.

I am aware, however, that it is not the medium itself that encourages a sense of adventure, but the attitude and approach of the tutor, which, in turn, influences the expectations of the student. In the past the letterpress workshop would have been used by both design students and printing students, though not at the same time! I am quite sure that printing students would have been prepared for a different impression of letterpress than that of design students.

Printers, generally, have a specific, predicted outcome in mind and, in the same way, expect tools and equipment to be in a predictable place and a predictable state. Designers do not always know exactly what the outcome will be, and even if they do, they are always on the lookout for ways of improving it. This can lead to disagreements between tutors from print and design departments regarding the way equipment is used and stored. As if to emphasize these differences, printers would (and some still do) call designers "artists" – usually with derogatory intent!

Right: The various proofing stages that a document of any size must undergo leaves behind an accurate and therefore valuable record of the intellectual process that the author, proofreader, and printer must go through in order to bring the text to fruition. Illustrated is an early proof from *In Darkest England*. Proof marks by Clive Chizlett, 1997.

another part-time lecturer at Colchester, had worked as Alan Kitching's assistant at the Typographic Workshop. It was seeing the work of RCA students that made me realise the potential of letterpress as a means of teaching typography at a time when computer technology was taking hold. Alan himself subsequently became a regular visiting lecturer at Colchester. The success of our letterpress workshop is illustrated by the inclusion here of two sheets produced by students in 1996; Darren Hughes, who is now technician for the letterpress workshop at the RCA and Robert Park-Barnard presently employed at (..........)

The first part, concerning *photographic* observations is based around the work of Humphrey Spender. I am very fortunate to have known Humphrey, also a visiting lecturer at Colchester Institute, who knew Tom Harrisson and worked closely with him during the first few years of Mass Observation. I interviewed Humphrey three times, but it was the first that was the most productive. This was conducted with a very limited knowledge on my part of Mass Observation and, perhaps because of this, Humphrey seemed particularly at ease. My initial intention had been to do a 'test run' by discussing one particular photograph that I had found, taken by Humphrey, which depicted Tom Harrisson and others around a breakfast table in the Mass Observation headquarters in Davenport Street, Bolton. I asked and was given permission to reproduce all the material from the (taped) interviews with an absolute minimum of editing. I wanted the text to read like a Mass Observer's notes of a conversation overheard, complete with all the mannerisms, inflections, hesitations, repetitions and asides.

It was important that the eight sheets carrying this material worked together as an integrated whole as well as functioning individually. This was to aid the visual and literary flow of the interview and the subsequent linkage with other observers' reminiscences. It would also emphasise that these sheets are principally the record of *one* observer, Humphrey Spender.

As my research into the thoughts and activities of the other observers progressed, it was unavoidable that Tom Harrisson would take centre stage. Harrisson was a man of great energy and intellect, but for many he was also selfish, egotistic, inflexible, even brutal in his behaviour to people who did not agree with him. But, if like Humphrey Spender, you made an effort to concentrate on his positive characteristics, then he could be fascinating and compelling company. Besides a certain sense of humour, other shared sympathies drew the two men together. Both came from upper-middle class backgrounds and yet both had a passionate distaste for the moral values of a society that encouraged the injustice of a class-system driven by self-interest and greed. Tom was also interested in the arts (having written poetry, a book and various other publications). Humphrey, who trained as an architect before turning to photography had, through his brother, Stephen, had links with the Bloomsbury Group of artists and writers, and would have brought a welcome sense of creativity to Mass Observation. Harrisson was keen to employ observers from the widest possible class range in the expectation that their differing view-points would be reflected in their reports and therefore provide a more accurate (if more complex) record of what was being observed. This distinctly unscientific approach was roundly vilified by the academic community who resolutely refused to recognise Harrisson's work by refusing all applications for financial support for Mass Observation, much to Harrisson's annoyance. He was always critically hostile towards academia. To Harrisson, their attitude summed up everything that was wrong with learning methods of the day – the gaining of knowledge from books and the protection of this isolationist activity from the (supposedly) mundane everyday activities of human existence. For Harrisson the real truth of human existence lay in those mundane activities, activities which he so fervently wanted to have accurately recorded.

And so 'In Darkest England', which derives from the title of H M Stanley's Africa journals of 1887, is an appropriate title for this publication. For most of the observers, and this was certainly the case with Humphrey Spender, going up to Bolton was as alien an experience as going to Africa itself. It is also a clear reference to Tom Harrisson's favourite theme for Mass Observation: that we know so little about ourselves, and yet we earnestly send expeditions out on anthropological surveys to so-called primitive societies in order to make scientific studies and produce learned papers. It was on his return to the UK following just such a protracted mission that Tom Harrisson wrote 'Why not study the cannibals of Lancashire, the head-hunters of Stepney?'

The use of the grid as an ordering system is the expression of a certain mental attitude inasmuch as it shows that the designer conceives his work in terms that are constructive and oriented to the future.

This is the expression of a professional ethos: the designer's work should have the clearly intelligible, objective, functional and aesthetic quality of mathematical thinking.

His work should thus be a contribution to general culture and form part of it.

Constructive design which is capable of analysis and reproduction can influence and enhance the taste of a society and the way it conceives forms and colours. Design which is objective, committed to the common weal, well composed and refined constitutes the basis of democratic behaviour. Constructivist design means the conversion of design laws into practical solutions.

Work done systematically and in accordance with strict formal principles makes those demands for directness, intelligibility and the intergration of all factors which are also vital in sociopolitical life.

Working with the grid system means submitting to laws of universal validity.

The use of the grid system implies
the will to systemize, to clarify
the will to penetrate to the essentials, to concentrate
the will to cultivate objectivity instead of subjectivity
the will to rationalize the creative and technical product on processes
the will to intergrate elements of colour, form and material
the will to achieve architectural dominion over surface and space
the will to adopt a positive, forward-looking attitude
the recognition of the importance of education and the effect of work devised in a constructive and creative spirit

Every visual creative work is a manifestation of the character of the designer. It is a reflection of his knowledge, his ability, and his mentality.

INCREASE LEADING 2pt — 3pt

In 1964, one of graphic design's seminal texts was produced by a printer/designer/ teacher Anthony Froshaug: a booklet called Typographic Norms. This modest publication is a kind of manifesto for letterpress. Three years later he wrote a design article for Designer magazine in which he articulated his ideas. The key sentence is this: The word typography means to write / print using standard elements; to use standard elements implies some modular relationship between such elements; since such a relationship is two dimensional, it implies the determination of dimensions which are both horizontal and vertical.' The booklet explores this idea of standardization, showing the spaces, bodies, the relationships, the constraints and rules that operate inside the bed in which letterpress type lies. 'Acknowledge all constraints.' says Froshaug, by which he meant understand the nature of type and how it got that way.

In 1990, Octavo, the Tomato of its day, called for a rejection of letterpress derived-dead typography and all its attendant convention. This is both one of those mini-statements that is initially thrilling (like declaring the 'death of print,') but on reflection seems increasingly foolish and insubstantial. Almost every typeface in use today was first designed and cut for letterpress (including Octavo's favoured Helvetica.) Many of the new, funky, wholly electronic fonts go back to the 15 th and 16 th century examples. Type is still designed on rectangular bodies, bodies that hold the letterforms in an invisible frame separate from the letters next to it above and below it. Many of these conventions have been carried into the typography of our computers: the skeleton and structure of ethereal 21 st century digital type is still firmly physical. The language betrays this: points, upper and lower case, baselines, even the word typeface refers to the 'face' that is presented to be inked. The conventions developed during the centuries of the letterpress era are so embedded in how type has been developed that it is impossible to separate type from the process that created it.

What has spelled the end of letterpress is its labour-intensive process; it is unrelentingly real. It is also slow, fiddly and unforgiving: if your fingers are inky that pull is ruined. Every single decision had to be considered, planned, and then acted out, all in reverse. The sheer physicality is what puts designers off, it seems so impossibly slow and complicated, and to engage in it you would have to transform yourself from being a mind-worker to being an actual-worker. That, and also that you have to know before you start what you are going to do, you cannot just switch the whole nature of letterpress type is fixed, immutable, in a way completely opposed from a computer: it cannot be shrunk or stretched. You can change the type by physically cutting it or scoring it, but unlike the virtual world, where command z restores it instantly, in the actual world it stays damaged.

But perhaps it does have something to offer. We are so dulled by the machine aesthetic, by the sterling ease and speed it does things, by its feature. We are so used to multiples that bear no relation to human energy, to print runs in the hundreds of thousands, millions even, to copying what we refer to as 'artwork' down the telephone lines.

In letterpress, every action you make has an effect, if you bleed the colours it prints that way. You can see the dust from the paper swirling in the sunlight, you can hear the treacly crackle as you reel at the smell of the turpentine. Each little piece of type you ink bites itself into the paper. The surface of work printed by letterpress undulates minutely; the type sinks to the back, the ink has sheen. Each print differs, even if only by tiny fractions, from its fellows, it is typography that has clearly and definitely been made by painstaking, and varying human effort. We forget that letterpress is still close as graphic design ever comes to the production of something unique.

Above, left and right: The design process sometimes leaves behind intriguing documents, and proofs are surely one of the most fascinating. The color, density, and rhythmic nature of these marks suggest more than just a record of faulty setting. They provide a whole new project to explore. (Tutor, Phil Baines.)

Hw mny ltrs cn U tke out of a SnTNce B fR !'TS uN R DbLE?

I am not arguing for one way of working over another. On the contrary, the contrast and tension between channeled and exploratory ways of working are a constant part of creative endeavor, and letterpress technology highlights these tensions better than most. This, indeed, is one of its chief values. Clearly, unrelieved regulation is bad, but so is a complete lack of any sense of responsibility or organization. Unlike digital technology, letterpress requires social considerations: after all, someone else will be using the same type and the same proofing press after you, and it is the responsibility of any student to leave the workshop as he or she would like to find it. Verbal communication skills are also called for, if only to explain where you left the quoin key!

Ron Springett described the problem succinctly. "Design is an intellectual process; part thinking and part doing, but most importantly, it is a process that cannot be done in isolation. People influence people; in fact, course structure is an irrelevance when compared to the people who run it and take part in it."[2]

All technologies have their own qualities that, in educational terms, should be held in equal esteem. But clearly, new solutions do not necessarily require the use of new technologies. Such a knee-jerk reaction might provide short-term political kudos, but education must always take the longer, more intelligent view.

Though letterpress is a technology of the past, it has intrinsic qualities that are of direct relevance to the teaching of computer-aided design: computer design will be more effective if approached with experiences gained through using letterpress.

Left: Henrik Kubel, circa 2000. An experimental piece, printed in black and silver.

Below: Ian Gabb, 2001. Typography Workshop poster devised by overprinting a selection of the constituent formes that made up the workshop prospectus.

5

Connecting past and future

"... the familiar feel of the stick and the reach of the job case, slowly assembling the fixed text by the fleeting motions of hand composition – that is the true meaning of festina lente."
Peter Koch, *printer*

HARD WORDS

PETER RUTLEDGE KOCH

MUSEUM OF FINE ARTS
THE UNIVERSITY OF MONTANA

11 August – 9 September 2000

Metal type

There are some who relish the pretence of antiquarian purity, and rebuke the use of products of contemporary manufacture, such as adhesive tape, foam rubber, and synthetic inks. However, for the vast majority of letterpress users, these materials have become indispensable and, importantly, the use of such materials is to the benefit of quality, through heightened control, rather than efficiency.

For most contemporary letterpress printers, time is no longer money, so quality is the only incentive. Despite the obvious indulgence implicit in such a remark, this should not be mistaken for a statement from the wealthy owner of one of those private presses whose ostentatious opulence is made so clearly visible.

ΔΕ

ΟΕΝΤΑ

ΤΑΙ ΩΣ ΕΣΤΙΝ

MONO

ΤΑΥΤΒΙ

ΑΛ·ΩΣ ΑΓΕΝΒΤΟΝ ΕΟΝ

ΥΝΟΓΕΝΕΣ ΤΕ ΚΑΙ ΑΤ

ΟΥΔ·ΕΣΤΑΙ ΕΠΕΙ Ν

Α ΓΑΡ ΓΕΝΝΑΝ ΔΙΖ

Ν

ΟΥΤ·ΕΚ ΜΒ ΕΟ

ΓΑΡ ΦΑΤΟΝ

Ν ΜΙΝ ΚΑΙ

ΛΕΝΟΣ

Previous spread, left: Print ephemera from Peter Koch, including an invitation to an exhibition of his work at the University of Montana, 2000.

Previous spread, right: A fragment from Peter Koch's *Parmenides*, 2003. The newly commissioned typeface was set at the Golgoonoza Letter Foundry.

Right: The Type Museum, London, has a thriving educational program.

During the period following World War II, all appeared to be well for letterpress. The mighty Monotype Corporation released Spectrum in 1955, Joanna in 1958, and Dante in 1960. But there, apart from Octavian, which was released only in a trial size of 14pt, the production of new, hot-metal typefaces ground to a halt. Production of Monotype's existing book types continued for some time and in 1995, that part of the business was saved from oblivion through its acquisition by what has now become the London Type Museum.

A complete list of companies able (and willing) to provide foundry type can never be up to date. Fonts can, of course, be obtained from anyone with a Monotype keyboard and caster, and such people are not difficult to trace. Typesetting services are fewer, but, again, not too difficult to track down. For example, the Type Museum continues to produce composition matrices for the full range of fonts that Monotype cut from the many thousands of punches it holds and, in the unfortunate case of damage, can cut new punches from the original copper patterns. This work is currently done by retired men and women from Monotype who also do the curating and museum-keeping on a voluntary basis.

There are many museums of printing around the world, but few that specialize in type. The Type Museum has based its collection on metal type from the Monotype Corporation, and there is a museum in Two Rivers, Wisconsin, that has a collection of wood type from the Hamilton Manufacturing Co. (now Fisher Hamilton Co.). The company began type production in the early 1880s and by 1900, Hamilton had become the largest provider of wood type in the us. The Hamilton Wood Type and Printing Museum occupies about 15,000 sq ft (c. 1,400 sq m) in the original factory.

Collection of the Hamilton Wood Type & Printing Museum
Two Rivers, Wisconsin

Collection of the Hamilton Wood Type & Printing Museum
Two Rivers, Wisconsin

Left: Two specimen sheets displaying decorative wood elements from the huge collection held by the Hamilton Wood Type and Printing Museum. Design by Dennis Ichiyama, 2000–2001.

Presses

The availability of presses varies, depending upon the type of press that is required. The two kinds, platen and cylinder, were both designed as proofing presses, but the large platens, such as the magnificent American Columbian press, with its eagle perched on top, and the less ornate British equivalent, the Albion press, were rarely seen in commercial print shops of the twentieth century. Despite the fact that the manufacture of both has long since ceased, their cast-iron construction means that many have survived intact and are, today, generally put to excellent use and lovingly cared for in the printmaking departments of art colleges around the world. Consequently, they are rarely for sale, so when one in good working condition is made available, the price will tend to be in the thousands.

Cylinder letterpress proofing presses were being used efficiently in commercial printing companies until relatively recently, so these machines are still quite plentiful, and can be obtained quite cheaply. A typical flatbed proofing press is the Vandercook; a single-roller cylinder press. These flatbed presses vary according to age, but most of the newer models are fitted with inking rollers, many of which are power-driven.

Quite apart from the fact that such presses are still quite cheap and plentiful, they are also very forgiving. The flatbed allows the user to compose the type (and/or woodblocks) without the need to lock it into a chase in order to allow the transfer of the metal type (forme) from the work surface (stone) to the press. Naturally, all the elements must still be locked up securely, but the fact that the printer can work on the bed of the press means that the levels of technical proficiency required initially are less daunting.

During the nineteenth century, the book and jobbing printers required power-driven presses for their particular needs. In 1858 the British Wharfedale, a stop-cylinder machine, was developed for larger volume and scale of work, and in the 1880s, the American Miehle, a two-revolution machine, was developed for the same reasons. These presses, and others like them, were built in a range of sizes, and improved versions of both are still used today. Their size and complexity are a very definite drawback for the letterpress craftsperson, and for this reason alone they remain excellent value, when they become available.

Smaller platen presses were designed specifically to cater for the needs of the jobbing printer. The first of these were the small, self-inking treadle presses developed circa 1840; typically, the Ruggles, Gordon, and Cropper-Charlton presses. The adoption of electricity as a source of power allowed these machines to be designed with automatic paper feed and delivery. Again, these handpresses and their automated versions were in commercial use until very recently. Their sheer weight means that they are not easily thrown away, so they can still be found in the corner of small jobbing printshops, often converted to do cutting and creasing work.

Right: Printrooms should be visually stimulating and intellectually as well as physically challenging.

Far right: In a commercial context, the iron handpress was quickly overtaken by the much faster and more efficient machine-powered press. In fact, since the 1890s, iron handpresses such as the Columbian were generally limited to pulling proofs of wood engravings, woodcuts, and linocuts. As a result, many have ended up in printmaking studios at colleges of art.

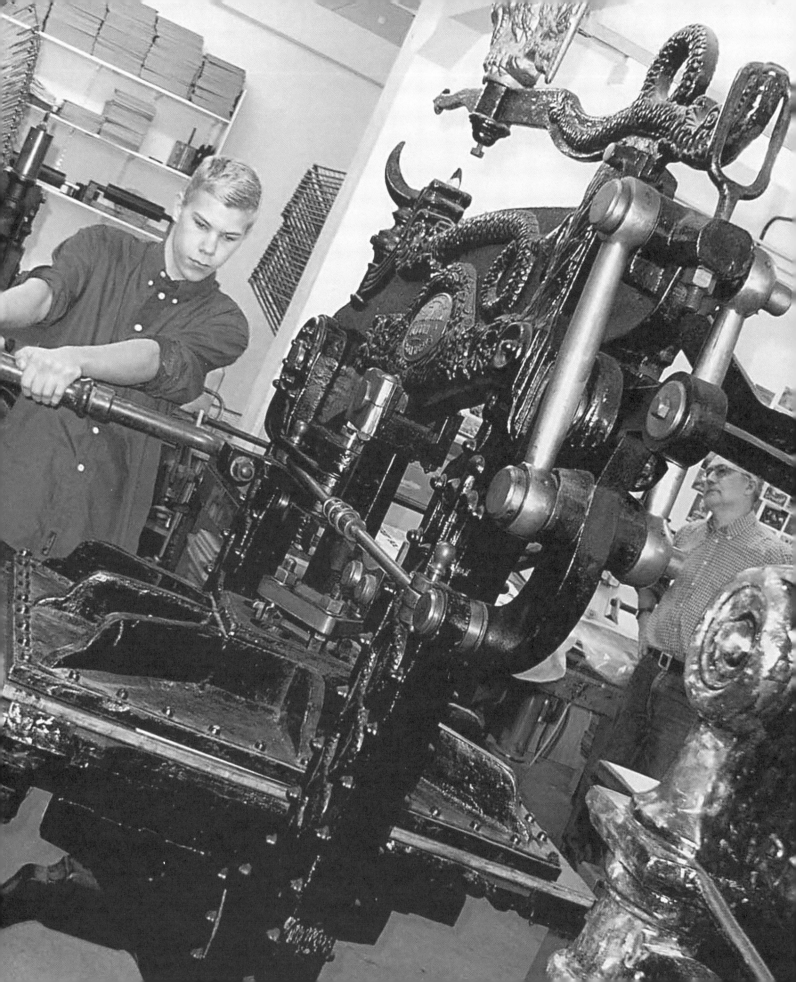

[Connecting past and future] 5.2 Appropriating technologies

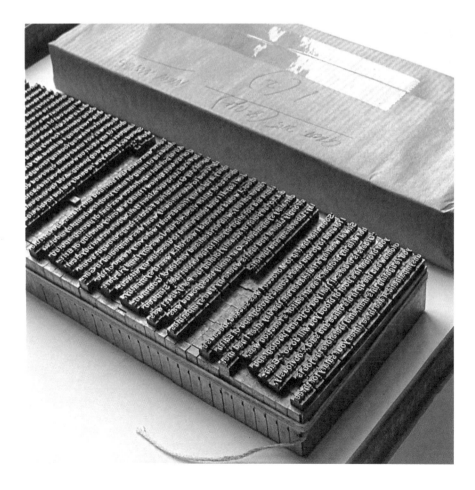

Typesetting and casting from disk

One definition of "technological" is "resulting from improvements in technical processes that increase productivity of machines and eliminate manual operations." What place, therefore, do technological advances have in letterpress printing? Surprisingly, letterpress, like every other craft, has been, and continues to be, affected by digital technology. However, the way computer technology has been applied suggests that "resourceful improvisations" might be a more appropriate title for this chapter.

A major development in typesetting for letterpress is the ability to set Monotype hot metal (or provide 31-channel punched paper tape for those with their own Monotype caster) from CD-ROM, zip disk, or email. This remarkably creative feat of engineering, marrying new technology with the quality of the old, has been achieved uniquely by Harry McIntosh, in Edinburgh, Scotland.

Adobe's PageMaker and InDesign, and Quark XPress, in both PC and Mac systems, can be used. Settings, of course, are fixed to the correct hot-metal character widths; they cannot be adjusted to tracked or kerned settings on the computer. Ligatures (characters consisting of two letters joined together) and accented characters need to be keyboarded separately. The range of such characters is limited only by the capacity of the matrix case. PDF (portable document format) files are sent as proofs, on which corrections or alterations can be indicated and returned. These corrections are implemented before commitment to punched tape or type. A few days later you receive, in galley form, metal type, tied and neatly wrapped in brown paper, and exactly what you had previously seen on your computer screen.

The system can, of course, produce text in any arrangement, ranged left, right, centered, and anything in between. There are many modes of indents, hyphenation, word spacing, letter spacing, and kerning, and even tabulation, dropped-initial allowance, unit shifting, and utilizing alternative wedges. Sizes of type are limited to those standard sizes available from Monotype. The maximum measure is currently 60 ems. Spacing, based on units, is extremely flexible, including word spacing under three units for extra-tight requirements. This is a rare necessity, but it illustrates the sophistication of Harry McIntosh's remarkable system.

His latest capability is to mix italic, bold, small caps, etc., with the same set from other die cases. This is done by leaving the correct allowances in the master galley and creating new galleys of the italic, etc., for casting with their correct die cases. These can be inserted by hand at a later stage – very useful for large compositions when there is only one font per die case. McIntosh is currently developing a program to mix any set size within the physical limitations of the wedges.

UNITS	NI	NL	A	B	C	D	E	F	G	H	I	J	K	L	M	N	O	
5	I	l	i	j	'	j	'	i	□	l	,	·	i	l	j	,	.	1
6	J	f	t	()	-	f	t	□	f	t	'	'	!	-	()	2
7	S	,	;	I	r	s	I	r	s	:	:	!	r	s	;	:		3
8	F	E	J	q	z	v	c	e	e	c	z	J	e	c	v	z	?	4
9	B	T	y	o	3	6	9	a	□	x	o	p	q	b	9	6	3	5
9	L	d	g	n	7	4	1	0	g	y	h	g	y	0	1	4	7	6
9	P	b	p	h	2	5	8	u	a	v	a	n	u	d	8	5	2	7
10	X	Y	R	C	A	o	x	d	p	b	q	k	S	?	J	£	k	8
10	Z	Q	v	fi	fl	?	k	u	o	h	n	fi	fl	£	x	fi	fl	9
11	K	D	G	H	N	'ff	U	F	S	T	L	P	ff	P	ff	S	F	10
12	M	Z	B	E	w	Z	F	T	E	L	B	w	E	T	L	P	B	11
13	K	V	C	G	R	A	V	C	w	A	R	C	V	Y	K	X	Z	12
14	X	Y	N	O	U	m	Q	A	O	R	X	Y	m	U	N	D	G	13
15	w	Q	D	H	K	D	ffi	ffl	m	U	N	G	H	&	O	H	Q	14
18	Œ	E	W	Æ	M	%	Æ	Œ	M	Æ	W	Œ	M	—	W	—	□	15

| NI | NL | A | B | C | D | E | F | G | H | I | J | K | L | M | N | O |

Above: Layout of a matrix case.

Left: Harry McIntosh started out as a Monotype compositor, in 1952, before becoming a keyboard operator. Inventive as ever, he uses buckets, packed into cardboard boxes that are surrounded by newspapers, as a practical, cost-effective way of sending set type, tied and wrapped in paper, through the mail.

Right: Seeing the apparatus Harry McIntosh has devised does not help you believe it can actually work, but it does!

Photopolymer relief plates

An alternative method of generating the means of printing large amounts of text, but one which also allows for all the additional flexibility available on the computer, is the use of photopolymer relief plates. In this book, I have kept references to computer-generated typography to a minimum,[1] but, with the introduction of photopolymer relief plates, the two technologies actually overlap, so such a comparison, however brief, becomes unavoidable.

Photopolymer relief plates utilize the computer-generated image of, for example, a page of text. This is transferred to the photopolymer plate via a same-size negative made from good-quality printouts. The process is the same for images. Once the text has been transferred onto a polymer plate (using a light-sensitive solution), the plate is then mounted so that the type is the same height as letterpress type.

For a time, when a secure supply of matrices was in doubt and Monotype keyboard and casting machines appeared to be in danger of disappearing, photopolymer relief plates appeared to be one possible way of maintaining the use of letterpress presses. Those early fears seem less prevalent today, but photopolymer has prevailed because of its flexibility and, of course, its compatibility with the computer.

Computer technology is far more flexible than letterpress, however, the conventions of typography, developed over hundreds of years, are as appropriate for computer-set type as they are for hand-set metal type. Badly set computer type is the consequence of ignorance and lack of time on the part of the designer. It is *not* the fault of computer technology. It is easy to demonstrate good typesetting on the Macintosh. The fact that it allows the typographer to do things that the compositor working in metal could never contemplate – setting lines in circles or spirals, merging and overlapping characters, or blending type and image together – does not make such work automatically bad. And the fact that it allows the spaces between characters to be adjusted by increments of a thousandth of an em is entirely positive.

The computer offers these almost infinite options, but it is a sad fact that the hurried pace and unrealistic design budgets mean that, even when designers have the skills and knowledge, they generally don't have the time to implement fine typography.

Below: *The Pyed Pyper*, **The Old Stile Press, 2002. Woodcuts by Angela Lemaire.**

Right: *The Revelation of Saint John the Divine*, **The Old Stile Press, 2002. This consists of 38 sheets, concertina folded, all with drawn and collaged images and text. The type used is Columbus.**

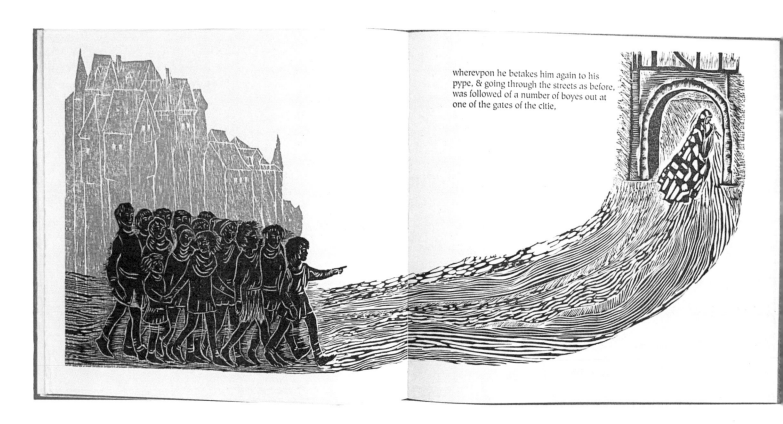

wherevpon he betakes him again to his pype, & going through the streets as before, was followed of a number of boyes out at one of the gates of the citie,

locusts up
ons of the
not hurt
only
them
ed five
when he stri

And he opened the bottomless pit
smoke of a great furnace
sun and the air were darkened
out of the smoke they ha
locusts upon the earth
as the torment of a scorpion
in those days shall men seek death
Greek tongue hath his name the locusts w
come, two woes more her
battle, and on their heads were as it w
es were as the faces of men. And they
their teeth were as the teeth of lion
breastplates of iron, and the soun
chariots of many horses running
orpions, and there were stings in
en five months
em, having breast they had a k
horses

smoke of
earth:
given
anded
green
of Go in th
not kill them
rment was as the t
those days shall
saw another
and a rainb
and his feet as
he set his right
with a
seven thunders
ared their vo
unto m
earth lifted up his hand
and ever, who created heav
the things that therein
there should be time
angel when he sh
hath
from
which
upon the earth
little book
thy belly bitter
I took the little book
up. And he
little book

a blind man could see how much I love you

If the letterpress user does have the skills and knowledge, why not apply them, via the computer and photopolymer relief plates, to letterpress printing? Digital versions of typefaces are generally fairly faithful to the metal versions they were adapted from, but there is some variation. While some Monotype fonts are identical to those originally cut for letterpress, most were adjusted to maintain standards of readability when printed offset (lithographic) as opposed to direct-contact (letterpress). It was boasted that such fonts were being modified by the inclusion of ink traps to improve their appearance when printed offset. Whatever the reason, they are different from the original letterpress fonts and this needs to be understood, especially, of course, if printing letterpress.

Despite the infinite options and control of typography that the use of a computer makes possible, in practice these are rarely utilized. There is something about the image on a screen that persuades the user that the technology will "do the right thing." This attitude is due to the lethargy caused by sitting in front of the same screen all day. Boredom is not the right frame of mind for creative or technical endeavor.

Above: *Language of her Body*, 2003, with large-scale photographs by Derek Dudek, ink-jet-printed directly onto the paper using archival pigmented inks. The text is set in Arrighi and printed by Robin Price. Each page also includes individually hand-rendered Japanese brush paintings by Keiji Shinohara.

Right: *Lines*, 2002, The Old Stile Press. Book cover printed using photopolymer relief plates to enable the fluid, handwritten text.

Far right, top and bottom: *Codex Espangliensis: From Columbus to the Border Control*. Letterpress printed from zinc plates by Felicia Rice. The Moving Parts Press, Santa Cruz, 1998.

In contrast, when setting metal type by hand, one has to move about, and the elements being handled are generally small and require constant checking. Conscious decisions must be made about spacing, line endings, word breaks – the minutest details. Because of this, with letterpress the quality of the typography tends to be far higher than that generated by digital technology. However, computers are machines, just like the typecasters and printing presses that came before them. They do not threaten the craftsmanship of typography. As with any machine, it is the user who determines the value they add. There is every reason to expect beautiful work from someone who has chosen the typeface carefully and has set the type with care.

The use of photopolymer relief plates has steadily increased. The stigma that was once associated with this technique is disappearing. The advantages are clear; it is cheaper than having large quantities of metal type set, it is very easy to handle, and, possibly most important, it enables new ideas to be realized and proffers other possibilities simply by its physical nature. And there is, of course, no reason why text printed using photopolymer plates should not be used alongside illustrative material using traditional woodcut or any other medium. The private presses are not just a repository for the craft of letterpress. They are the means to pursue a passion and the discoveries that these bring.

Footnotes

0 Introduction

1 There are few publications that have consciously drawn together various and disparate users of typography and offered an evaluation of their differences in culture, semiology, and aesthetics. Three notable exceptions are: John Lewis, *Anatomy of Printing* (UK, 1970); Herbert Spencer, *Typography: Design and Practice* (UK, 1978); and Herbert Spencer, *Pioneers of Modern Typography* (UK, 1969).

2 "Type of all descriptions, old as the building itself, or shining new from the foundry, was as abundant as gravel in a gravel pit, and seems about as much cared for. Pots, pans, dishes, and cooking utensils ground the face of it as it lay upon men's bulks, and under the heels of the busy crowd, as they tracked their sinuous path through the piles of formes stacked together in every available space…" C. M. Smith, *The Working Man's Way in the World*, 3rd issue (London, 1857); "A Royal Commission, quoted by the London Society of Compositors in 1866, recorded that the death rate of printers was 47 percent higher than that of the population as a whole, and that 70 percent of the deaths could be ascribed to some form of chest disease." E. Howe, *The London Compositor; Documents Relating to Wages, Working Conditions, and Customs of the London Printing Trade 1785–1900* (London, London Bibliographic Society, 1947); see Walter Tracy, "The composing room," *TypoGraphic* no. 60 (The International Society of Typographic Designers, UK, 2003), for an excellent and detailed description of a young apprentice's life in his first years of work in a large London printworks in the 1940s.

1 The nature of letterpress
1.1 The allure of the handmade

1 William Morris, "The Revival of the Handicraft," *Fortnightly Review* (November 1888).

2 The designer must establish the fact that "rough" was how the designer intended the work to be perceived and is not simply the result of poor workmanship.

3 It is general practice to miter display sorts (any type over 14pt) to enable a better character fit.

1.2 The material of letterpress

1 Emery Walker's words (1924) quoted by C. Franklin, *The Private Presses* (UK, Studio Vista, 1969).

2 Conventions and rebellions
2.1 Establishing conventions

1 Gutenberg's first, and probably only book printed from movable type is his two-volume *Latin Bible*. The *Gutenberg Bible*, also known as the *42-line Bible*, was finished a little before 1455. It has been estimated that the edition, containing 643 leaves, consisted of about 180 copies, some on vellum, others on paper. There are 12 surviving copies on vellum and 36 on paper. The vision and organizational brilliance that enabled Gutenberg to push a project of this scale through to completion – including, presumably, extensive experimentation, designing and building equipment, training assistants, and spending approximately four years painstakingly composing and printing – is breathtaking. The costs, of course, were enormous, and eventually bankrupted Gutenberg before the project was complete.

2 Aldus Manutius was the first printer to break away from all patterns of the medieval manuscript. His books, unadorned and with a smaller, condensed, cursive type (designed by Griffo), were smaller and less expensive than those of his contemporaries. But when Manutius discarded the large folio in favor of the smaller, octavo format (c. $10^{3}/_{4}$ x $6^{1}/_{2}$in), he was aiming at serving the convenience of scholar/ diplomats and aristocratic councillors of State. It is surely incorrect to imagine that he was thinking of tapping "popular markets" with texts devoted to classical Greek works. The term "student" should not be interpreted as the rise of a new class, but rather, the slight enlargement of the Latin-reading elites.

2.2 Breaking conventions

1 Between 1800 and 1850, the population of the UK doubled from 10 to 20 million. During the same period, the cost of living *dropped* by approximately 50 percent, while wages continued to rise, if slowly. This meant more people with more money, and yet, as the nineteenth century progressed, the main commercial printing process remained letterpress, and of the 500 printing firms in London in 1850, it is estimated that over 80 percent employed just three people or fewer. It was the "small" printer working for local customers who was leading this change in the role of letterpress printing.

2 Edmund G. Gress, *Fashions in American Typography* (New York, Harper & Brothers, 1931), page 73.

3 An insight into the changing way the American printer viewed the product of his newly established "art" is offered here in a review of a print specimen reproduced in the influential journal *American Model Printer* in 1879. "A. V. Haight, Poughkeepsie, New York, sends us his latest business card, which we must pronounce as beautiful. The design is Japanesque, with all the beauties of modern adornment. It is elegant in its simplicity and precise in execution. The colors used are gold, emerald green, bright red, medium violet and orange tints, field of light blue tint, also a field of gloss black. The lettering is Gothic italic capitals, worked in gold and black, producing a fine gold shade."

4 The term "exotic" commonly encompassed anything that might be "out of the ordinary." This certainly included anything "foreign," but also appears to include anything from the more distant past, especially all things "medieval."

5 The contempt, even embarrassment, which was finally felt for artistic printing is typically expressed here by the American, Samuel E. Lesser, writing in the *British Printer* in 1929. "... despite all the ingenuity exercised, it must be admitted that Artistic Printing was all 'loves labour lost' in so far as lasting worth was concerned. It had as little relation to real typographic beauty as the process of putting jigsaw puzzles together has, and, indeed, it required just that kind of mentality and skill. If this be an American contribution to typography, none can be found today to be proud of it as such." This is reflected in the scarcity of Oscar Harpel's book today, presumably because throwing it away came to represent an emphatic end to a discredited era.

6 American followers of the private press movement gave credence to the letter William Morris wrote to the editor of the *Daily Chronicle* in London in which he commented on the current state of typography in Europe, ending with the statement "... and as for American printing, it is quite abominable." Technically, American printing had been generally accepted as superior to British printing by a considerable distance, so it is not surprising that the editor requested verification. Morris replied "I *do* think American printing the worst from the point of view of good taste. Of course, I am aware that there are technical matters in which the American printers excel; but what is the use of that, if the result is ugly books very trying to the eyes?"

7 Most Linotype matrices carried two letters rather than one; usually the same letter in roman and italic. Wherever such letters share a matrice, they must have a common width. The Monotype also restricted the type designer's freedom, but less stringently. Roman and italic could have independent widths, and letters such as *f* could be kerned against their neighboring letters.

8 The company was originally named the Lanston Monotype Corporation. Its British offshoot, The Monotype Corporation, was established in 1897 and financed separately.

9 There are numerous records and anecdotes relating to Beatrice Warde's educational visits and lectures to students in printing schools as part of her role as Publicity Manager of Monotype. Typically, see Philip Turner's account in "Meetings with Remarkable People: Beatrice Warde," *TypoGraphic* no. 62 (December 2003), published by the International Society of Typographic Designers.

2.3 Reviving standards

1 This paradox, at the heart of the Arts and Craft movement, had its origins with John Ruskin rather than Morris. Ruskin's sweeping attack on nineteenth-century taste and modes of production in his famous chapter, "The Nature of Gothic," in *The Stones of Venice*, introduced a fierce Luddism to the argument for the Arts and Crafts movement, which was uncompromising and indiscriminate. The chapter contains 30,000 words and amounts to a book in its own right. It is easy to sympathize with him, however, when reading contemporary descriptions of the vogue for Victorian style, such as this one from Clarence Cook's *The House Beautiful*, published in 1877. "There needs to be a protest against the mechanical character of our decoration with ... [objects] so cheap that everybody gets them, and, of the smaller decorative things, gets so many that our homes are overrun with them, encumbered with useless ugliness."

2 Morris had his paper made for him, based on a north Italian pattern and made wholly of linen, using handwoven wire molds to provide a slightly irregular texture. The ink was made with linseed oil, freed from grease by the use of stale bread and raw onions rather than chemicals, mixed with boiled turpentine, and matured for six months before organic, animal lampblack was ground into the mixture.

3 Joseph Blumenthal, *The Art of the Printed Book 1455–1955* (New York, Bodley Head in association with the Pierpont Morgan Library, 1974).

4 The private venture of Count Harry Kessler, a German diplomat. Like the Doves Press books, the only decoration in Cranach books is initial letters, drawn by Anna Simons. Edward Johnston declined the invitation to do these and sent a student instead. However, J. H. Mason, compositor at the Doves Press until 1909, was persuaded to travel to Weimar to work for Kessler.

5 Albatross published English paperback editions to be sold in Europe (not England). The philosophy of Penguin Books suited Tschichold well. "Standardization instead of individualization. Cheap books instead of private press books. Active literature instead of passive leather bindings." Jan Tschichold, *Eine Stunde Druckgestaltung* (Stuttgart, Europa, 1930), page 7.

6 Marshall Berman, quoted in the introduction to Tanya Harrod's *The Crafts in Britain in the Twentieth Century* (USA, Yale University Press, 1999).

7 The Russian Revolution of 1917, the worldwide Depression of the late 1920s and early 1930s, and the British miners' strike of 1926 (not for more money, but to fight against cuts in pay), all helped to give the crafts of the time – with their emphasis upon maintaining the integrity of the raw materials and the notion of "staying true" to their inherent, natural characteristics – a political as well as a cultural edge.

2.4 Against the establishment

1 The term *livre d'artiste*, when translated, becomes "book of the artist" or "artist's book," but not every artist's book is a *livre d'artiste*. The futurists, for example, made a point of shunning the extravagance of limited editions, which were aimed at the rich patrons of the arts, in favor of inexpensive publications produced in large numbers by industrial, photomechanical means.

2 Beatrice Warde regularly berated the commercial artist and particularly the "professional typographer." This description is from the article "Typography in Education," reproduced in the anthology, *The Pencil Draws a Vicious Circle* (UK, The Sylvian Press, 1955).

3 Beatrice Warde, "The Crystal Goblet," *The Pencil Draws a Vicious Circle* (UK, The Sylvian Press, 1955).

3 Independent publishing
3.1 Craft and control

1 "It has always been possible for designers to adopt a political stance in relation to their work. Doing so is normally seen as an individual (and possibly eccentric) choice in which concerns that are external to the activity of design are 'smuggled in' as part of a personal agenda." Opening paragraph of Andrew Howard's article, "Design beyond commodification," *Eye* no. 38 (UK, 2000).

2 "Despite the emphasis on the 'mechanics' of written form in education, interestingly, teaching the rules of writing is not perceived as restricting creativity. Whereas teaching the rules of visual communication is often perceived as inhibiting creativity. The grammar employed to write poems or fiction is, essentially, the same grammar used when writing letters, memos or reports." David Jury, *About Face: Reviving the Rules of Typography* (UK, RotoVision, 2002).

3 "... for a certain amount of money you [the designer] have this to offer, and for a bit more money you can have a bit more – like prostitution. The profession does not speak of responsibility or ethics: the designer is not the hunter, but the victim." Lars Müller, "Form Follows Attitude," *Eye*, no. 20 (UK, 1996).

4 The commonly held view that artists generally work alone (while designers generally work collaboratively) is, of course, not always true. Artists have often used assistants (or "pupils") while designers, particularly with the opportunities offered by digital technology, can also say that they are more independent than ever before.

3.2 Craft and commerce

1 Dennis Hall, "Bias and Bigotry," *Parenthesis* no. 3, (May 1999), page 15.

2 John Grice, "Metal Typesetting by Gloucester Typesetting Services," *TypoGraphic* no. 60 (International Society of Typographic Designers, September 2003).

3 Walter Tracy, "Composing Room Days," *TypoGraphic* no. 60 (International Society of Typographic Designers, September 2003).

4 F. J. Hurlbut, "Decline of the Book Printer," *Inland Printer* (USA, June 1890).

3.3 Craft and technology

1 William Morris, "The Revival of the Handicraft," *Fortnightly Review* (November 1888).

2 J. H. Mason discussing the "artistic printing" displayed in the pages of *The American Printer* in *Imprint* no. 3 (1913).

3.4 Craft, design, and art

1 Rudy Vanderlans' editorial in *Emigre* no. 43 describes the moral and aesthetic issues that are a part of "selling out." *Emigre* no. 42 was the first issue to take advertising and the editor clearly received complaints from some of the readership. This is Vanderlans' final paragraph. "I guess the trick is to avoid putting yourself in a position where the realization of your ideas becomes entirely financially reliant on outside sources. Particularly if these sources have quite differing, if not opposing, interests from your own. Once you do this, 'selling out' happens, and everybody loses."

2 Mr. Keedy, *Emigre* no. 43, page 41. Continuing the theme outlined in Vanderlans' editorial (above), Keedy's article, "Greasing the Wheels of Capitalism with Style and Taste or the Professionalization of American Graphic Design," discusses the relevance of independent values. For example, "When it comes to influence, contribution, success, and recognition in the cultural arena, or the commercial world, designers are screwed... Perhaps it is time to look elsewhere for acknowledgment. Maybe designers should stop looking for public adoration and start working on mutual respect."

3 Some "printed matter" has, indeed, transcended its initial status; the graphic work of the Russian constructivists, for example. Despite the mass-production methods and poor quality of the materials used, the publications produced by these designers are today generally accepted, and certainly displayed, with all the reverence usually reserved for art.

4 Simon Lawrence, "Grant Aid for the Private Press?" *Parenthesis* no. 3 (May 1999), page 15.

5 J. H. Mason discussing the artistic printing displayed in the pages of *The American Printer* in *Imprint* no. 3 (1913).

6 John A. Walker and Sarah Chaplin, *Visual Culture: An Introduction* (UK, Manchester University Press, 1997), page 184.

7 There are notable exceptions, for example, David Pye, *The Art and Nature of Workmanship* (UK, The Herbert Press, 1968), and Sōetsu Yanagi (adapted by Bernard Leach), *The Unknown Craftsman* (Japan, Kodansha International Press, 1972).

4 Craft and education
4.1 The integrity of craft

1 The severity of this problem varies from country to country, but from my experience the UK is one of the worst offenders.

4.2 Appropriating craft

1 Susanne Edwards, Julia Lockheart, and Maziar Raein, "CODEX; setting the scene for a debate in graphic design education: the function of old and new technologies in the teaching of typography," *TypoGraphic* no. 60 (International Society of Typographic Designers, September 2003).

2 Ron Springett, quoted in David Jury, "Purchasing power," *Graphics International* no. 62 (1999).

5 Connecting past and future
5.2 Appropriating technologies

1 The subject of computer-generated typography and its functional relationship with the conventions established during the use of previous typesetting and printing technologies is discussed in my book, *About Face: Reviving the Rules of Typography* (UK, RotoVision, 2001).

Glossary

The language used in any trade reveals something of how the craftsmen perceive and value their work. It is not uncommon for tools or activities to be described anthropomorphically, but printers seem to have used human attributes more than most. For example, with metal type; from *head* to *foot*, there are *body*, *face*, *beard*, *shoulder*, *belly*, and *back*. The process of adjusting the spaces between individual characters and individual words is called *dressing* (though the word *kerning* is more commonly used today). On the page itself are: *running heads* or *head margins*, *running feet*, *footnotes*, *bastard titles*, *widows*, and *orphans*. A book has a *spine*, *headbands*, and *footbands*. An illustration or photograph that extends beyond the edge of the page will be cut and therefore *bleeds*.

Type is *matter* and during its composition it is referred to as *type matter*. In newspaper and magazine production, an item that cannot be included is *over matter*. On completion of a job, the original proof, when returned to the author, will be marked *dead matter*.

As technology changes, so descriptions from superseded processes are often carried forward with little or no logical reason; *leading* is a good example. *Uppercase* and *lowercase* have also been carried on, although *uppercase* letters are, on the whole, perceived to be larger, taller, and to generally indicate something more important than *lowercase*, so these terms still seem vaguely appropriate. A *galley* no longer means the metal tray that held the lines of composed type from which a *galley proof* might be pulled; instead, it now tends to describe raw copy prior to it being arranged on the page.

In hand composition, a practice unchanged since the fifteenth century, foundry type is picked from the case in which it is stored and placed in a *composing stick*. When the *compositor* has completed several lines of type matter, he transfers them from his *stick* to the *galley*. When all the required *text matter* has been composed, it is then transferred from the *galley* to the *stone*; a flat, smooth, metal-surfaced worktable. A suitably sized rectangular metal *frame* or *chase* is then positioned around the *text matter*. *Furniture*, standard-sized sticks of wood or metal, are arranged around the text matter to form the white areas of the page, and then, with the aid of *wedges* or *quoins* (expandable clamps), the whole *forme* – *type matter*, *furniture*, *quoins*, and *frame* – is lifted and transferred to the *press* as one whole piece. Finally, as such, it is *made up*.

This glossary limits itself to actions, materials, and tools directly related to letterpress itself. Italicized words are listed and described separately within this index.

Albion Press An iron, flatbed, *platen* handpress. American, designed by R. W. Cope, 1822

Back (of a letter) Opposite the *nick* side (see *belly*)

Bastard body A *body* which is not one of the standard sizes

Bastard font A *font* of type which is cast with a small *face* on a large *body*, the object being to obviate the use of *leads*

Beard (of a letter) The outer angle of the square *shoulder* of the *shank*, which reaches almost to the *face* of the letter

Bed (of the press) The flat surface on which the *forme* is placed

Belly (of a letter) The front or *nick* side

Bind When *furniture* is carelessly put together so that the pressure of the *quoin* is not exerted on the type

Blanket Material which interposes between the type and the impressing surface

Bleed The arrangement of a page so that the printed surface extends beyond the trimmed area

Bodkin A pointed steel tool used in correcting, for picking out wrong or imperfect letters

Body (of a letter) The *shank*

Body (matter) Text *matter* (as distinct from display)

Body (of the work) Text *matter* (as distinct from preliminary *matter*); the measurement, from top to bottom of a type

Botched Careless work

Break up To unlock a *forme* and *diss* the type and *furniture*

Cap Abbreviation for capital letter

Case Shallow wooden or metal drawer, divided into various compartments in which letters are kept. A pair of *cases* consists of *upper-* and *lowercase* letters

Case rack Rack for holding *cases*

Caster A machine that converts molten typemetal into individual items of type (characters and spaces)

Casting The work of the caster and its operator

Cast off To calculate how many pages the given copy will require in a given size of type; to calculate the cost of composition

Chapel An association of *journeymen* compositors in a printing office or a meeting of that association

Chase A rectangular metal *frame* in which type *matter* is securely fastened, enabling it to be carried to and from the press

Clean A *proof* with no errors

Cleaning pie separating various sizes and kinds of type from a confused mass and each letter in its proper place

Close up To push together, reduce *spacing* material

Cold type Photographically *composed* type *matter* (as opposed to hot [metal] type)

Columbian Press Iron *handpress*, American, invented by Clymer of Philadelphia, 1797

Compose To arrange type *matter* ready for printing

Compositor A typesetter

Composing stick An adjustable metal hand tray used for holding *movable* type *matter* as it is set

Copyfitting tables A simple yet reliable method of *casting off* copy based on an approximate character count

Cylinder machine A printing press which provides an impression via a curved surface (as opposed to a *platen press*)

Dead matter Type awaiting distribution (see *diss*)

Deckled edge The feathery edge of a sheet of handmade paper

Didot A system of type measurement used, generally, throughout Europe, named after its originator Françoise-Ambroise Didot (1730–1804)

Diss Colloquialism for distribute (return of type to the *case*)

Double case A case comprising a complete lowercase and half a normal *uppercase*

Draw-out *Movable* type which has not been securely locked in the *forme*, allowing the suction of the rollers to draw out the type

Dressing (the cylinder) Providing the necessary packing to the cylinder to ensure the correct impression

Dressing (the *forme*) fitting *furniture* and making other fine adjustments to *spacing material*

Em quad *Spacing material*, its width equal to the height of the *body* of a given size of type. For example, in a *font* of 10pt type, an em will be 10pt high and 10pt deep

En A unit of measure approximately equal to the average width of a given size of type

Face The printing surface of type

Family A series of typefaces, usually consisting of various weights and widths, in *roman*, *italic*, and small caps

Feed The placing of paper either by hand or by automatic feeder so that it can be held by the *grippers* for printing

Feedboard That part of the printing press from which the paper is fed in

Feededges Those parts of the paper held by the *grippers* of a printing press

Fingers An alternative term for *grippers*

First impression Initial printing, before any alterations or additions have been made

Fitting The spatial relationship of letters

Flatbed press A press that prints from flat *formes* (a *platen press*)

Flowers ornaments (mainly for use in borders etc)

Font A complete set of type, often given the spelling fount

Forme Type *matter* or type and blocks secured in a metal frame called a *chase*

Frame A sloped stand to hold type *cases*, the lower case will usually rest at 30° and the upper case at 40°. There is usually also a rack underneath to hold type *cases*

Fullfaced A *font* of caps occupying the whole of the type *body*. Also known as titling

Furniture *Spacing material* used in making margins or for filling up the space left in a *chase* after the type *matter* has been arranged

Galley Metal tray on which type is made up or stored

Galley proof A *proof* taken from type *matter* while still in the *galley* (usually achieved with a handheld roller)

Galley stick A long wedge of wood providing a temporary lockup. Commonly used when taking a *galley proof*

Gone to bed Used to describe a job which has gone to press

Gripper The *fingers* of a printing press which grip the edge of the paper when it is fed into the machine

Hair A very thin space, approximately half a *point* in width and used between characters

Handpress A printing press that is worked by hand, not driven by a motor

Head Top edge or margin of a book or page of text

Height-to-paper The standard height (·918in) of types, blocks, or any other *letterpress* printing material

Hell box A box for battered type (to be melted down and recycled into new type)

Hempel quoin Device for *locking up formes* consisting of two wedge-shaped pieces of metal with teeth on their inner sides into which a key is inserted and turned. This pushes one wedge in one direction and the other in the opposite direction, thus causing the two wedge-shaped pieces to "expand"

Impose To arrange pages of type in a *forme* so that they can be read consecutively once the printed sheet has been folded

Imposing surface A table with a planed, steel surface. Also known as a stone

Imprint The name of the printer and the place of publication

Intaglio Printing done from an incised plate (opposite of relief [i.e. *letterpress*] printing)

Interspacing Intercharacter or *letterspacing*

Italic A general term for type which slopes upward to the right. Generally considered to have been first used by Aldus Manutius circa 1501 and copied from a style of writing (Chancery) of that period

Jobbing Display work and small-size commercial work (ephemera; as distinct from bookwork)

Job chase A small *chase* without crossbars

Journeyman The name given to a *compositor* or pressman who had completed his apprenticeship

Kern The part of a *movable* type projecting beyond the *body*, typically the *italic* f. (Kerning is a term commonly used today to describe fine adjustments to the intercharacter and word spacing. See *dressing*)

Kiss Where there is little or no discernible indentation of the paper after printing

Lay The order in which a *case* of type is organized (the lay of the case)

Layout The plan of a book or document

Lead A strip of lead, less than type high, used to separate lines of type. Available in various thicknesses

Letterpress Relief printing from type and/or blocks or other raised surface (as distinct from *planographic* [*lithography*, collotype] and *intaglio* [gravure, engraving, etching] printing)

Letterspacing Intercharacter spacing

Linotype A machine operated by means of a keyboard for setting and casting lines (or *slugs*) of words. Invented by Ottmar Mergenthaler. First machine installed in 1886 at the *New York Tribune*

Lithography *Planographic printing*; printing from a flat surface. Invented by Alois Senefelder circa 1796. With commercial offset lithography the image is transferred from the plate onto a rubber-covered cylinder before being transferred *offset* to the paper

Live matter Type *matter* which has yet to be printed from

Lock up To fasten the *quoins* of a *forme* so that all the type *matter* and *furniture* is secure

Lowercase "Small" letters or textual minuscules such as a, b, c

Make ready The process of preparing a *forme* for printing and press

Makeup Arrangement of *matter* into pages

Matrix The mold used for *casting* type

Matter Type that is *composed*; a manuscript or copy to be printed

Measure The length (of line) to which it is decided type should be *set*

Mid A space *cast* four to the em of its own *body*

Misprint A typographical error (a typo)

Miter To cut the ends of a rule to 45° so that when a complete border is made the corners will join flush

Monotype A machine consisting of two parts, keyboard and *caster*, for composing and *casting* single types. Invented by Tobert Lanston

Mortise To cut away the nonprinting area on the side of a letter so that the character that follows (and which might also be mortised) may fit more closely

Mount The base upon which a printing (or photopolymer) plate is secured in order to bring it up to the correct height

Movable A term used to distinguish between single (mono) types and *slugs*, blocks, or photopolymer plates

Mutton A term used to describe an *em* quad of any *body* size

Nick A groove cast in the *shank* of a *movable* type as an aid to the *compositor* (to place it correctly in the *composing stick*)

Offset As in *offset lithographic printing*, describing the transference of an image from plate to paper via a rubber-coated cylinder

Overlay A method of increasing pressure to ensure solid, dark tones where required

Overmatter Excess *matter*

Overprint To print over or on work already printed

Overs Extra paper allowed to be used as *spoils*

Palette knife Used for mixing inks

Perfecting Printing the reverse side of a sheet

Pica An old size of type, now used to denote an *em* of 12pt; a pica em equals 12pts (·166in)

Pie Type indiscriminately mixed

Pied *set* type accidentally "broken"

Planer A flat, smooth piece of wood used for ensuring type is level before *locking up*

Planographic printing A means of printing from a flat surface, for example, *lithography*

Platen press A printing press which has a flat impression (as opposed to a cylindrical one)

Point (pt) A unit of measurement. (12pt = 1 *pica*; 72pt = 1in)

Point system The use of a typographic standard *pica* (·166in) of ·178in in the *Didot* system

Press proof The last *proof* to be examined before going to press (see also *gone to bed*)

Proof A trial impression

Proof correction marks Errors highlighted within text *matter*, and corrections described using rule-governed marks in the nearest margin

Pull a proof Take an impression for the purposes of checking or verification

Punch A piece of steel engraved with a type character and hardened. Used for making *matrices*

Punch cutting The process of engraving punches

Quad A quadrat. *Spacing material* cast in multiples of the *body* size. Usual sizes; *en*, *em*, 2, 3, and 4 *ems*

Quoin *Locking-up* device made of metal (or wood) and used in *imposition*

Random A *composing frame* or desk

Reader A proofreader

Reader's marks See *proof correction marks*

Register When pages, columns, and lines are accurately positioned and back one another precisely on the paper. If such *matter* is inaccurate it is "out of register"

Reglet A thin strip of wood, usually 6 or 12pts in thickness, used to create "blanks" between columns of type

Revise (*proof*) A second or subsequent *proof*

Roman "Normal," upright characters as distinct from *italic* or small caps etc.

Rotary press A printing press on which the printing surface (*lithographic* or *intaglio* plate) is placed around the cylinder to revolve with it, in contact with the paper

Rule Strips of brass or type alloy of type height, used to print lines

Set The width of a type character

Setoff The transfer of ink from one sheet of paper to another

Shank (of a type) The *body*, on which are the *nick*, *belly*, and *back*

Shooting stick (or shooter) An implement used with a mallet when *locking up formes*

Shoulder (of a type) The top of the *shank* from which the bevel of the *face* begins

Skeleton chase (or spider chase) A *chase* with bars extending from the corners or sides to hold a smaller *chase* within it

Slip galley A long, narrow *galley*

Slug (*Linotype*) A type-high metal bar having on its upper edge the type characters to print an entire line

Solid type *Matter* set without interline spacing (set solid)

Spacing material Metal "blanks" of various standard sizes for placing between words and characters

Spoils Used to describe imperfectly printed sheets

Titling *Font* of capitals only, each occupying the whole *body*

Uppercase Capitals, majuscule

Index

Acknowledgments

I would like to record my gratitude to Clive Chizlett for all the advice and assistance that he gave me during the writing of this book, and also to my editor Lindy Dunlop, at RotoVision.

Three books in particular have been invaluable to me during the period I spent writing this book. I would, therefore, like to record my indebtedness to the following:

David Pye, *The Nature and Art of Workmanship* (UK, The Herbert Press, 1968) Sōetsu Yanagi (adapted by Bernard Leach), *The Unknown Craftsman* (Japan, Kodansha International Press, 1972) Peter Dormer (ed.), *The Culture of Craft*, UK, The Manchester University Press, 1997). This is a collection of essays by various authors, but in particular I found Dormer's own contribution, "The Language and Practical Philosophy of Craft," helpful.

Other texts that I avidly read during the period I was writing this book:

W. Turner Berry and H. Edmund Poole, *Annals of Printing: A Chronological Encyclopaedia* (UK, The Blandford Press, 1966) Joseph Blumenthal, *The Printed Book in America* (USA, The Scholar Press, 1977) Nicolete Gray, *Nineteenth Century Ornamented Typefaces* (London, Faber & Faber, 1951) Edmund G. Gress, *Fashions in American Typography, 1780 to 1930* (USA, Harper & Brothers Publishers, 1931) Maggie Holtzberg-Call, *The Lost World of the Craft Printer (Folklore and Society)* (USA, The University of Illinois Press, 1992) Robin Kinross, *Modern Typography: An Essay in Critical History* (London, Hyphen Press, 1992) Alexander Lawson, *The Compositor as Artist, Craftsman and Tradesman* (USA, The Press of the Nightowl, 1990) John Lewis, *A Handbook of Type and Illustration* (London, Faber & Faber, 1956) John Lewis, *The 20th Century Book* (UK, Van Nostrand Reinhold, 1967) Norman Potter, *What is a Designer: Things, Places, Messages* (London, Hyphen Press, 1980) Richard-Gabriel Rummonds, *Printing on the Iron Handpress* (USA/UK Oak Knoll Press and the British Library, 1998) Micheal Twyman, *Printing 1770–1970: An Illustrated History of its Development and Uses in England* (UK, The British Library Press in association with Reading University Press, 1970).

The following people kindly allowed me to photograph material from their personal collections: Karen Bleitz, Micheal Cox, John Hall, and John Lingwood.

Thanks also to the staff of St. Bride Printing Library, London.

Thanks to the following for their generous help in compiling the material for this book:

Karen Bleitz (UK), Peter Koch (USA), Warren Lee (Holland), Jan Middendorp (Belgium), and Ulrika Stoltz (Germany).